Essential
MICHELANGELO

This is a Parragon Publishing Book
This edition published in 2003

Parragon Publishing
Queen Street House
4 Queen Street
Bath BA1 1HE, UK

Copyright © Parragon 2000

ISBN: 0-75255-147-7

Printed and bound in China

Essential
MICHELANGELO

KIRSTEN BRADBURY

Introduction by Lucinda Hawksley

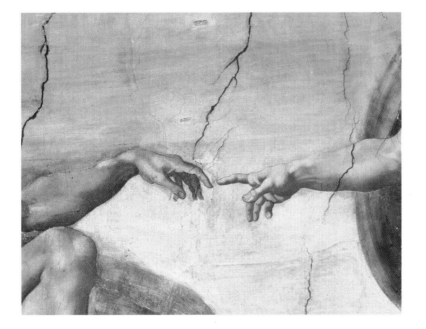

P

CONTENTS

INTRODUCTION

MICHELANGELO Buonarroti was born on March 6 1475. He lived for almost a full century and died on February 18 1564; he was still working six days before his death. During his life, the western world underwent what was perhaps the most remarkable period of change since the decline of the Roman Empire. The Renaissance saw changes in all aspects of life and culture, with dramatic reforms sweeping through the worlds of religion, politics, and scientific belief. Michelangelo was one of the most fervent advocates of this exciting new philosophy, working with a remarkable energy that was mirrored by contemporary society.

He was born at Caprese, in Tuscany, the second of five sons of Lodovico di Leonardo (a civil servant) and Francesca Buonarroti. The family had two homes: one in the Tuscan countryside, and a much smaller one in the city of Florence. In 1481, when Michelangelo was six years old, his mother died. 1481 was to be a portentous year in more ways than one, as it was also the year in which he had his first drawing lesson from a local artist named Francesco Granacci.

In 1488, at the age of 13, Michelangelo moved to Florence and began working as an assistant to Domenico Ghirlandaio (1449–94), who had recently started work on Florence's Santa Maria Novella church. In 1489, after completing just one year of his apprenticeship, Michelangelo came to the attention of Lorenzo de' Medici, who summoned the boy to his court. There, he was free to wander the gardens at will, drinking in all the fine examples of Classical statuary owned by the Medicis. It was there that he began to learn the secrets of sculpting, teaching himself by making drawings of the statues and attempting to recreate them in clay. He was

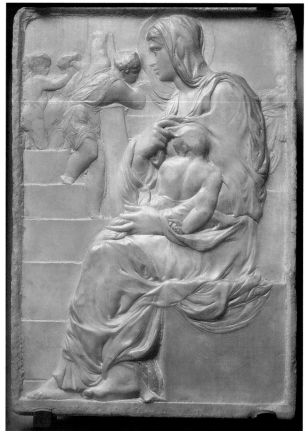

aided in his studies by the elderly curator of the gardens, Bertoldo di Giovanni (1420–91), who had formerly studied under the master sculptor Donatello (*c.* 1386–1466).

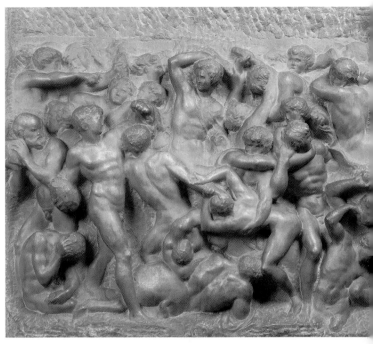

Through his association with the court of Lorenzo, Michelangelo was in contact with the most brilliant thinkers, artists and writers of his day. This experience was to enrich his life and consciousness. He was not only an artist, architect, and sculptor; he also wrote proficiently, producing countless poems and letters in his lifetime. Other influences on his young mind included two members of the church: one was his local priest, who, in return for the gift of a crucifix the young sculptor had carved, allowed him access to the bodies kept at the church so that he could study anatomy; the other formative influence was an articulate and opinionated monk named Fra Girolamo Savonarola (1452–98). He was a zealous reformer and an outspoken preacher; he was later to become the moral dictator of Florence for several months after the flight of the Medicis in 1494. He ruled by instilling religious fear into the Florentine people, foretelling great disaster if God was offended. His blistering sermons scalded many facets of Renaissance society and implicated many of the most powerful people of the day. This led to his eventual excommunication and execution in 1498; he was burnt at the stake in the Piazza della Signoria, where Michelangelo's *David* was later to stand.

Michelangelo first heard Savonarola preach in 1492, the year in which his first patron, Lorenzo de' Medici, died and Michelangelo returned to his father's home. The monk's sermons and his subsequent violent death had a lifelong effect on the artist and many of his works; the loss of Lorenzo also deeply affected his artistic consciousness.

By the age of 16, Michelangelo had begun to produce his own works. These included *Madonna of the Steps* (1491–92) and the *Battle with the Centaurs* (1491–92). These two pieces, although of a similar date, are vastly different from one another: the *Battle* abounds with

agression and vitality, it is filled with writhing, undulating shapes filling every section of the marble with boundless energy; in contrast the *Madonna* is serenely tranquil, containing little movement within an unfinished relief created to invoke an atmosphere of gentleness.

In 1494, Florence suffered severe political upheaval. Until that time, it had been a separate city state led by the powerful Medici family, but in 1494 the city was invaded by the French king, Charles VIII. The political climate for intimates of the Medici circle became troubled, and when news of the forthcoming French invasion reached Florence, Michelangelo, like many other prominent Florentines, fled the city

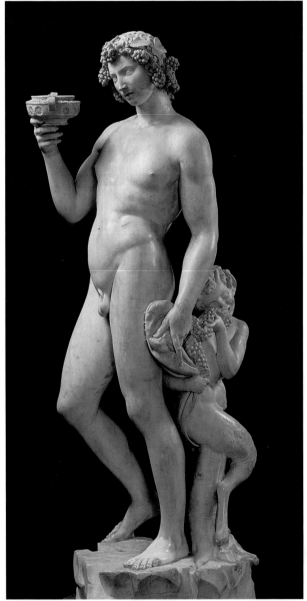

before the troops arrived. First, he traveled to Venice and then to Bologna, before he felt able to return home in 1495. While in Bologna, he was commissioned to complete a sculpture that had remained unfinished for 200 years, the tomb of St Dominic, Bologna's patron saint. The piece was begun by the sculptor Nicola Pisano (*c.* 1284–1314), but three figures needed adding. These were free-standing statues—the first of Michelangelo's career: St Proculus, St Petronius, and an angel.

Michelangelo's work for the Medici family continued after the invasion of Florence. At the age of 21, he made his first trip to Rome —a city that was both to play a prominent part in his life and cre-ate many frustrations for him. This time he spent five years in the city, creating some of his best-known works. In 1496–97 he completed his first important commission, *Bacchus*. As was his wont, the sculptor depicted the god of wine

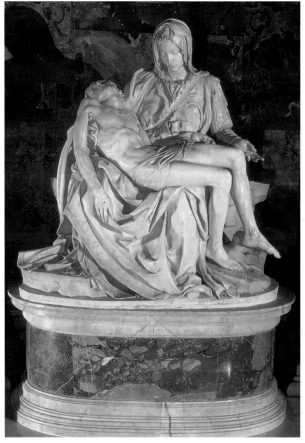

in a way never seen before. In place of the usual vision of Bacchus, an omnipotent force, genial but capable of brutality if crossed, Michelangelo sculpted a decadent, stupefied, almost effeminate drunk. Typically of his work, Bacchus's anatomy is executed superbly, the fluidity of the back muscles suggesting he has only just slipped into his drunken posture. It is a world away from previous depictions of the god and of the attractive, youthful *Bacchus* of Jacopo Sansovino (1486–1570), created just 15 years later, which reverts to the traditional Classical method that Michelangelo had considered outdated.

In 1497–98, Michelangelo created the *Pietà*, a masterpiece of sculpture that could not be further removed in content from the witty *Bacchus*. The *Pietà* is heralded as one of his greatest achievements. The sorrowing face of Mary, contemplating the lifeless body of her eldest child, still wrings the heart today. He took the subject out of a religious context and placed it in a humanist light, emphasizing the grief of Mary and the mortality of her dead son.

On August 4 1501, the turbulence of previous years seemed to come to an end and the city of Florence was declared a republic. On August 16, the new republic commissioned Michelangelo to make the statue of David. He was asked to sculpt it from a single block of marble; one which had been worked on 40 years previously by Agostino di Duccio, but had been left unfinished.

David is perhaps the world's most famous statue and a cult has grown up around it. When one views this 16th-century masterpiece, it is apparent what all the fuss is about. Michelangelo's command of anatomy is superb; every muscle is painstakingly defined, every movement understood by the artist. Traditionally, works on this subject show a diminutive David standing by the severed head of the defeated Goliath;

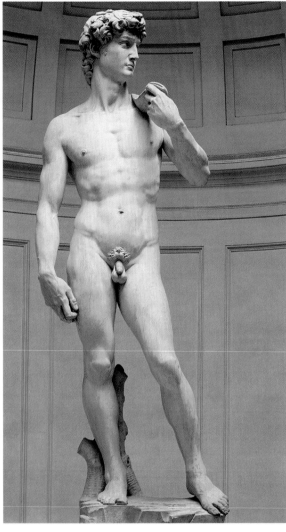

Michelangelo chose to change the perspective of this time-honored myth. His *David*, his face determined and thoughtful, stands strongly and pensively waiting to attack the giant. His hand holds the shot, his catapault is slung over his back. Michelangelo captures the brief moment of reflection on the hero's face, showing tremendous concentration as he decides how to save his people. The subject matter was apt for the Florentines, themselves on the brink of a new era having recently been freed from a political dinosaur.

On September 8 1504, the completed sculpture was taken to the Piazza della Signoria in the center of Florence, where it was placed in front of the Palazzo Vecchio. Such was the impact of Michelangelo's creation that it changed Florentine law—becoming the first naked statue to be allowed on public display since Classical times. Today, the original is housed in the Galleria della Academia, but a copy also remains in the Piazza della Signoria in the heart of Florence.

In 1505, Michelangelo was summoned to Rome on the orders of Pope Julius II, who ruled between 1503 and 1513. He was a member of one of the most important families in Italy—the della Rovere family, political rivals of the Medicis. Hungry for earthly immortality, Julius commissioned Michelangelo to make his tomb; a monument of vast and expensive proportions, which was intended to be finished within five years.

The next few years were to be the most frustrating and miserable of Michelangelo's life, in which he found himself at the mercy of an inconsistent, temperamental authoritarian. The power of the pope forbade Michelangelo to leave Rome, even though he was unable to begin working on the tomb: Julius stalled the project through his indecision as

to where the great edifice was to be placed. In preparation for his own death, the pope began an extensive recreation of St Peter's cathedral, intending to rest in supreme state for eternity—meanwhile Michelangelo was left in a state of limbo.

Relations with the pope eased when, on May 10 1508, Julius gave Michelangelo a new commission, which drastically changed the way in which he saw himself and his art. Until now he had been, by definition, a sculptor, yet the pope commissioned him to fresco the

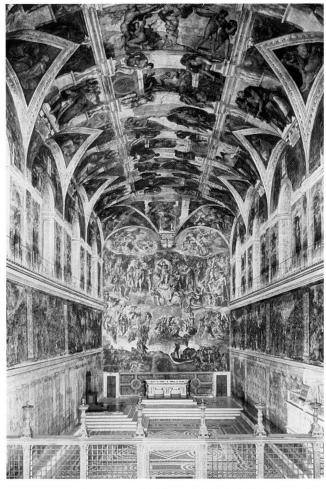

ceiling of the Sistine Chapel. Michelangelo had to learn the art of painting, just as he had had to do with sculpture as a teenager. He found this arduous and disheartening; a letter sent to his father in 1509 records his extreme frustration:

"*... my work does not seem to go ahead [as I would like it to] ... This is due to the difficulty of the work and also because it is not my profession. In consequence, I lose my time fruitlessly. May God help me.*"

The frustrated artist looked to his former master, Ghirlandaio, for assistance with the technique of fresco painting, in 1481–82. Ghirlandaio had begun the task of painting the Sistine Chapel ceiling in 1481 before his death in 1494.

Between 1508 and 1512, Michelangelo painted over 300 figures on to the ceiling. As with *David* and *Bacchus*, the scenes were not always depicted in the expected, conventional, and traditional manner of the time. This is most notable in his *Garden of Eden* fresco, where both Adam and Eve are seen as equally culpable for their downfall after eating from the Tree of Knowledge. The ceiling was eventually completed on October 21 1512; a task that was arduous in the extreme.

In 1513, Pope Julius II died—his magnificent tomb still unfinished—leaving Michelangelo to continue discussions about the tomb with his more agreeable heirs. However, the tomb was to suffer further setbacks for much of the sculptor's life. After the death of Pope Julius II, Giovanni de' Medici was ordained as Pope Leo X. He remained in power for ten years. Michelangelo's links with the Medici family had remained strong and Pope Leo determined to keep the association going —not least to prevent the harried artist from having any free time in which to work on the tomb of a della Rovere.

The reign of Leo X was liberating to Michelangelo. Within a couple of years of Leo's election, he was back in his beloved Florence,

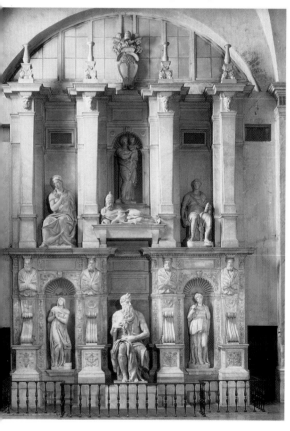

free to live where he chose and still to undertake prestigious projects for the new pope. Meanwhile, Julius II's tomb was planned and re-planned several times—each new drawing diminishing the tomb in size from previous plans and becoming less and less ornate.

Michelangelo made his home in Florence from 1515 until 1534. During this time, the city once again suffered massive upheavals. Since the time of Charles VIII's invasion and the city's subsequent republican status, the Medici family had returned. Although originally supported by the Medicis, Michelangelo was a fervent supporter of the republic. In 1527, the Medicis were driven from Florence once more, and the city declared a republic for a second time. Michelangelo was among several prominent Florentines who foresaw great political times ahead; He was appointed Governor of the Fortifications, a position that he took great pride in, although the rapid return to power of the Medicis thwarted his political ambitions. In 1530, the Medicis, aided by King Charles V of Spain, were restored to long-term power in Florence.

1530 also saw a new commission for Michelangelo, given by Baccio Valori, the hugely unpopular governor of the Florentine republic. The result of this commission was the work that has become known as

David (Apollo), due to uncertainty about which figure it represents. There are arguments for both and, with no concrete evidence, the art world will never be able to decide for certain. If it was intended as David—some critics suggest this because the crude round shape on which the figure's foot rests may have been intended as an unfinished head of Goliath—it is significantly inferior to his earlier masterpiece. This has often been cited as indicative of Michelangelo's dislike of his patron Valori; he often used his art as a medium to express his opinions of people. For instance, he incorporated recognizable portraits in the ceiling of the Sistine Chapel, using the character of the painted figure to suggest his like or dislike of the person intimated. He also incorporated his own face into his work at times—his self-portrait can be discerned in several of his works.

In 1532, Michelangelo paid one of his frequent visits to Rome. Here, at the age of 57, he fell in love with a young nobleman called Tommaso de' Cavalieri. Two years later, he decided to leave Florence and settle in Rome. Cavalieri was extremely handsome, and as one who

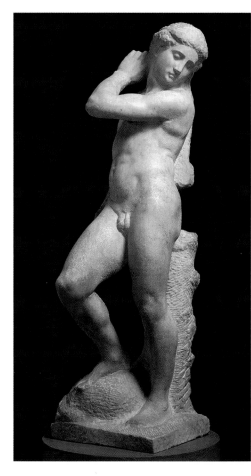

strove to create beauty in his art, Michelangelo saw his lover as God's most perfect artwork, describing him as the "paragon of all the world." Much of their correspondence survives, as does the poetry that the sculptor wrote to his lover. His creative energy now had a new outlet, which complemented his prolific output. The two men remained close until Michelangelo's death.

Another important friend of the artist was a widow named Vittoria Colonna, Marchioness of Pescara. She was a deeply religious woman and a Catholic reformer, whose forward-thinking views held abundant interest for Michelangelo. He

wrote her some of his most evocative poetry and, until her death in 1547, the two were extremely close—some sources suggest they were lovers, while others see it as an impassioned friendship. Michelangelo, as a poet, was strongly influenced by the work of yet another famous Florentine, the revered Dante Alighieri (1265–1321). During his early exile from Florence, in the time of King Charles VIII's invasion, and subsequently, during his enforced time in Rome under Pope Julius II, Michelangelo must have felt kinship with Dante, who had also been exiled. In his poetry to and about Vittoria, Michelangelo often compared her to Beatrice Portinari, the eulogized object of Dante's love. He also produced some of his finest religious drawings for Vittoria, in particular a masterful *Pietà*, drawn in 1546, just one year before she died. The distraught but powerful mother of Christ sits with her arms outstretched, embodying the cross from which her son has just been removed. The

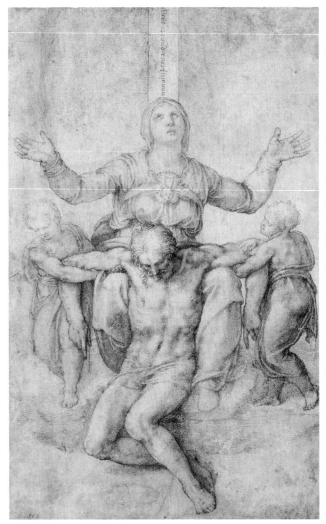

dead Christ is slumped between her knees—supported on either side by a robust, sorrowful *putto*— his head bowed with the sins of the world, his limbs loose in death. Both mother and son are powerfully drawn, with Christ's figure utilizing Michelangelo's fine command of anatomy. From the start of his friendship with Vittoria Colonna, Michelangelo's work became more religious in content, and his poetry and art also became more concerned with death.

Michelangelo's time in Rome was filled with commissions —alongside which he was still attempting to finish the long term project of the tomb of Pope Julius II. This was eventually unveiled in 1547; it had taken 42 years to reach completion. While in Rome, he was appointed Chief Architect of St Peter's in the Vatican and was

commissioned to paint the frescoes in the Vatican's Pauline Chapel (Pope Paul III's private chapel).

The works of Michelangelo are an intimate insight into the superb mind of a remarkable man; a man who, even in his own lifetime, was revered as a genius. His contemporary and biographer, Giorgio Vasari (1511–74), wrote of him as "the divine Michelangelo", describing him as a "master" who "surpasses and excels" not only the artists of his own time, but also all artists who came before, including the great sculptors of antiquity. Michelangelo was a deeply spiritual man, whose genius came in part from his observations of the many different forces to which he was exposed throughout his extraordinary life. It came from the teenage years spent at the court of Lorenzo de' Medici—who was a prominent humanist and forward-thinking leader of Renaissance philosphy—and from Lorenzo's brilliant circle of acquaintances; from Michelangelo's admiration for the fervor of Savonarola; via the traditional religious views of the Vatican under two very different popes; and from the passionate religious beliefs of Vittoria Colonna.

Michelangelo lived for almost 89 years—an unusually long lifespan for a man of his era. In 1557 he had been forced to leave Rome due to the threat of invasion by Spain; he spent several of the last years of his life traveling in much the same way as he had started his adult years. He returned to Rome after the threat had passed and it was there that his life ended; he was buried at the church of Saint Apostoli in a huge formal ceremony. However the story of his remarkable life was not over even in death: after burial, his body was secretly reclaimed and smuggled back to Florence, on the orders of Duke Cosimo de' Medici. There it was laid to rest in the church of Santa Croce. It remains there today, in a magnificent marble tomb designed by Vasari in 1570. The tomb bears a bust of Michelangelo, below which are sculptures of three sorrowing women: Architecture, Painting, and Sculpture.

LUCINDA HAWKSLEY

MADONNA OF THE STEPS (1491–92)

Courtesy of AKG London

MADONNA of the Steps dates from 1491–92, during the period of Michelangelo's apprenticeship to the Florentine sculptor Bertoldo di Giovanni (*c.* 1420–91) at the Medici Palace. At that time the head of the Medici family was Lorenzo the Magnificent, the most powerful and influential man in Florence, an important patron of the arts and leader of the Renaissance. His vast collection of ancient sculpture and artefacts was housed in the garden of San Marco, a nearby monastery. Michelangelo had unlimited access to this treasure trove of antiquities and the influence of his studies there is apparent in this piece.

For this marble rectangular relief, Michelangelo has chosen the popular religious scene of the Madonna with the baby Jesus, to which he would return in later years with his sculpture *Madonna and Child* (1520–34). He departed from the traditional treatment of this theme by placing the Madonna sideways, a position often used in ancient Greek funerary decorations, which gives the piece a somber air.

The strong influence of Donatello (*c.* 1386–1466) is evident in the shallow pale-yellow marble relief, and although there are several faults in perspective, as well as in form, the work is representative of the development of an incredible talent in the young Michelangelo.

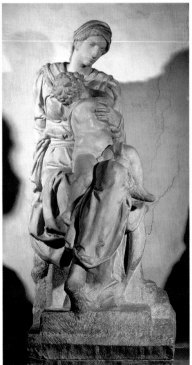

Madonna and Child (1520–34)
Courtesy of AKG London/Erich
Lessing. (See p. 164)

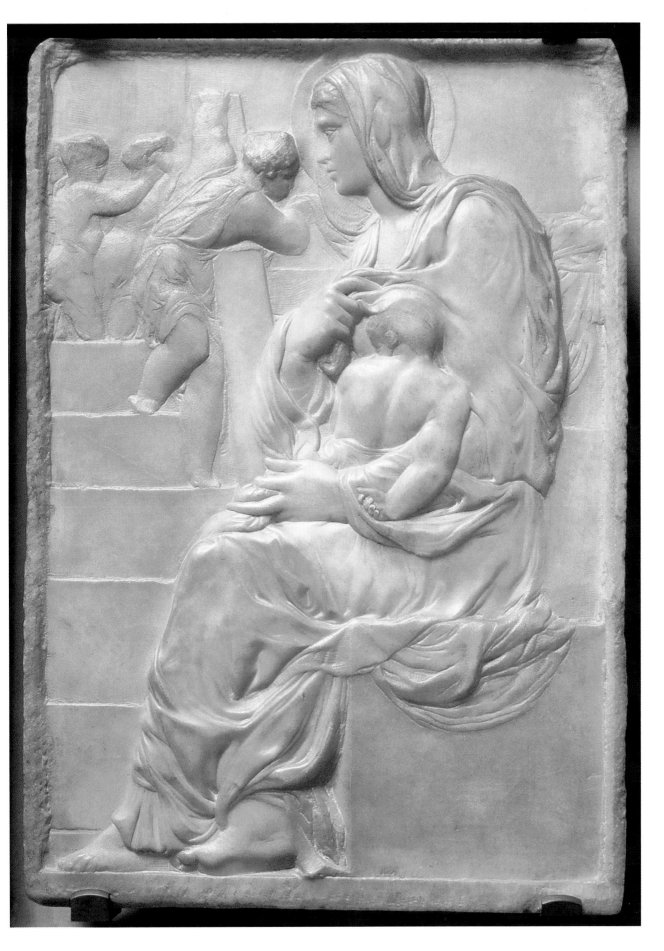

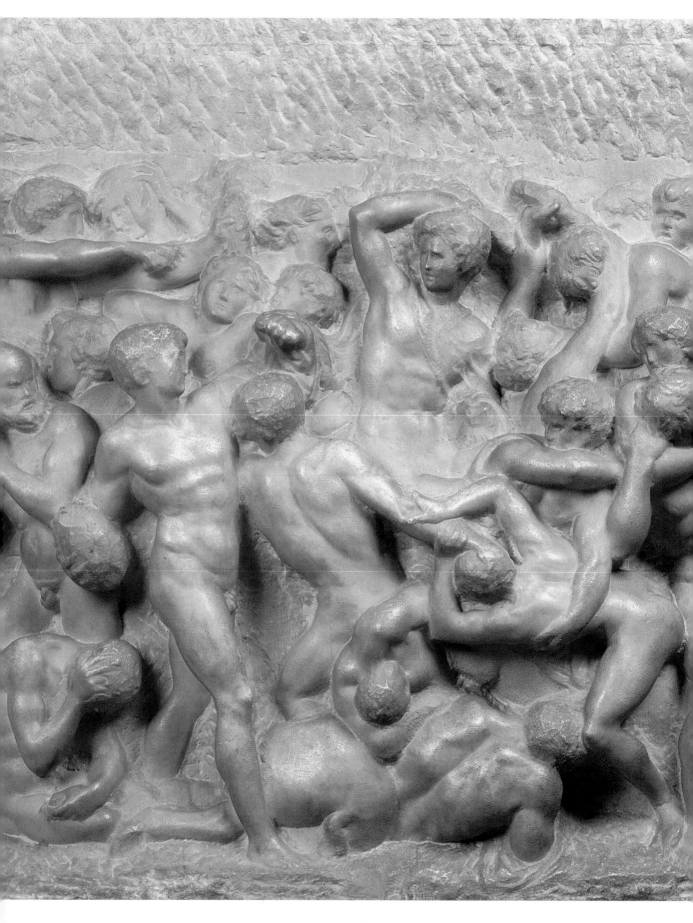

BATTLE OF HERCULES WITH THE CENTAURS
(1491–92)

Courtesy of The Bridgeman Art Library

ALONG with *Madonna of the Steps* (1491–92), the marble relief of *Battle of the Centaurs* is counted among Michelangelo's earliest surviving pieces. Thought to have been started between 1491, but never completed, the piece presents a theme that was to dominate Michelangelo's work throughout his career—the male nude in movement. Here, as with his later cartoon *Battle of Cascina* (1504), Michelangelo created a consolidated expanse of male nudes frozen in a violent and turbulent struggle. Arms grab, push, or throw punches and both pieces focus on the men's interlocking limbs and the gestures forming this compact mass. Some of the figures are in relief while others, in the foreground of the sculpture, appear almost free-standing.

The theme of *Battle of Hercules with the Centaurs* was a popular choice in Classical sculpture and the artist found inspiration for the work amongst the artefacts kept in the Medici garden. The piece is based on a tale in Ovid's (43 BC −18 AD) *Metamorphosis*, in which a wedding feast is disrupted by centaurs attempting to kidnap the women present, including the bride. Michelangelo has depicted all the figures as human, despite the centaurian subject of the relief, focusing mainly upon the muscular torsos of the men.

Battle of Cascina **(1504)**
Courtesy of The Bridgeman Art Library. (See p. 52)

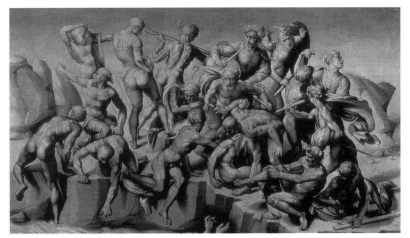

BACCHUS (C. 1496–97)

Courtesy of The Bridgeman Art Library

BACCHUS of Greek and Roman mythology was the god of vine, wine, and mystic ecstasy and Michelangelo chose to represent the two former qualities of the god. Bacchus, his head crowned with grape vines, stands with his cup held aloft as if about to offer a toast. His expression is one of vague puzzlement, as though he has forgotten what he intended to do. His head is tilted and his mouth open, while his eyes appear glazed and unfocused. The unsteady stance of the god furthers his drunken appearance; one leg is partly lifted while his body tilts backwards, making him seem unsure of his footing, almost staggering in his drunken stupor.

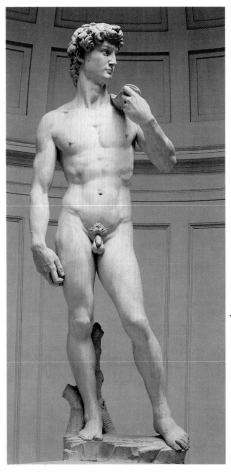

David (1501–04)
Courtesy of AKG London/Erich Lessing.
(See p. 31)

The piece was commissioned by wealthy Roman banker Jacopo Galli between 1497–98, while Michelangelo was living in Rome. The piece was placed in his garden and at one point the raised arm was broken off deliberately to increase the statue's Classical appearance. *Bacchus* is the earliest surviving life-size statue by Michelangelo. The perfection of the natural, realistic form that Michelangelo achieved here shows, as does *David* (1501–04), that despite his youth, he was far beyond the reach and ability of other sculptors of his time.

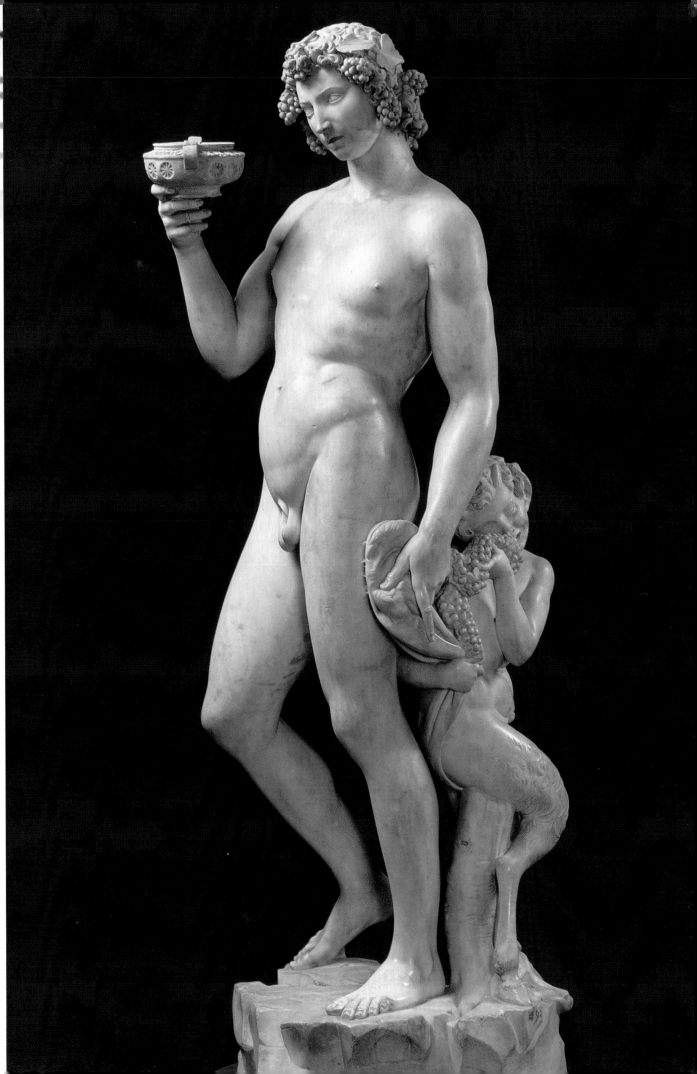

SATYR (DETAIL OF BACCHUS) (C. 1496–97)

Courtesy of AKG London/Erich Lessing

*I*N Classical mythology the satyr was a demon of nature, representing the animal elements of humanity with its half-man and half-animal form. The satyr was sometimes represented as a horse, but more commonly as having the legs and hind-quarters of a goat, cloven hooves and budding horns. Traditionally satyrs were the attendants of Bacchus, following him around and joining in with his festivities and sybaritic excesses.

This diminutive satyr hides behind the back of Bacchus, who is swaying drunkenly, and he nibbles at the grapes he steals from the leopard skin that Bacchus holds loosely. It was with this statue, and in particular along the edges of limbs such as the satyr's left leg, that Michelangelo started to perfect his use of the drill to create textured surfaces. This effect would not have been possible with his preferred tools—the claw, toothed, and flat chisels.

Bacchus was created to be viewed from every angle; to be a free-standing statue. When viewed from the front, the satyr can only be partially glimpsed and it is necessary to walk around the statue to see it fully. The two figures are not attached by their bodies but by the leopard skin and the grapes; the satyr's body, however, curves suggestively, mirroring the form of Bacchus.

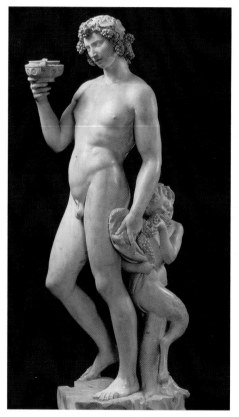

Bacchus (C. 1496–97)
Courtesy of The Bridgeman Art Library.
(See p. 20)

STUDY OF A MAN (THE ALCHEMIST) (*c.* 1500)
Courtesy of The Bridgeman Art Library

*T*HE *Alchemist* is one of Michelangelo's earliest sketches. The form and pose of this old man can be seen to derive from the famous fresco painting *The Tribute Money*, part of a series known as *The Life of St Peter* (1425–80). Housed in the Brancacci Chapel, Florence, begun by Masolino (*c.* 1383–1447) and continued by his pupil Masaccio (*c.* 1404–28), *The Tribute Money* showed the figure of St Peter handing out coins to the poor. The fresco had been the basis of a study Michelangelo made between 1489 and 1490 when he was serving an apprenticeship with the Florentine master Domenico Ghirlandaio (1449–94). Ghirlandaio was highly skilled at fresco painting and Michelangelo must have learnt the technique from him, although in later years he claimed that he learnt nothing at all during his apprenticeship. Michelangelo was to use this same form and pose for his portrayal of God in the fresco panel for the Sistine Chapel, *The Creation of Eve* (1508–12).

 The Alchemist shows a draped figure; the folds of his robes are formed with a cross-hatching technique. It is known as *The Alchemist* because the man may be holding a skull. It has also been called *The Astrologer* by those who believe the object he holds is a sphere.

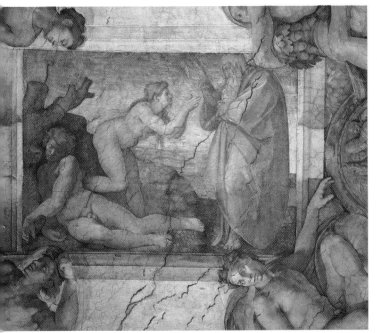

The Creation of Eve **(1508–12)**
Courtesy of AKG London. (See p. 76)

PIETÀ, ST PETER'S (1498–99)

Courtesy of The Bridgeman Art Library

*P*IETÀ (1497–99) established Michelangelo as a master sculptor beyond comparison to any of his contemporaries. The sculpture now stands in St Peter's, on a high pedestal and protected by bullet-proof glass, following a recent attack.

The pietà, a scene in which the Virgin Mary supports the dead body of Jesus in her lap, was a popular subject-matter in other areas of Europe but had rarely been depicted in Italy. The composition of the

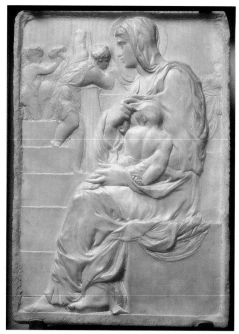

Madonna of the Steps (1491–92)
Courtesy of AKG London. (See p. 16)

pietà had caused other artists much difficulty in creating a realistic position that allowed Mary to support the body of an adult man. Michelangelo solved this problem by making Mary's robes heavy and large, creating an area in which the body of Christ could lie across her lap.

Pietà shows a reversal of the popular theme of Madonna with Child that Michelangelo explored in his early work *Madonna of the Steps* (1491–92). In *Pietà*, Mary holds the lifeless body of her only son, her left hand is stretched palm upwards, as if she is questioning the fate of

Jesus. This gesture draws the viewer in to the scene emphatically, reiterating the Christian belief that Jesus died for humanity's salvation.

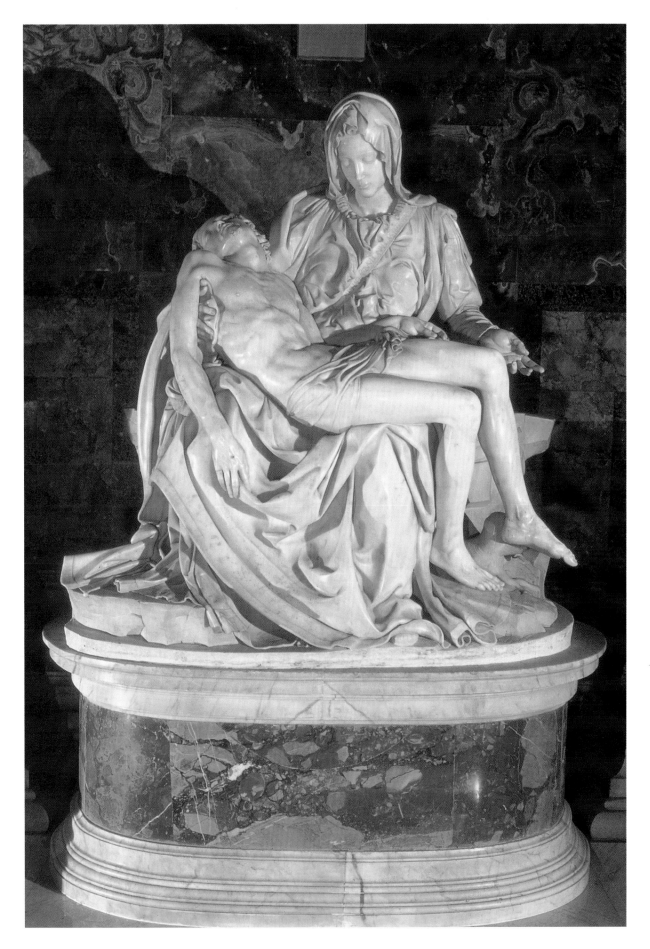

THE VIRGIN'S HEAD (DETAIL FROM PIETÀ) (1498–99)

Courtesy of The Bridgeman Art Library

DURING Michelangelo's lifetime, the face of the Virgin in this statue was criticized for appearing too young to be that of the mother of the adult Christ. Michelangelo defended his creation by saying: "Don't you know that women who are chaste remain much fresher than those who are not? How much more so a virgin who was never touched by even the slightest lascivious desire" He went on to add that he portrayed Jesus as older to emphasize his humanity; that he had subjected himself to the effects of mortality.

"Pietà" is the Italian word for pity. Despite its youthful appearance, the face of Mary still manages to convey the tragedy of the scene. Her eyes are downcast, almost shut. There is a quiet stillness in her expression, as if she is accepting the death of her son.

Across Mary's chest is a sash upon which Michelangelo carved the words "Michaelangelo Buonarroti Florentine made this." *Pietà* was the only work Michelangelo signed in this manner, and his biographers recorded that he overheard some people credit *Pietà* to another artist, so that night he carved his name across the piece. The manner in which the sash follows the shape of Mary's body underneath the drapes would indicate that this story is a work of fiction. Nonetheless, the prominent positioning of his signature is evidence of Michelangelo's pride in his work.

Duomo Pietà (c. 1547–55)
Courtesy of AKG London. (See p. 238)

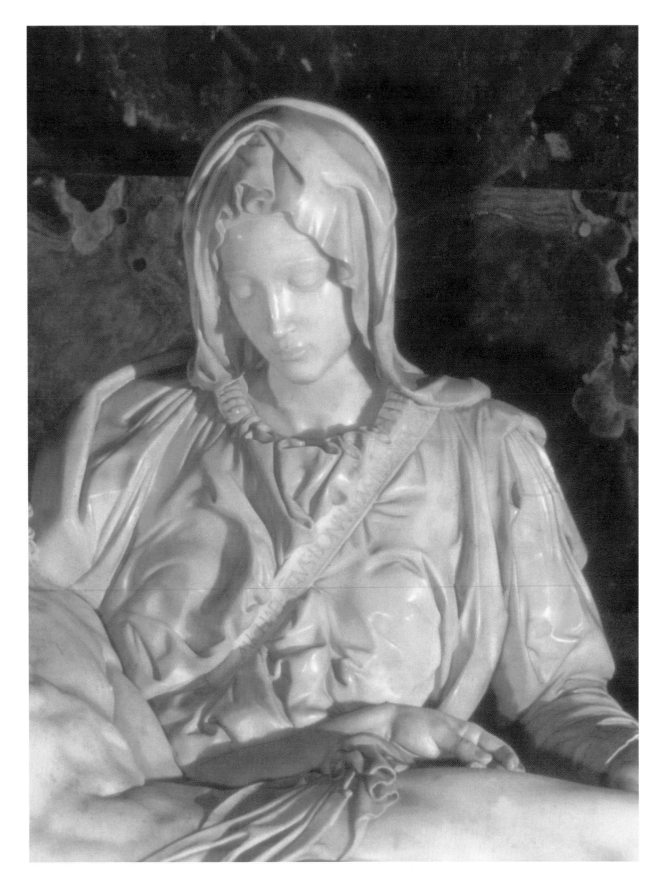

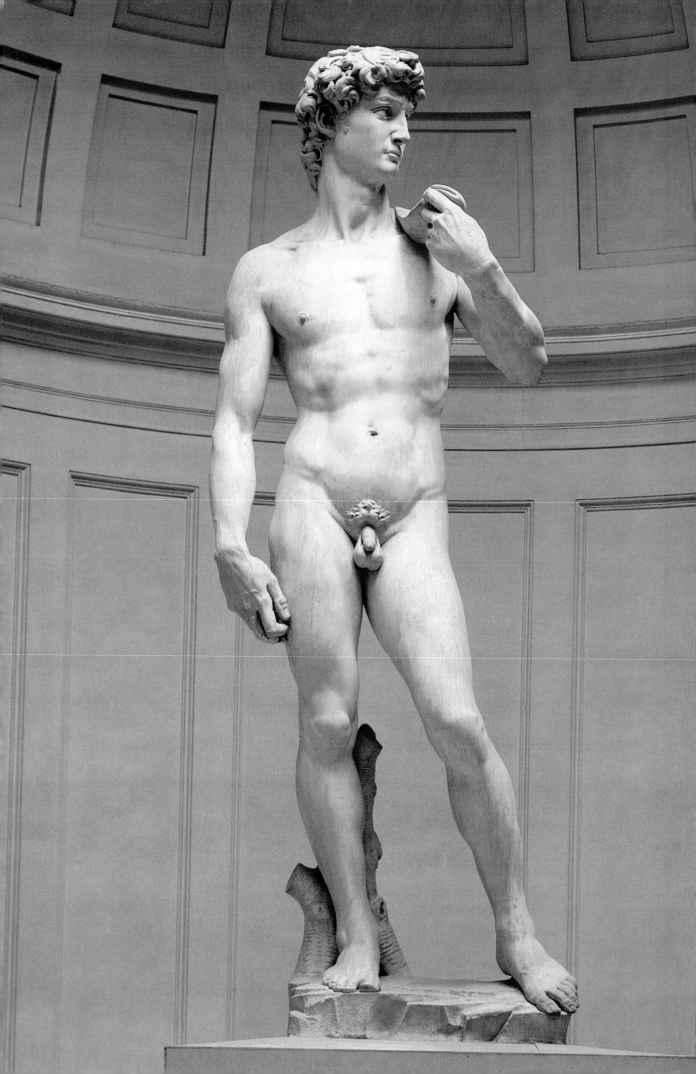

DAVID (1501–04)

Courtesy of AKG London/Erich Lessing

ICHELANGELO'S *David* (1501–04) sealed his reputation as the greatest living sculptor of the time. The piece was commissioned by Piero Soderini, the first chancellor of the Florentine republic, after the sculptor returned to Florence flushed with success from Rome.

The marble for *David* was a huge block that early-Renaissance sculptor Agostino di Duccio had abandoned about 40 years previously and it had been lying disused ever since. Several other sculptors wanted the commission but Michelangelo was the only one to achieve a design of such enormous dimensions that used only this marble block, requiring no additional parts. Due to the limitations of the damaged marble that Michelangelo worked from, the statue is much broader than it is deep and so *David* was intended to be viewed from the front or back rather than the side.

For the Florentines, the Biblical character of David was an exemplar of strength and enormous courage in the face of adversity.

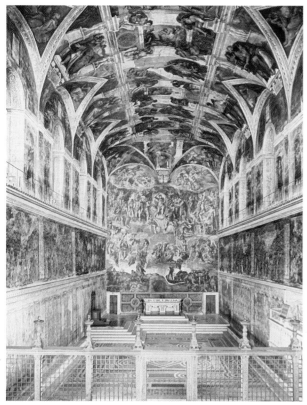

Upon its completion the statue became a centerpiece of civic pride in the city and Michelangelo would later draw upon this victory scene in the Sistine Chapel. His portrayal of David differs from other versions in form as well as in position—he uses developed, more muscular forms and creates a powerful physical presence in the spirit of a giant-slaying hero and future king.

***Sistine Chapel* (1508–12)**
Courtesy of The Bridgeman Art Library. (See p. 61)

FACE (DETAIL FROM DAVID) (1501–04)
Courtesy of AKG London/S. Domingie-M. Ralatti

AS the Republicans had beaten the Medici family to gain ruling power in Florence, the subject of David was chosen as a reminder to the republican government that David had beaten mighty Goliath and that he had ruled his people well and fairly thereafter. The face of *David* emphasizes this idea through its watchful and anticipatory expression, frowning with intense concentration. This expression is matched by the almost stationary pose; he seems pensive yet alert with the loaded sling-shot held lightly over one shoulder as he gazes into the distance, waiting for his foe to come within range.

Some critics have noted that the head and hands of David are slightly too large for the body. Given that the statue is almost 17 ft (4.5 m) high, only photographs enable us to have a direct view of the youth's face, an experience not possible for a contemporary viewer. The model for the statue was an adolescent boy and these slightly over-defined features ring true in their natural rendering of a boy not quite fully grown.

The face itself is classically ideal, with perfect features. Upon completion of *David*, Piero Soderini told Michelangelo that the nose was too large. To appease him the sculptor climbed up the statue and carefully pretended to chisel at the nose, letting some marble dust fall to the ground to enforce his deceit.

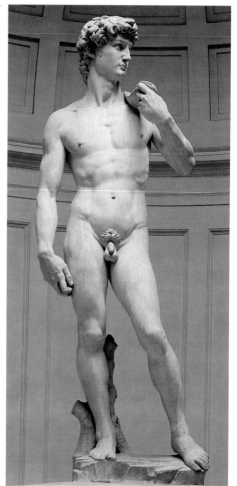

David (1501–04)
Courtesy of AKG London/Erich Lessing. (See p. 31)

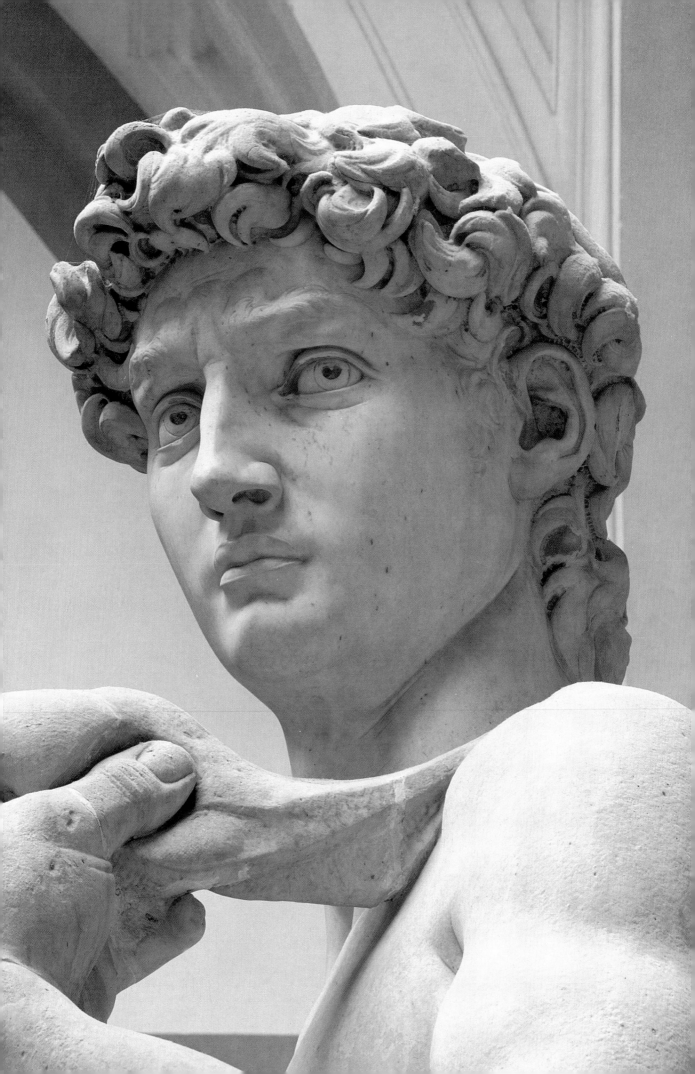

DONI TONDO (THE HOLY FAMILY) (1504)

Courtesy of The Bridgeman Art Library

*T*HE *Holy Family* is known as *Doni Tondo* as it was commissioned by Michelangelo's friend Angelo Doni between 1503–04.
Michelangelo rarely worked in the medium of panel painting and *Doni Tondo* is the only piece that can undeniably be attributed to him; other surviving paintings, such as *The Entombment* (*c.* 1506) have a more questionable status.

The three figures are closely linked together by their positions and their movements, forming a compact, almost sculptural whole. The round frame is set off by the triangular configuration and the delineation of the figures is crisp, almost harsh, with a sharp, clear definition. This is a technique that, while necessary in tempera painting, further increases the sculptural quality of the figures by making the three stand out against the background, as if they have been superimposed.

The colors are bold and brightly vivid; the orange-gold material of Joseph's clothes seems to have a satin sheen. Michelangelo used color in a similar way throughout the Sistine Chapel frescoes, as can be seen in *The Delphic Sibyl* (1508–12). The contrasting colors also create blocks within the figures that emphasize their movements.

The Delphic Sibyl (1508–12)
Courtesy of The Bridgeman Art Library. (See p. 116)

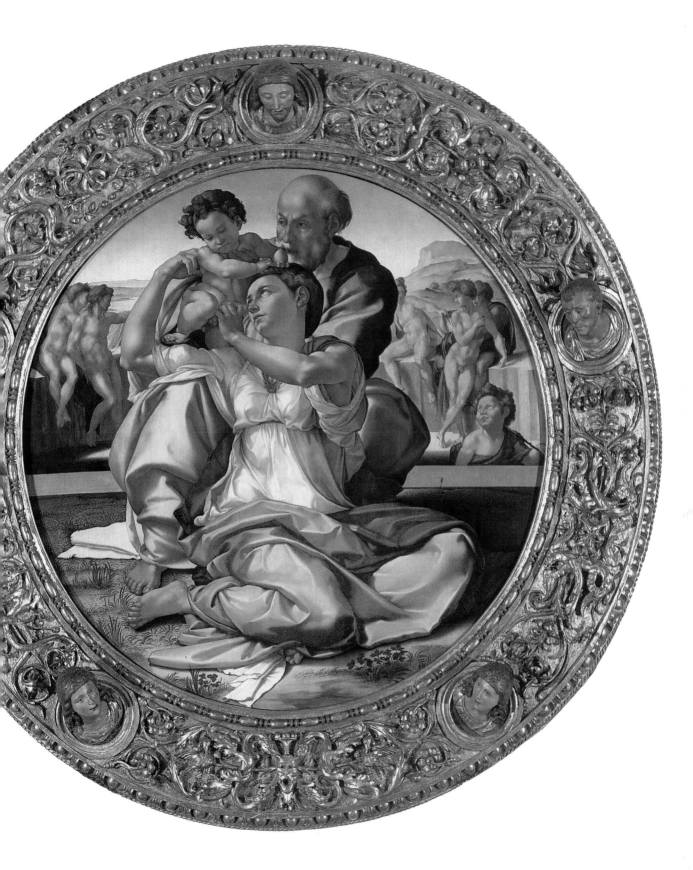

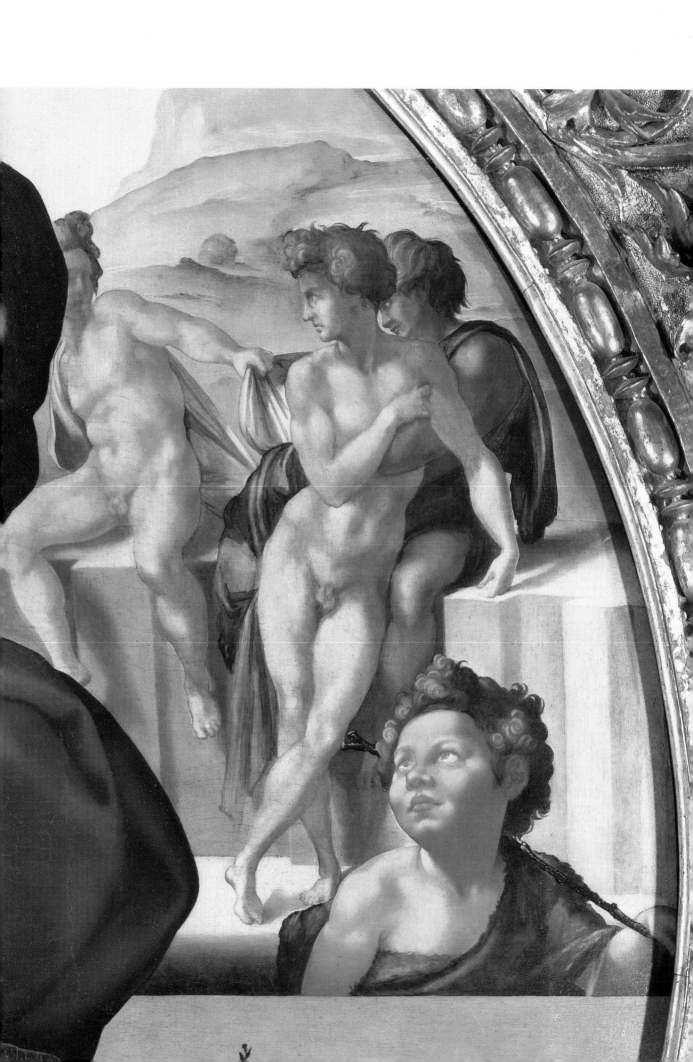

ST JOHN THE BAPTIST
(DETAIL FROM THE HOLY FAMILY) (1504)

Courtesy of The Bridgeman Art Library

ST John the Baptist appears in the middle ground of *Doni Tondo*, as he does in the later *Pitti Tondo* (*c.* 1504). With his animal skin draped around him, he gazes adoringly at the baby Jesus held aloft, symbolically, between his parents. A celestial light falls on to St John that seems to emanate from the family themselves.

The distant landscape is barren, with a rocky mountain that can be seen at the top of this detail. Between the family and the mountains are five young male nudes. One of the nudes has his arm around the youth in front of him, while to their right another playfully tries to pull off the cloth that is draped over him. The significance of these nudes has been generally taken to be that they denote the pagan world from which St John has turned away to face the Holy Family, as if he can already sense their importance. Michelangelo created symbolic layers within this picture, representing the path of man: from the harsh natural world, to his naked paganism, to the intermediary St John and to the Christian world, newly formed and represented by the child in the foreground.

Pitti Tondo (*c.* 1504)
Courtesy of The Bridgeman Art Library. (See p. 44)

STUDY FOR THE DONI MADONNA (1503)

Courtesy of The Bridgeman Art Library

*M*ADONNA *and Child* (*Study for the Doni Tondo Madonna*) is a preliminary drawing for the *Doni Tondo* (1504). Michelangelo chose not to use the positioning seen here, opting for a triangular configuration. Michelangelo's preferred medium for this type of work was red chalk, which had been introduced by Leonardo da Vinci (1452–1519) during the year this work was executed. His confident depiction of the child demonstrates the ease with which he mastered new media and he went on to use it frequently, as in his *Study of Adam* (1511).

Study of Adam (1511)
Courtesy of AKG London. (See p. 74)

From 1503, both Leonardo and Michelangelo were living in Florence. The two great artists were both later to receive a commission for battle scenes which were to be placed next to each other. There is said to have been great rivalry between the two; Leonardo had long been acknowledged as a genius, while Michelangelo was still building his reputation, although his success with *Pietà* and *Bacchus* had considerably strengthened his fame. Michelangelo also derived the notion of a triangular configuration—which he used for the Holy Family in his *Doni Tondo*—from Leonardo's work, but it was an idea that he developed and made his own.

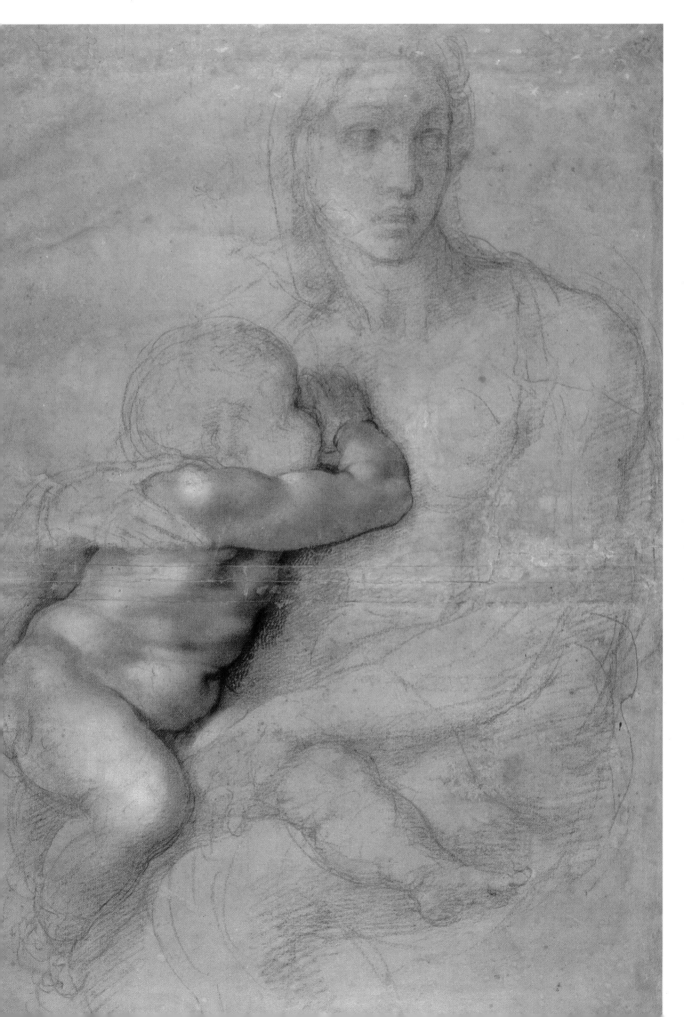

ST PETER (1501–04)

Courtesy of The Bridgeman Art Library

ST *Peter* is one of several statues of saints that Michelangelo made for the Cardinal Francesco Piccolomini. Piccolomini went on to become Pope Pius III in 1503 but died after only three weeks. On Michelangelo's return to Florence in 1501, flushed with the success of his *Pietà* in Rome, he received a three-year commission from the future Pope to carve 15 statues of saints. Each statue was to be 4 ft (1.5 m) high and they were to be situated in the Piccolomini altar in the Sienna Cathedral. Following the death of the Pope, the contract was renewed by his heirs, but Michelangelo was never to fulfil its terms, delivering only four of the saints in 1504—*St Peter, St Pius, St Paul,* and *St Gregory*.

St Peter leans slightly to one side with his knee bent and raised, giving the appearance of his being caught in mid step. His head is lowered, his eyes humbly kept to the ground. The statue is a conventional treatment of the saint, much unlike the St Peter seen in the fresco of *The Crucifixion of St Peter*.

The Crucifixion of St Peter (1542–50)
Courtesy of The Bridgman Art Library. (See p. 235)

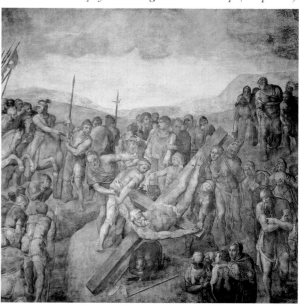

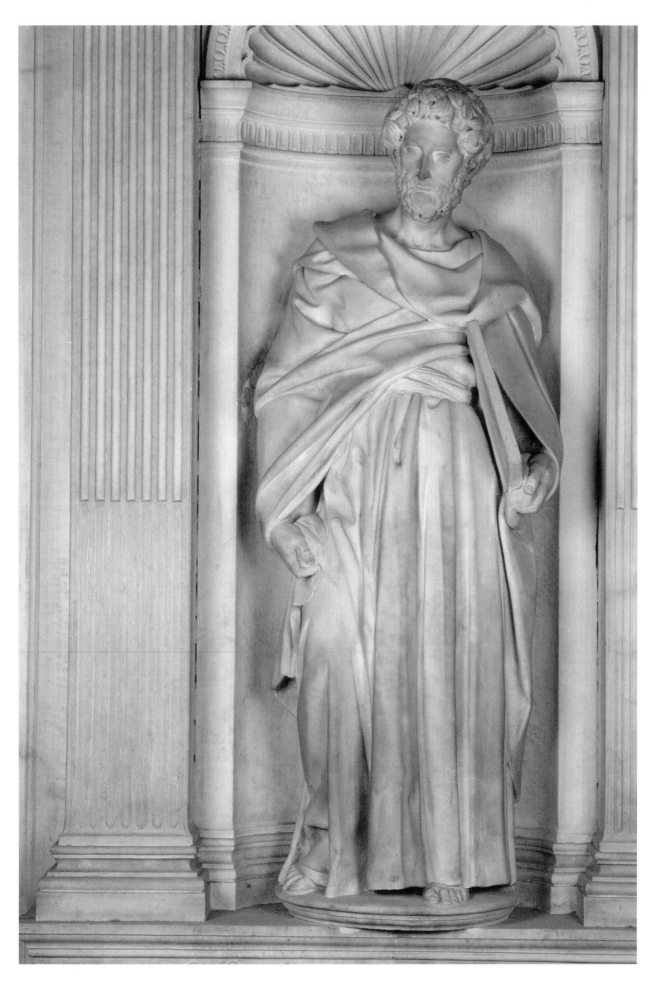

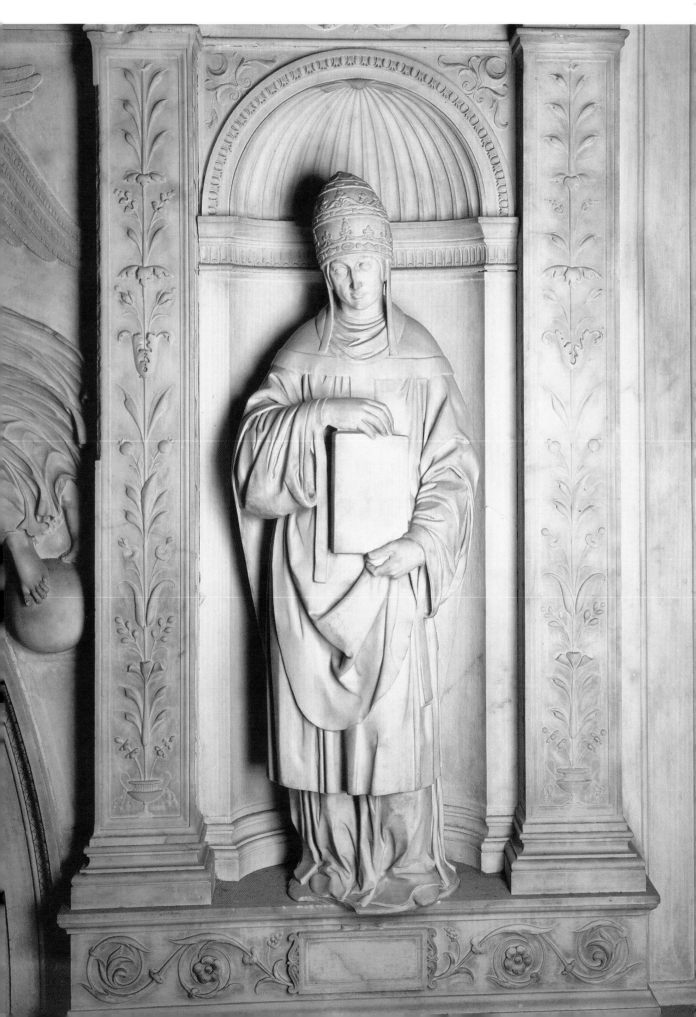

ST GREGORY THE GREAT (1501–03)

Courtesy of The Bridgeman Art Library

*T*HIS statue of *St Gregory*, along with *St Peter*, was one of the four saints that Michelangelo carved as part of his commission for the Piccolomini altar and was completed between 1501 and 1504. Although it is recorded that Michelangelo did deliver the four statues, it is unclear as to how much of the work he actually completed himself and only two of these four can be reliably attributed to him.

The commission for the Piccolomini statues came at a time when demand for Michelangelo's work was increasing rapidly due to the significant rise in his reputation that came with the success of his recent work in Rome. He had already gained the commission for *David*, which was to be a considerable undertaking, so it is understandable that the statues did not seem to be of pressing importance.

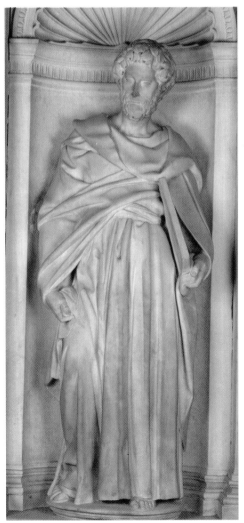

St Gregory, who gave up his worldy wealth to become a monk, wears his papal costume here, which was the conventional treatment of this saint. He was considered a great and important pope partly because of his great administrative skills; he was the pope, who, among other laws, insisted on celibacy among Catholic clerics.

St Peter (1501–04)
Courtesy of The Bridgeman Art Library.
(See p. 40)

PITTI TONDO (C. 1504)

Courtesy of The Bridgeman Art Library

*P*ITTI *Tondo* (1504–05) and *Taddei Tondo* (*c.* 1504) were named after the Florentine families that commissioned them. By the time these two marble reliefs were made, Michelangelo was a very famous artist and his work was highly sought after. Both of these pieces were left unfinished and it has been suggested that this is because Michelangelo returned to Rome in 1505. Others believe, however, that he left them in this state deliberately; *Pitti Tondo* appears to be a finished work in which Michelangelo quite consciously used the effects of the unfinished surfaces as an aesthetic device.

'Tondo' means a round framed picture or relief. *Pitti Tondo* was one of three tondos that Michelangelo worked on in the space of two years, seeking different ways to make use of circular space. Here Michelangelo has broken the constraints of the circle by placing Mary's head outside it. To the left of Mary is the vague figure of St John, who also appears in the other tondos.

The *Pitti Tondo* relief is shallower than the *Taddei Tondo*. To create the illusion of perspective in the placement of St John, the relief is very shallow; he is ghost-like, being only lightly defined.

Taddei Tondo (c. 1504)
Courtesy of The Bridgeman Art Library. (See p. 46)

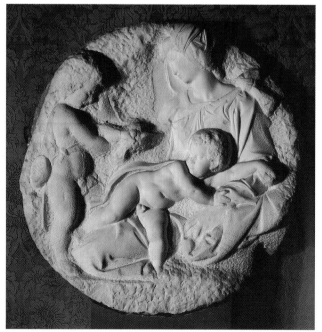

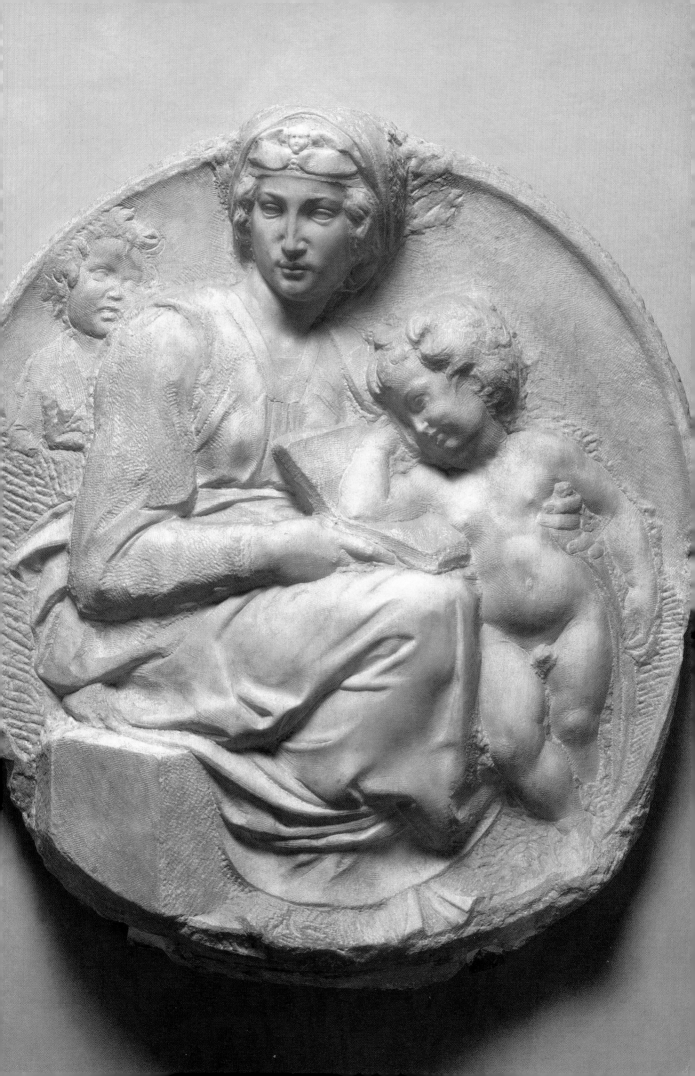

TADDEI TONDO (C. 1504)

Courtesy of The Bridgeman Art Library

*I*N *Taddei Tondo* Michelangelo further explores the theme of the Madonna and Child which he worked on in his teenage years with *Madonna of the Steps* (1491–92). As in the earlier relief, Michelangelo portrays Mary in a protective role while the Christ Child is shown as fearful or wary, clinging to his mother. Both pieces evince a somber atmosphere.

The Christ Child is cowering away in fear from St John on the left. He shelters in Mary's lap as she gently holds the other child at a distance from him. The cause of Christ's fear is a goldfinch held by St John; a bird that supposedly feeds on thorns and which symbolizes his Passion (passion meaning the suffering of Christ).

The placement of the figures in this scene is circular, thus echoing the round frame. Although the piece appears to be incomplete, it is more

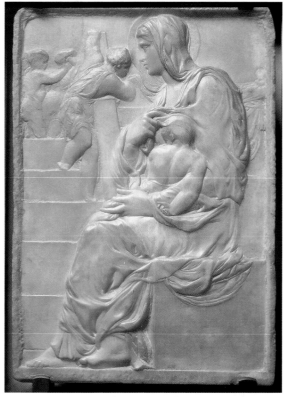

Madonna of the Steps **(1491–92)**
Courtesy of AKG London. (See p. 16)

likely that Michelangelo meant his strokes to be expressive; his roughly hewn chisel marks show clearly in the background. Parts of the scene are missing in entirety: the feet of the Christ Child and one of Mary's arms have yet to be carved.

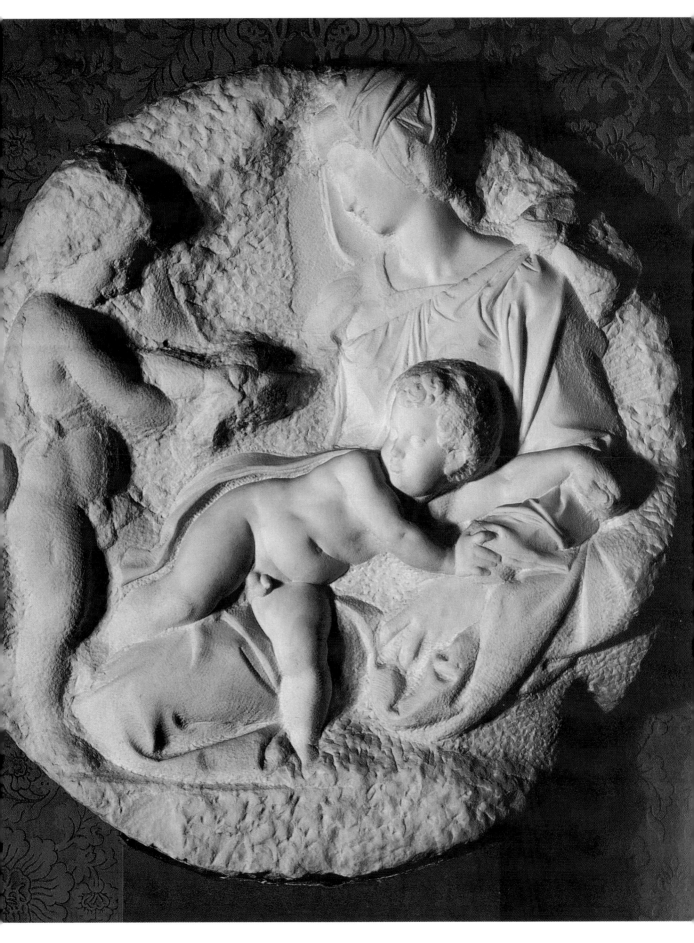

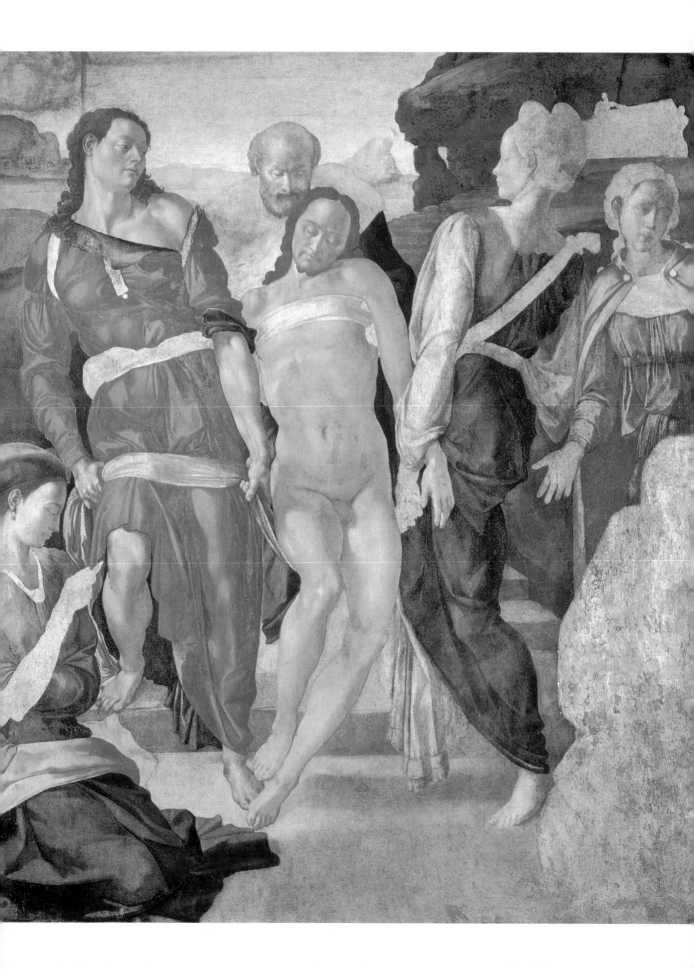

THE ENTOMBMENT (C. 1506)

Courtesy of The Bridgeman Art Library

*T*HOUGHT to date from 1506, the mix of tempera and oil paint that Michelangelo used for *The Entombment* suggests that the painting was possibly abandoned and then picked up at a later stage using a different medium. Oil paint was still a new medium in the 15th century but was becoming more widespread by the time this work was completed.

There is some doubt as to the authenticity of *The Entombment*. Some critics believe it to be the work of another artist based upon one of Michelangelo's sketches. Others have suggested that it may indeed be the artist's work, originally intended for the tomb of Pope Julius II, but that once the designs changed, ceasing the need for an altarpiece, the painting was discarded.

The colors in the painting are similar to those used in *The Holy Family*; particularly the woman in red on the left and the woman sitting by her feet. *The Entombment* also shares the features of the bald man who supports Christ, with the face of Joseph, in *The Holy Family*. The figure of Jesus is clearly drawn from *Pietà* (1498–99).

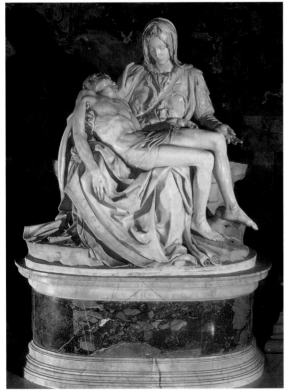

Pietà, St Peter's **(1498–99)**
Courtesy of The Bridgeman Art Library. (See p. 26)

MADONNA AND CHILD WITH THE INFANT BAPTIST (OR MANCHESTER MADONNA) (C. 1500)

Courtesy of The Bridgeman Art Library

*M*ADONNA *and Child with the Infant Baptist*, commonly referred to as the *Manchester Madonna*, is one of only three easel paintings by Michelangelo that have survived. Although as a young man he studied under the painter Ghirlandaio, Michelangelo held the belief that painting was only suitable for women or the lazy, his main love being sculpture.

The authenticity of the *Manchester Madonna* has been questioned by many. It is considered that if the painting is genuine it must be from the earliest period of Michelangelo's career, as the piece shows little of the excellence evident in the 1504 painting *The Holy Family*. The style of the painting as well as the flatness of the composition reveal the piece to be more indicative of the late fifteenth century.

The figures on either side of the Madonna are angels. It was a traditional practice, especially amongst Florentine painters, to portray the enthroned Madonna flanked by angels. Michelangelo breaks with tradition, however, by not giving the angels their customary wings. The Madonna is also denied her highly decorated throne, she simply sits on rocks. This lack of embellishment is typical of Michelangelo's work.

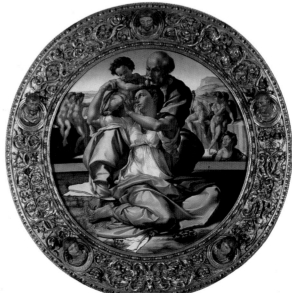

Doni Tondo (The Holy Family) (1504)
Courtesy of The Bridgeman Art Library.
(See p. 34)

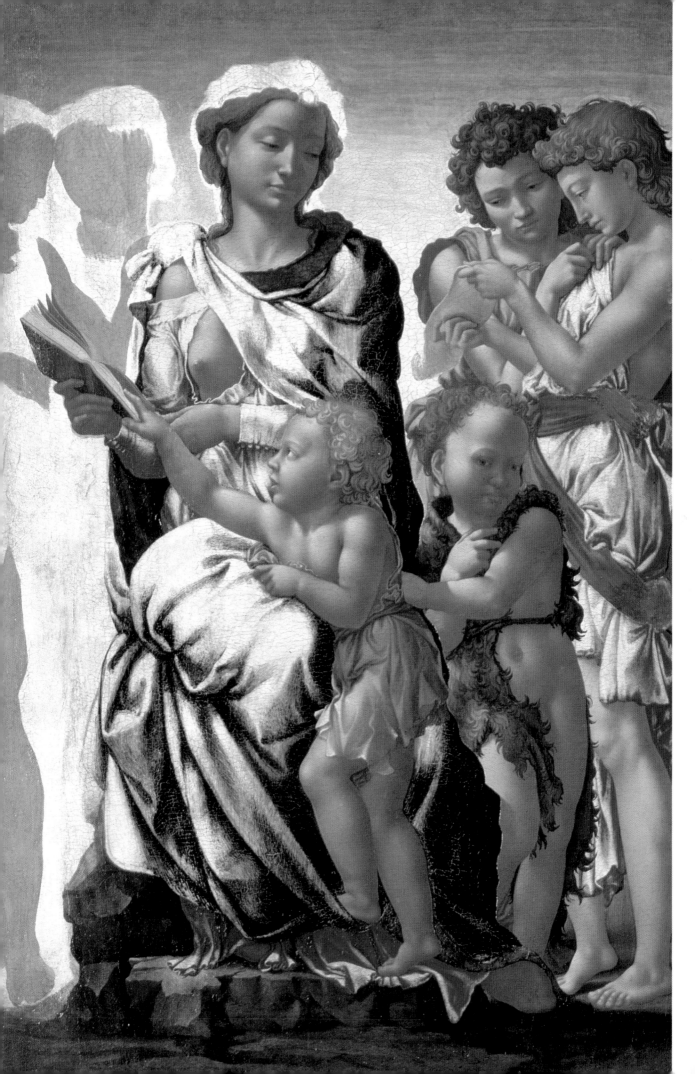

BATTLE OF CASCINA (1504)

Courtesy of The Bridgeman Art Library

THIS copy of Michelangelo's *Battle of Cascina* (1504), together with a few sketches, is all that remains of the great cartoon. In 1504 Piero Soderini commissioned Michelangelo to create a huge fresco depicting a battle scene. This was to be placed in the Signoria Palace alongside another, *The Battle of Anghiari*, to be produced by Leonardo da Vinci. The Signoria became the ruling power in Florence following the expulsion of the Medici family, so the battle scenes were apt decorations.

The fresco shows the story of a surprise attack by Pisan forces on the Florentine army, who were caught unawares while bathing in the river Arno. This copy, made in 1542 by Bastiano (Aristotile) da Sangallo (1481–1551), Michelangelo's friend and former assistant shows the middle section of the finished cartoon, which has been estimated to have been 22 ft high and 57 ft long (6.7m high and 17.37m long). Although the cartoon or preparatory drawing was completed, the fresco itself was never even begun. In 1505 Michelangelo was summoned by Pope Julius II to discuss designs for his tomb and subsequently commissioned to work on long projects based in Rome.

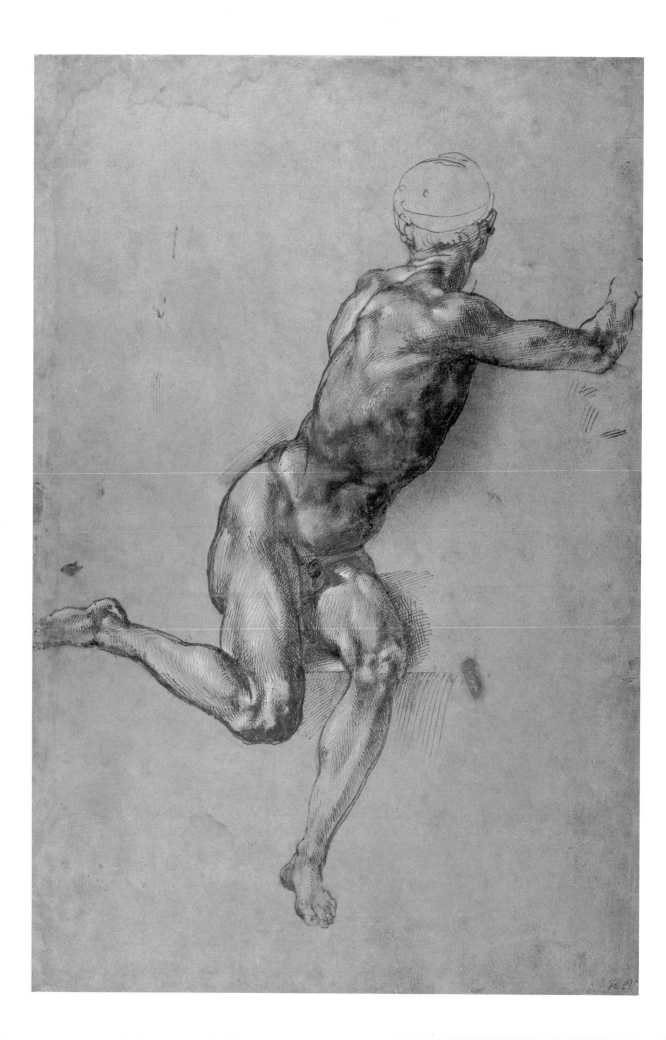

STUDY FOR A FIGURE FROM THE
BATTLE OF CASCINA (1504)

Courtesy of The Bridgeman Art Library

*T*HE *Battle of Cascina* cartoon was highly influential, and studied by many contemporary artists that visited Florence. Several effusive descriptions of the cartoon exist from renowned artists such as Benvenuto Cellini (1500–71). Many claimed that the cartoon was superior even to Michelangelo's painting of the Sistine Chapel.

The cartoon's significance stems not just from the influence it held but also because it signaled the development of Michelangelo's exclusive focus on the male nude in motion. The story of the Florentine captain raising a false alarm among his soldiers bathing in the river Arno provided an excellent opportunity to explore the many postures and poses of the body and gave a pretext for nudity. As in all his work the background is simple, the intensity of his focus directed purely on the human form.

This study shows the superb naturalism of the muscles working in the youth's back and gives an idea of what the original cartoon must have been like in the hands of the master. Bastiano da Sangallo's work often presents an anatomically inaccurate portrayal of the human body, this is evident when comparing Michelangelo's study with the same figure at the top of the da Sangallo cartoon.

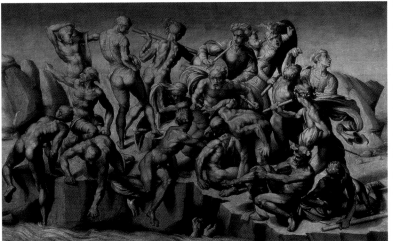

Battle of Cascina (1504)
Courtesy of The Bridgeman Art Library. (See p. 52)

STUDY OF A MALE NUDE LEANING (DATE UNKNOWN)

Courtesy of The Bridgeman Art Library

*K*NOWLEDGE of human anatomy was greatly limited in the 16th century and information that any art student can take for granted today was not available. Studies of medicine and anatomy increased throughout the Renaissance but were still uncommon. Much of what isolated Michelangelo as a genius and artist beyond compare, was the supreme naturalism that he portrayed in his depiction of nudes. As can be seen in this sketch, and the *Studies for a Flying Angel* (1536–41), every muscle was intently studied and perfected before he began to paint or sculpt his chosen image.

Michelangelo's outstanding representation of the human form was not simply derived from an astute observation of his models. In his late teenage years, following the death of Lorenzo the Magnificent, Michelangelo studied human anatomy. A prior at a local hospital allowed him access to the corpses and Michelangelo spent many grim hours dissecting these bodies to gain an understanding of the muscles, ligaments, and frame that make human movement possible. It was study that, according to his biographer Ascanio Condivi, left Michelangelo with a damaged appetite: "he gave up dissecting corpses because long handling of them had so affected his stomach that he could neither eat nor drink salutarily."

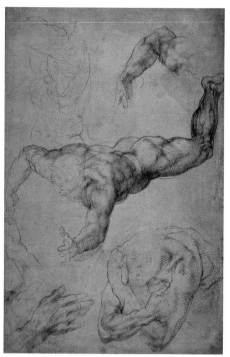

***Studies for a Flying Angel* (1536–41)**
Courtesy of The Bridgeman Art Library.
(See p. 211)

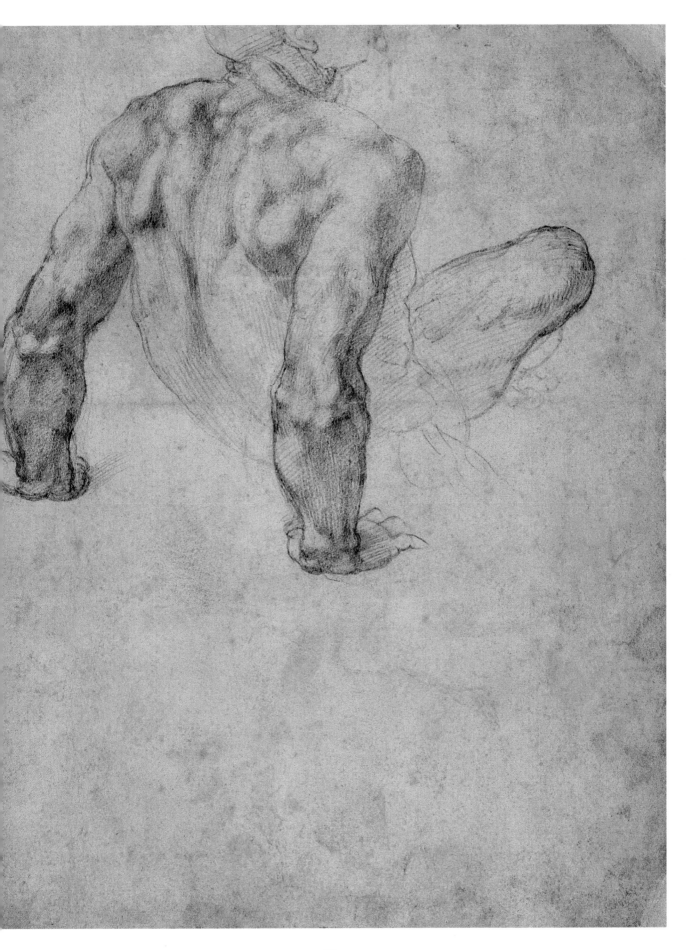

ST MATTHEW (1505)

Courtesy of The Bridgeman Art Library

THE Florentine Wool Guild and the Opera del Duomo commissioned Michelangelo to carve 12 statues of the apostles for Florence Cathedral in 1503. The Guilds were important patrons of the arts and the commission was a prestigious one for Michelangelo. Patronage of the arts had developed alongside the increase in wealth within the city and in turn had greatly improved the standing of the artist in society.

It was agreed that Michelangelo would produce one apostle statue a year, but *St Matthew* was the only piece that Michelangelo had begun and by the end of 1505, following his return to Rome, the contract was canceled before his work was completed.

The statue of *St Matthew* is significant as it indicates the emergence of an important stage in Michelangelo's career; the study of the body in contorted movement. The figure has one smooth, almost completed knee raised while his opposite arm grips the side of the huge marble block, as if he were about to push himself up and out of the marble constraint. Michelangelo was to continue exploring this new area of movement in his frescoes in the Sistine Chapel, especially the *Ignudi* (1508–12).

Ignudi Between The Drunkenness of Noah and the Flood **(1508–12)**
Courtesy of The Bridgeman Art Library. (See p. 90)

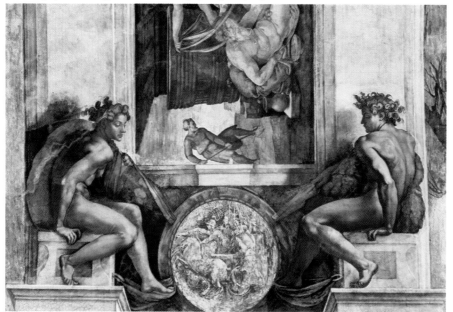

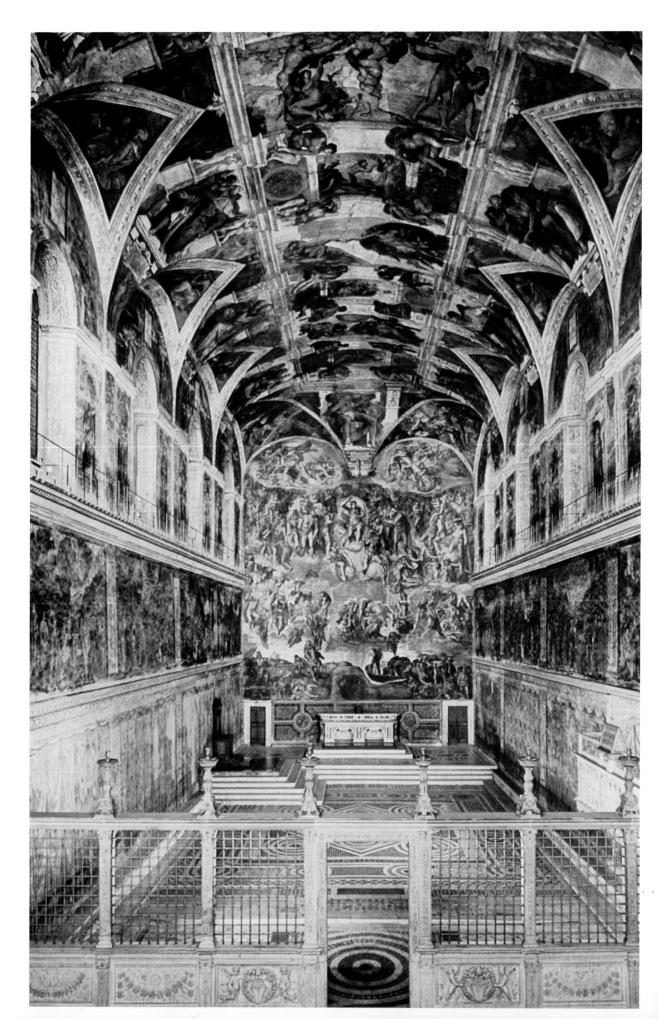

SISTINE CHAPEL (1508–12)

Courtesy of The Bridgeman Art Library

*T*HE Sistine Chapel creates an overwhelming impression, with a barrage of highly ornate and decorative images that surround the visitor. The chapel was named after Pope Sixtus IV (1471–84) and is used for meetings of the Conclave (the papal council who ran the elections). It has dense walls, the remnant of a past when sieges were a real threat to the papacy. The ceiling has a shallow barrel vault design and the only natural light to come into the chapel enters through the windows that are just underneath it.

The walls of the chapel are horizontally separated into three tiers, with the top tier housing the windows and their surmounting lunettes that were decorated by Michelangelo. Beside the windows there are paintings of the popes of the past by Sandro Botticelli (1444/5–1510). Beneath these portraits in the middle tier, Pope Sixtus had frescoes painted by three outstanding and highly influencial artists—Botticelli, Ghirlandaio, and Pietro Perugino (*c.* 1445–1523). These frescoes depict the life of Christ and Moses with the symbolic intention of underlining the concept that the papacy descended from the apostle of Christ, St Peter. The bottom tier contains painted curtains.

SISTINE CHAPEL CEILING (1508–12)

Courtesy of The Bridgeman Art Library

GIVEN the continuing respect and admiration for Michelangelo's epic masterpiece of the Sistine Chapel ceiling, it is ironic that the artist did not want to accept the colossal commission for the fresco. He believed that his rival, Pope Julius II's chief architect Donato Bramante (1444–1514), had convinced Julius to commission Michelangelo for the ceiling, believing that he would either refuse the pope, making himself dangerously unpopular with the most crucial of patrons, or that his fresco painting would be disastrous. Although he saw himself as a sculptor and not a painter, Michelangelo reluctantly gave in to the pope's wishes and accepted the commission in 1508.

The original ceiling was based on a simple star motif which Julius II wished to replace with a fresco of the 12 Apostles. Michelangelo believed this would appear "rather meanly" and eventually persuaded Julius to grant "commission to do what I liked best", ensuring that he had control of the design.

Michelangelo created an architectural framework to establish an order within the complex frescoes and also to link them with the real architecture of the chapel, such as the lunettes, spandrels, and curves of the vault. The ceiling is divided into nine narrative panels the painted pilasters.

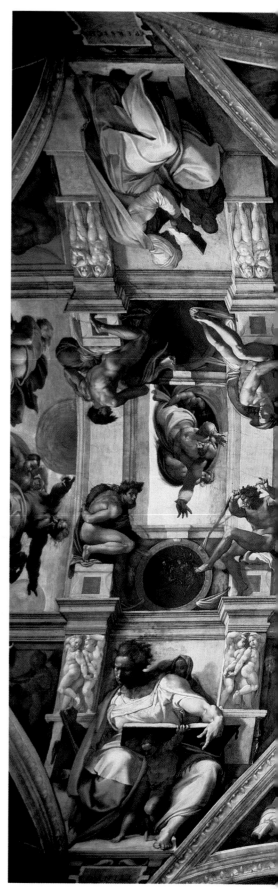

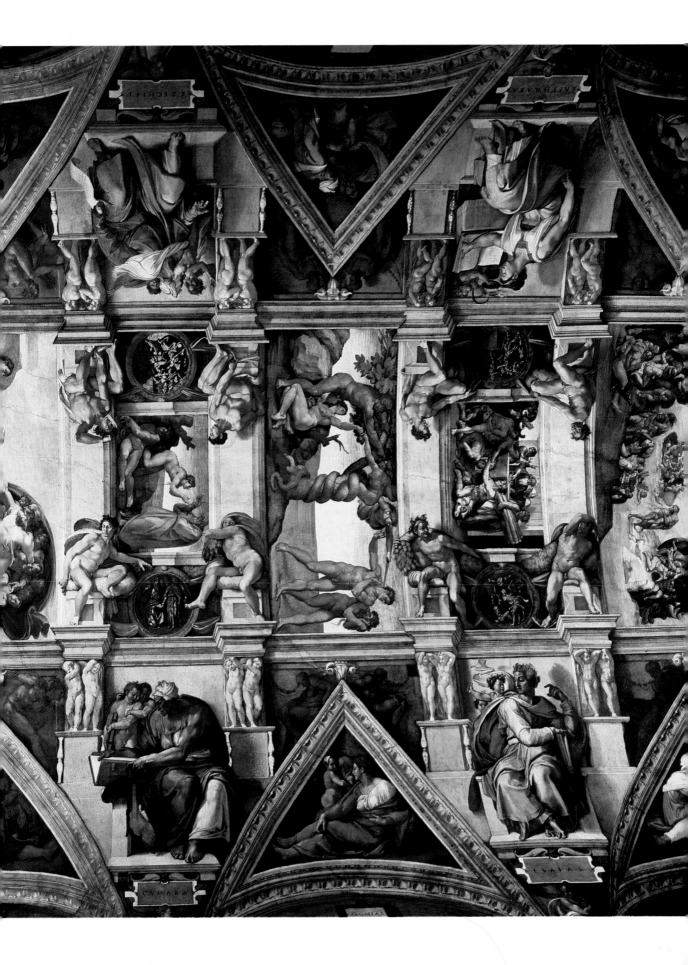

The Separation of Light from Darkness
(1508–12)

Courtesy of The Bridgeman Art Library

CHRONOLOGICALLY the first panel in the narrative scheme, *The Separation of Light from Darkness* is seen last if entering the Sistine Chapel through the lay entrance. Michelangelo chose to begin painting here and worked back towards the altar wall. The first five panels depict the creations of God, beginning here with the Creation of Form from Chaos (Separation of Light from Darkness). The narrative then moves on to highlight the Biblical history of mankind, starting with the Fall of Man, followed by three panels that show stories of Noah and The Flood. The narrative panels end with a panel that alludes to the re-emergence of sin among mankind, thus announcing the coming of Christ which links the panels to the earlier frescoes within the chapel.

Michelangelo was the first artist to attempt the illustration of such an ethereal and intangible subject as the beginning of the universe and he chose a literal translation of the Bible, focusing solely on the recognizable: the figure of God. God fills almost the entire panel as he reaches ahead, the appearance of movement created by the swirling colors about him.

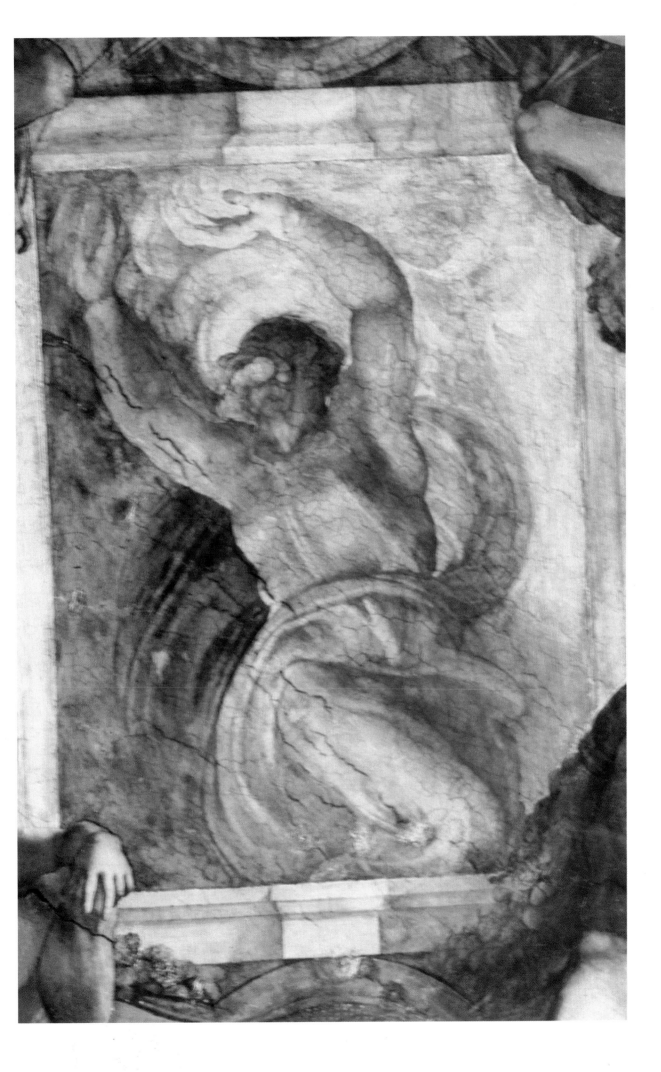

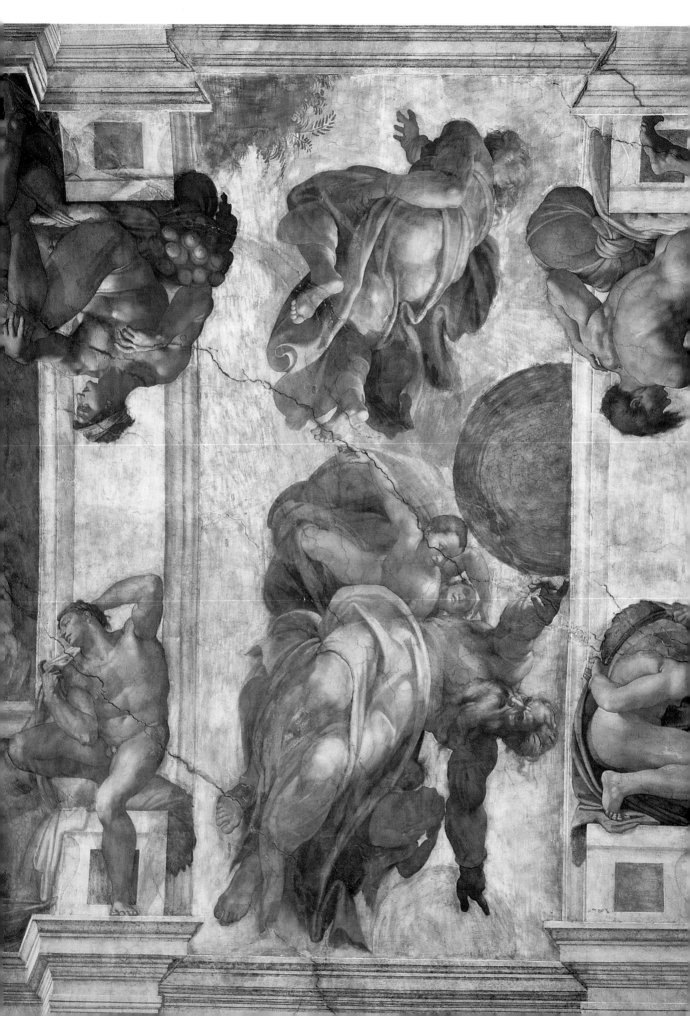

THE CREATION OF THE PLANTS, AND THE SUN, AND THE MOON (1508–12)

Courtesy of AKG London

FOLLOWING on from *The Separation of Light from Darkness* is *The Creation of the Plants, and of the Sun, and the Moon*. This painting is a continuous narrative depicting God in two of his acts of creation, so he appears twice within the sequence of the one panel.

On the right of the scene, by God's far-flung hand, is the vague, grey outline of the moon at which one of his fingers is pointing. Beside the outstretched right hand God's finger points to the huge globe of the sun, a burnt orange in color as if seen at dawn. The expression of concentration created by his furrowed brow and piercing stare give God a stern, fierce appearance; a God of action, immensely powerful and with the potential for a dangerous anger. Under his outstretched arms and among his swirling robes are naked cherubs or angels, that gaze up at God in awe at his incredible powers.

The second part of this narrative panel depicts God from a most unusual view point: from the back. We see the soles of his feet as he flies through the air, one arm reaching towards the green land beneath him.

THE SEPARATION OF THE EARTH FROM THE WATERS

Courtesy of The Bridgeman Art Library

*T*HE *Separation of the Earth from the Waters*, as with *The Separation of Light from Darkness*, is a difficult concept to express visually. This is one of the five smaller panels and like the first panel, Michelangelo has used the figure of God to fill the space, using extreme foreshortening so that he appears to fly out from the frame. This effect is exaggerated by the formation of God's robes, which create an oval-shaped, darker area for him to emerge from. Beneath God is a murky sea and above an equally blurred, misty sky.

God's features are similar to those of Pope Julius II, possibly as an attempt to appease the fiery pope. He was an old man and worried that he would not live to see the completed fresco, frequently visiting Michelangelo to check on his progress. On one such occasion when the Pope queried the time-scale of the project, Michelangelo replied, "When it shall be done." This surly reply angered Julius so much that he struck the artist, causing the equally hot-tempered Michelangelo to leave the chapel and return only after the pope had sent him money in way of an apology.

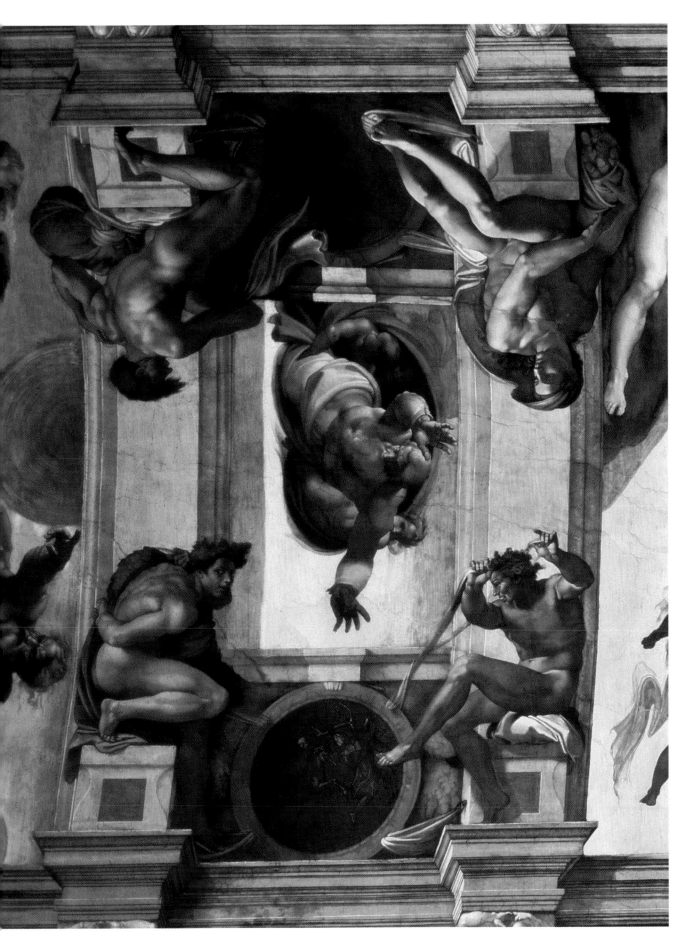

THE HAND OF GOD (DETAIL FROM THE CREATION OF ADAM) (1508–12)

Courtesy of AKG London

*T*HE *Hand of God* is perhaps the most enduring of Michelangelo's paintings. Almost five centuries later this image remains prevalent and is still being used in advertising, posters, and on T-shirts. This is particularly true of the detail that shows the two hands as they reach towards each other, tantalizingly close, almost touching.

The panel illustrates the moment when life is instilled in Adam by God. Michelangelo has placed the central focus upon the hands of God and of Adam, not just by the placement of the figures, but also by the lines of form that flow within the painting between the two outstretched arms.

Adam, who is only half-sitting up against the mountainside, seems weak and languid, with his arm resting upon one bent knee as if it is too heavy for him to hold up without some support. The hand is limp, the fingers are drooping as if they are without energy, awaiting the vital spark of life.

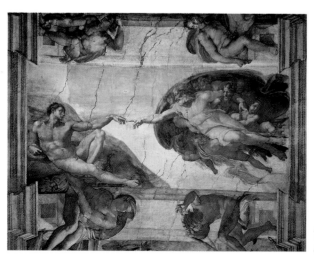

The Creation of Adam (1508–12)
Courtesy of AKG London. (See p. 73)

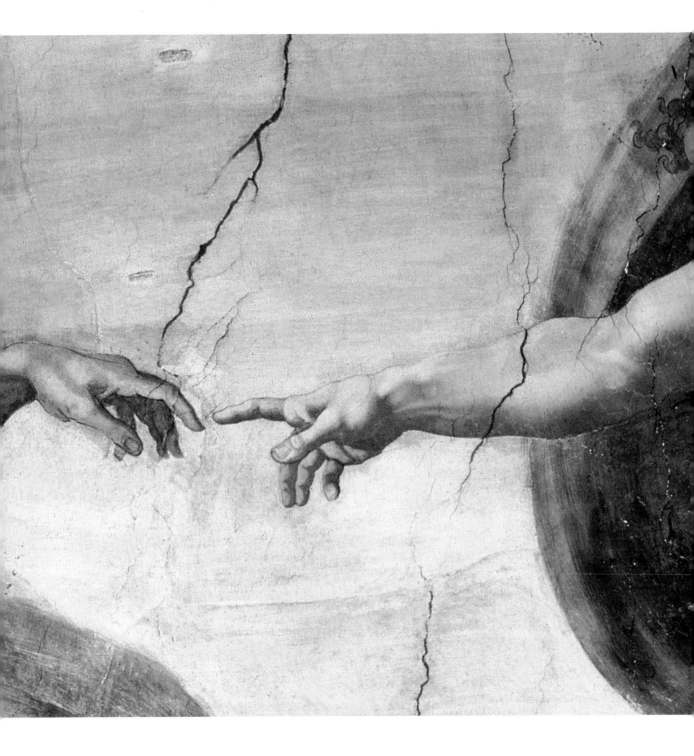

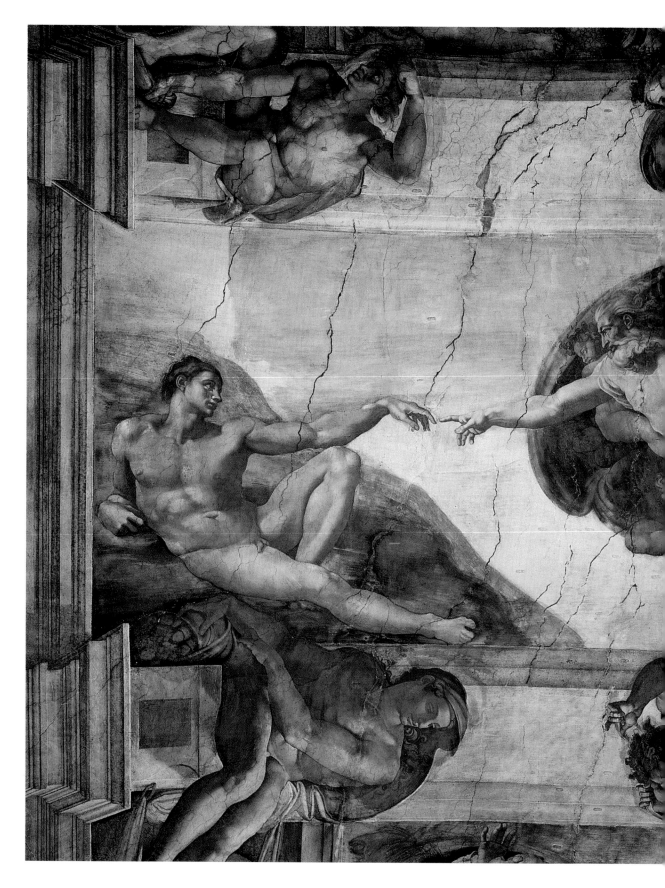

THE CREATION OF ADAM (1508–12)

Courtesy of AKG London

THE notion of God creating Man had been represented in art before Michelangelo began working on the Sistine Chapel, but never with the same majesty and vitality that he achieved. This treatment is not purely reserved for the figure of God but is equally abundant in Adam, fittingly so for a being made in his image. Adam has been painted nude, a massive figure that reclines against a rocky mountain amid an otherwise barren landscape. He is gracefully poised, a perfection of form —muscular yet beautifully proportioned—an heroically Classical image.

God is shown in movement, as he is in the preceding three panels that portray images of his Creations. The gestures and expressions of the angels and cherubs that cling to his side emphasize his movement; some are watching expectantly as the two hands draw close.

The scale within *The Creation of Adam* is larger than the preceding panels. The scaffolding had been removed from the completed half of the ceiling by this time and upon viewing it, Michelangelo decided to increase the size of the figures and decrease the detail, making the paintings more impressive and startling to the audience below.

STUDY FOR ADAM (1511)

Courtesy of AKG London

*T*HIS study for the figure of
Adam is one of many sketches
that have survived and are now
kept in the British Museum, London.
The red-chalk drawing dates from 1511,
the year that that Michelangelo began
working on *The Creation of Adam* panel
that this sketch was for. There are a few
details of hands surrounding the figure of
Adam. The re-tracings and re-positioning
that Michelangelo worked through
before finding his envisioned pose, can
clearly be seen in the bent leg.

This study is typical of Michel-
angelo's focus upon the torso of a figure,
leaving other parts untouched or only
partially complete. Here, the torso of
Adam has been completed with great
care over the correct positioning and
definition of his muscles, but his legs and
arms are left only roughly sketched and
incomplete. This concentration upon
torsos was evident in his earliest surviving
piece, the marble relief of the *Battle of
the Centaurs* (1491–92). It is also clearly
evident in several of the unfinished *Slaves*,
especially the *Awakening Slave* (1520–30),
where only the torso has been completed
to an appreciable level of finish, his limbs
appearing to be lost in the marble.

THE CREATION OF EVE (1508–12)

Courtesy of AKG London

THE figure of Eve has none of the majesty and heroic form of Adam in *The Creation of Adam*. Eve's body is hunched, her hands are clasped tightly together and she reaches up, towards God, appearing almost obsequious as he blesses her. *The Creation of Eve* is a small panel and Michelangelo has painted the figure of God as an immense form, clothed in heavy robes, with his head slightly bent forward so that he fits just within the panel.

In the bottom left-hand corner a fiery headed Adam lies unconscious against a dead tree, reminding the viewer of how Eve was formed (from one of Adam's ribs) and also that she will bring about the Fall of Man and the Loss of Paradise.

The colors used within this panel are repeated in the objects that the surrounding *Ignudi* hold and are themselves echoes of the hues from *The Fall of Man and the Expulsion from Paradise*. The recent problematic restoration of the Sistine Chapel ceiling revealed Michelangelo's original intense use of color once the dirt of almost 500 years had been removed.

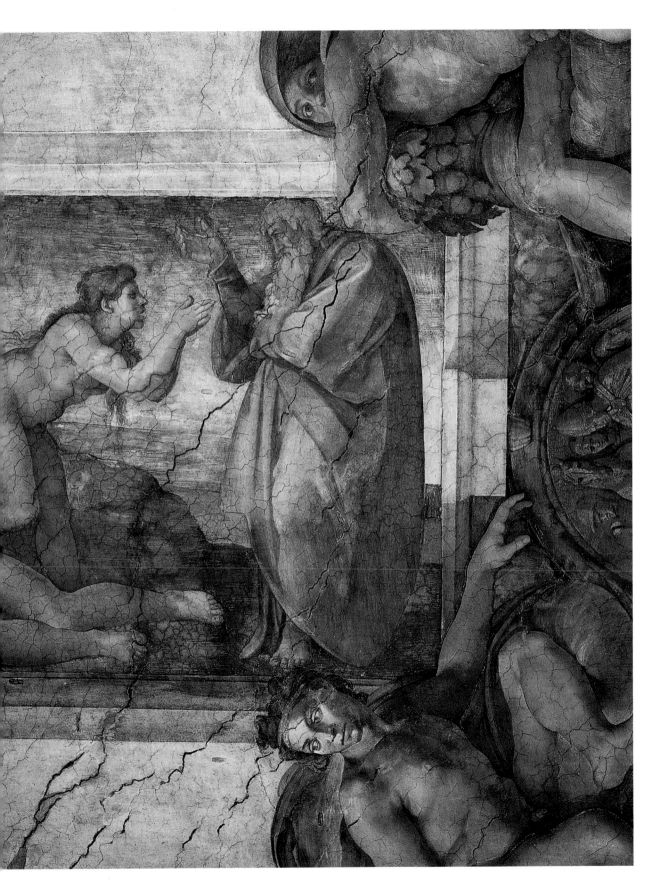

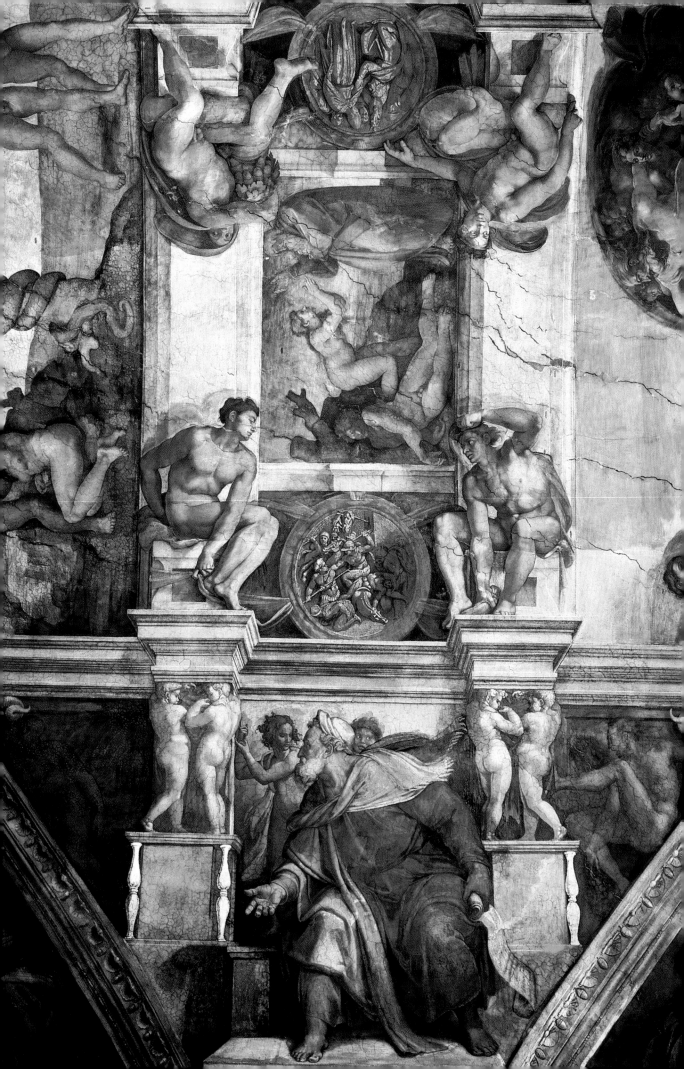

THE CREATION OF EVE AND THE
PROPHET EZEKIEL (1508–1512)
Courtesy of AKG London

MICHELANGELO painted a complex architectural structure, like that used for the tomb of Pope Julius II, to give his mammoth fresco structural order. The panel of *The Creation of Eve* is blocked off by two of the ten painted pilasters that separate the huge ceiling into the nine sections used for the central narrative panels. On either side of the small panel are two of the four larger narrative panels.

Figures of naked men perch at the base of the pilasters, often shown twisted in movement, demonstrating Michelangelo's skill at handling the male nude. Pairs of these figures, known as *Ignudi,* appear at either side of the smaller panels and hold medallions between them containing scenes from biblical history.

Underneath the *Ignudi,* carved into the columns, are small cherubic figures, also known as *caryatids,* who appear to prop up the cornice above them. Darkly painted nudes appear besides the *caryatids* in the triangular spaces created by the spandrels, beneath the larger narrative

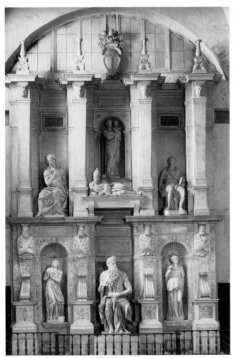

panels. They seem crammed into their tiny spaces, pushing against their confinement. Underneath the medallion that the *Ignudi* hold sits the prophet Ezekiel.

Tomb of Pope Julius II (1505–45)
Courtesy of The Bridgeman Art Library.
(See p. 136)

THE FALL OF MAN AND THE EXPULSION FROM PARADISE (1508–12)

Courtesy of AKG London

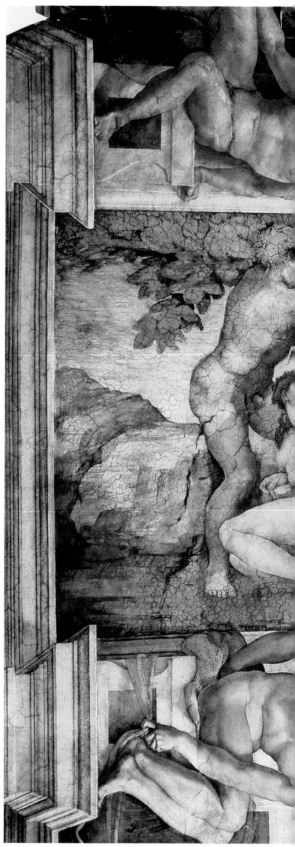

MICHELANGELO used the same device of continuous narrative for this large panel of *The Fall of Man and the Expulsion from Paradise* that he used in *The Creation of the Plants, and the Sun, and the Moon.* The tale begins on the left, with the figure of Adam grabbing the branches of a tree while Eve sits beneath him. Eve reaches behind her to take the apple from the serpent, while Adam stretches to grasp one of the forbidden fruits. The narrative continues its flow through the serpent in the tree on to the right, where the couple can be seen as they are cast out of Paradise.

The landscape is barren, almost inhospitable, with only a few rocks surrounding the figures, with the exception of the one tree where the serpent lurks. This is an unusual depiction of Paradise, contrasting with the verdant foliage and lush vegetation that can be seen in traditional representations of the story, or even in the 15th frescoes that line the second tier of the Sistine chapel. Throughout the work there is a noticeable lack of detailed background or lanscapes; Michelangelo's priority was always the natural and realistic depiction of the human form.

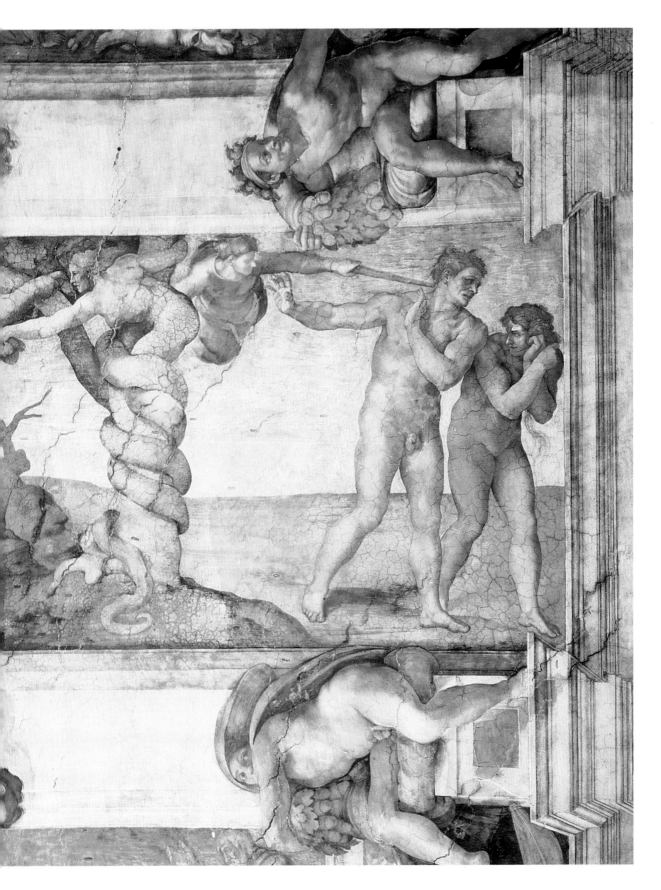

THE SNAKE AND THE EXPULSION
(DETAIL FROM THE FALL OF MAN) (1508–12)
Courtesy of AKG London

*T*HE snake from the Garden of Eden is usually portrayed as male or genderless. Michelangelo chose a feminine depiction for his serpent, tempting the eagerly awaiting Eve with the forbidden fruit while also focusing her gaze on the nearby Adam. Her lower half, in the form of a snake, is painted in lurid, bright colors while her top half takes the form of a voluptuous and tempting woman. This means that pictorially, woman is blamed twice for the fall and the expulsion.

On the right of the fresco, Adam and Eve are shown leaving Eden. Adam looks away from the scene of their disgrace, his hands sheltering his eyes from the sight as they are pushed out of their paradise by the angel hovering above. Eve looks back, her body hunched forward with her hand against her face as if trying to hide herself in shame. There are interesting comparisons to be drawn between Adam's tortured body and the majestic figure in *The Creation of Adam*. *The Expulsion* leans heavily on Masaccio's famous *Expulsion from Paradise*, in the Brancacci Chapel in Florence; a piece that Michelangelo was certainly familiar with.

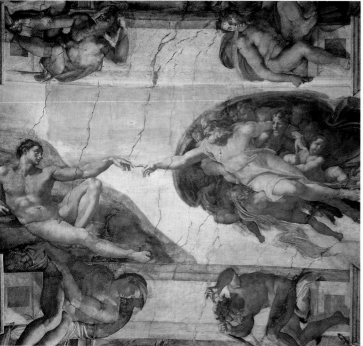

The Creation of Adam (1508–12)
Courtesy of AKG London. (See p. 73)

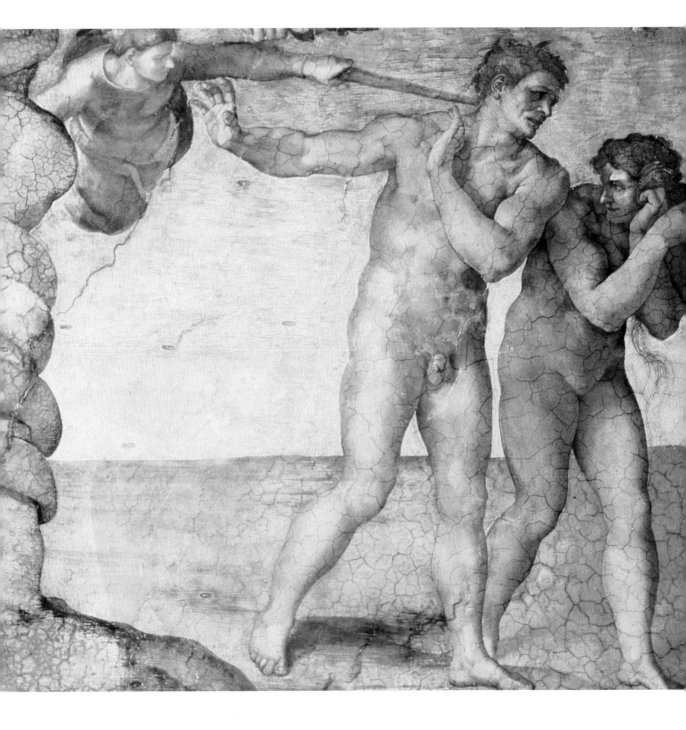

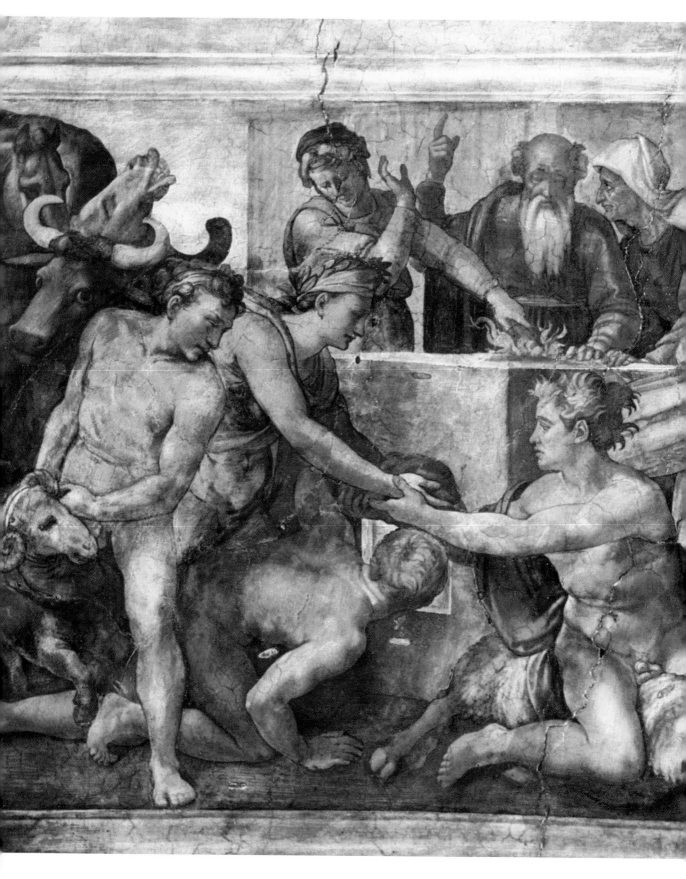

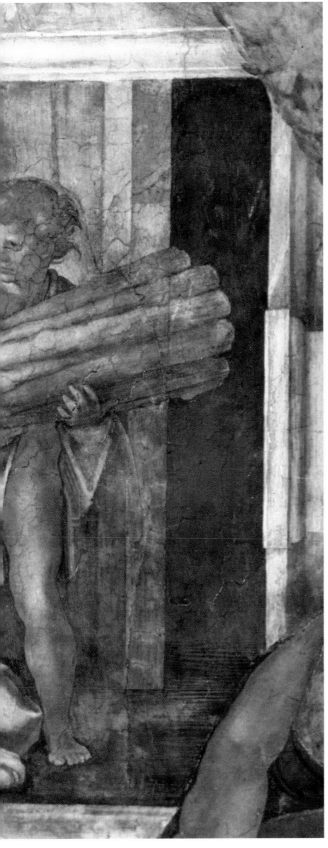

THE SACRIFICE OF NOAH
(1508–12)

Courtesy of The Bridgeman Art Library

CHRONOLOGICALLY the story of Noah's sacrifice belongs after the Flood, but the story of the flood required a large panel due to the amount of figures it was to contain. This smaller panel was the last Michelangelo painted before he changed the scale within his fresco: the following panel, *The Fall of Man*, shows fewer and larger figures which enhanced visibility.

In the background, behind the table, is the figure of Noah, one arm raised as if preaching to his family, trying to gain some order. On his left his daughter-in-law raises a hand and turns her head away, unwilling to hear his words. Noah's wife stands on his right, whispering words into his ear. In front of Noah and the table, his three sons are busy with their preparations for the sacrifice they are to make in praise of God. They grapple with the animals to be slaughtered, one sitting astride a ram, or carry wood. The scene is tumultuous and the two women, seemingly mid-argument, infuse the painting with a dangerous and sinister quality.

THE FLOOD (1508–12)

Courtesy of AKG London

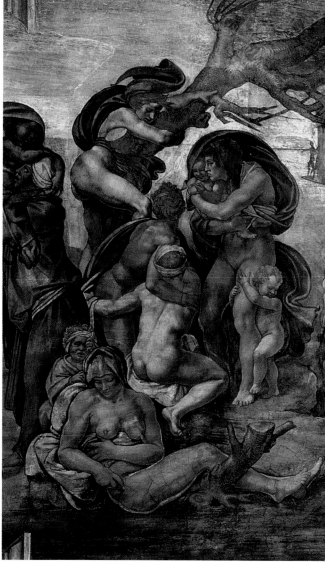

BELIEVED to have been the first narrative panel that Michelangelo painted, *The Flood* offers a wealth of images crowded together. It is the smallest of the nine panels and when viewed from the floor of the chapel it is difficult to make out the finer points of the piece. It is thought that he changed the scale after seeing *The Flood* from the ground, as all the subsequent panels have larger and fewer figures.

Given the similarities in their subject matter, *The Flood* bears a great resemblance to the later fresco, *The Last Judgment*, with its mass of troubled bodies. In the foreground of the picture, a woman lies despondent on the hillside. Behind her a long line of people, some bearing children, women, or belongings, struggle up the hill, in an attempt to gain sanctuary from the rising water. One figure clings frantically to a tree, almost bent double in the wind. To the right, a man carries the lifeless body of another towards a tent full of huddled people, who reach out their arms to help him. This compassionate portrayal dissolves in the background where figures can be seen beating each other on the boat, and again on the ark.

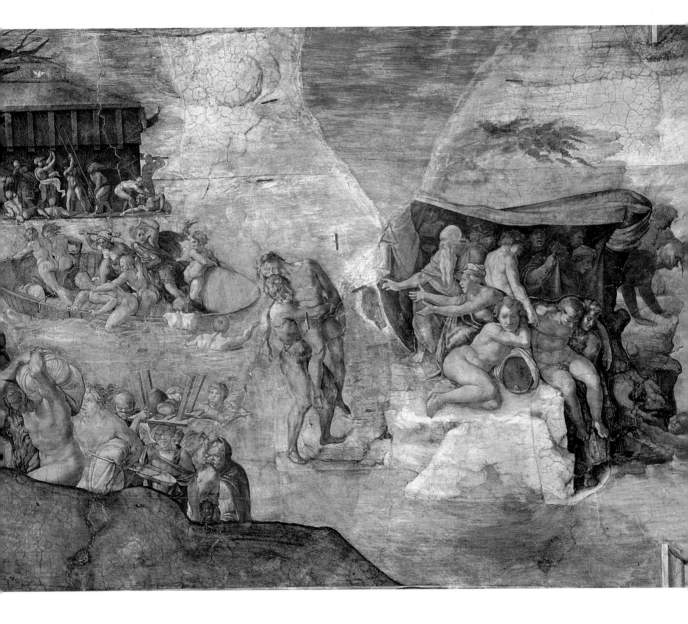

THE DRUNKENNESS OF NOAH (1508–12)

Courtesy of The Bridgeman Art Library

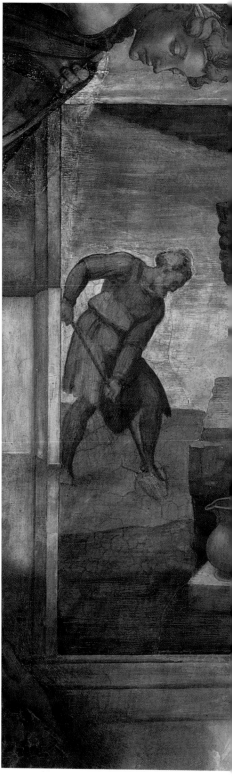

*I*N terms of the overall theme of the
ceiling, this panel is the final chapter of the
story. Having depicted the glorious creations
of God, the subsequent Fall of Man, and finally
the Flood God sent to wipe out mankind in order
to begin again with his chosen few, Michelangelo
chose to conclude with the tale of *The Drunkenness
of Noah*.

The naked figure of an old and pathetic
Noah, unwittingly drunk from the vines that he
has grown, lies in the foreground. To emphasize
Noah's pitiful state a figure is shown hard at work
in a field. The young nudes standing to the right of
Noah are his sons: Shem, Japheth, and Ham. Two
of his sons avert their eyes so they do not see the
shame represented by his nudity. Regardless of this
fact, Michelangelo portrays all the men nude.

This story is integral to the ceiling's theme:
it is linked with the mocking of Christ (Ham
mocks Noah and is later cursed by his father) and
it is the tale that, by showing the reversion to sin,
foretells the coming of Christ.

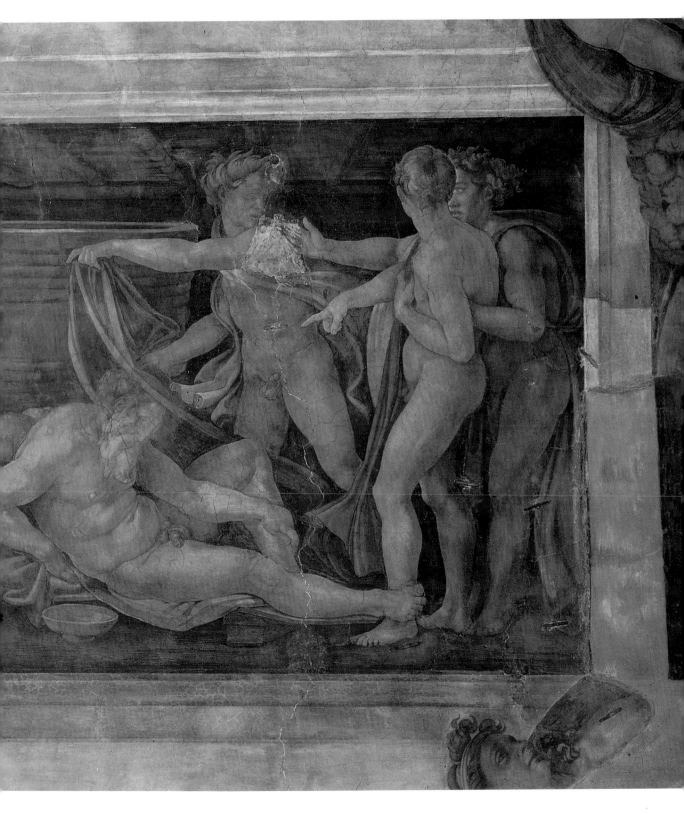

IGNUDI BETWEEN THE DRUNKENNESS OF NOAH AND THE FLOOD (1508–12)

Courtesy of The Bridgeman Art Library

AMONG the many nude figures that can be seen within and upon the painted architectural frame of the fresco, there are 20 *Ignudi*, placed in pairs on either side of the small narrative panels. They share delicate, almost feminine facial features and active figures. Their symbolism, or whether they actually have any, has been greatly debated and many theories for their inclusion in the ceiling have been expressed. Some believe that the *Ignudi* represent the ideal of man; others argue that they represent ancient pagan societies.

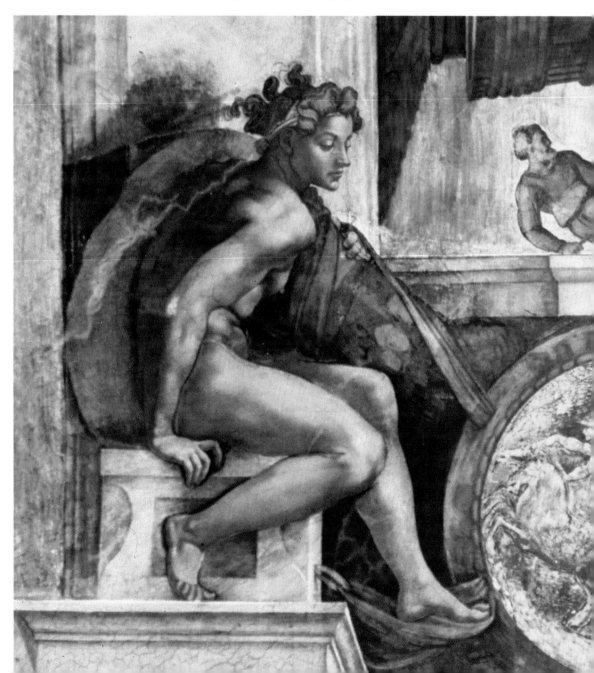

The first two sets of *Ignudi* to be painted surround *The Drunkenness of Noah*. For these first two pairs, Michelangelo used a cartoon for one of the *Ignudi* and then reversed it for the *Ignudi* placed opposite, so that they acted as mirrors to each other; the only difference between the paired *Ignudi* was to be in tone and minor details. This technique was quickly abandoned, however. It was initially devised in order that Michelangelo could pass on work to assistants, but he soon became dissastisfied with their work and dismissed them, continuing to work alone. The subsequent *Ignudi* were individually drawn.

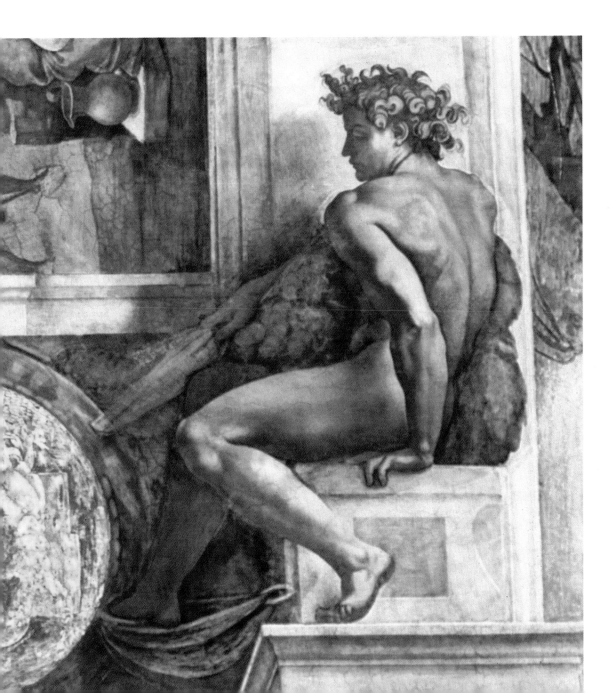

IGNUDO BETWEEN THE DRUNKENNESS OF NOAH AND THE FLOOD (1508–12)

Courtesy of The Bridgeman Art Library

THIS *Ignudo* shares many similarities with the *Libyan Sibyl* (1508–12); like her he twists in his seat with his legs bent to one side, holding the pedestal with his free arm as he half turns around to reveal his back. As with the *Libyan Sybil*, Michelangelo has positioned the *Ignudo* in such as way that the muscles in his back and arms are naturally taut and sharply defined. His skin tone is dark, almost bronze, in contrast to the golden paleness of the sibyl which is enhanced by the burnt orange glow of her dress. Both figures display the same facial features, indicating that they were based upon the same model.

Michelangelo had been working on sculptures for the *Tomb of Pope Julius II* (1505–45) at the time that the pope requested him to take on the immense task of painting the ceiling, and the *Ignudi* clearly demonstrate his sculptor's eye for position and form. The position of this *Ignudo* suggests he is straining to keep hold of the medallion that hangs between him and his partner; however, his relaxed, almost despondent facial expression negates this idea.

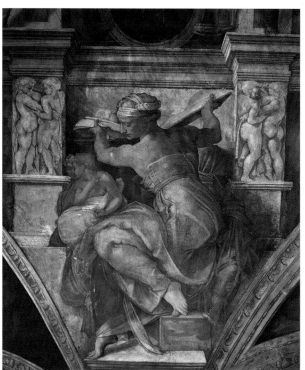

The Libyan Sibyl (1508–12)
Courtesy of The Bridgeman Art Library. (See p. 118)

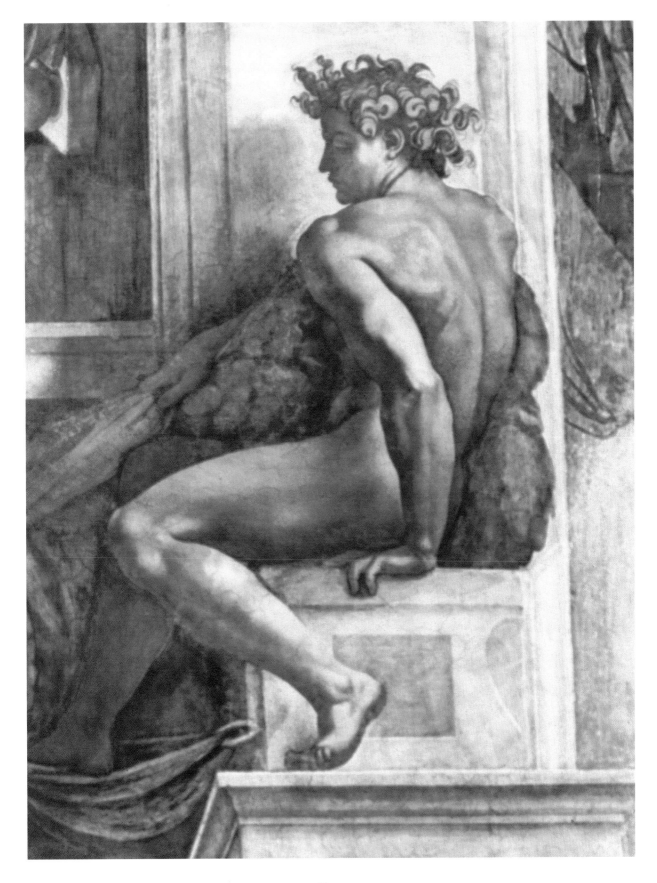

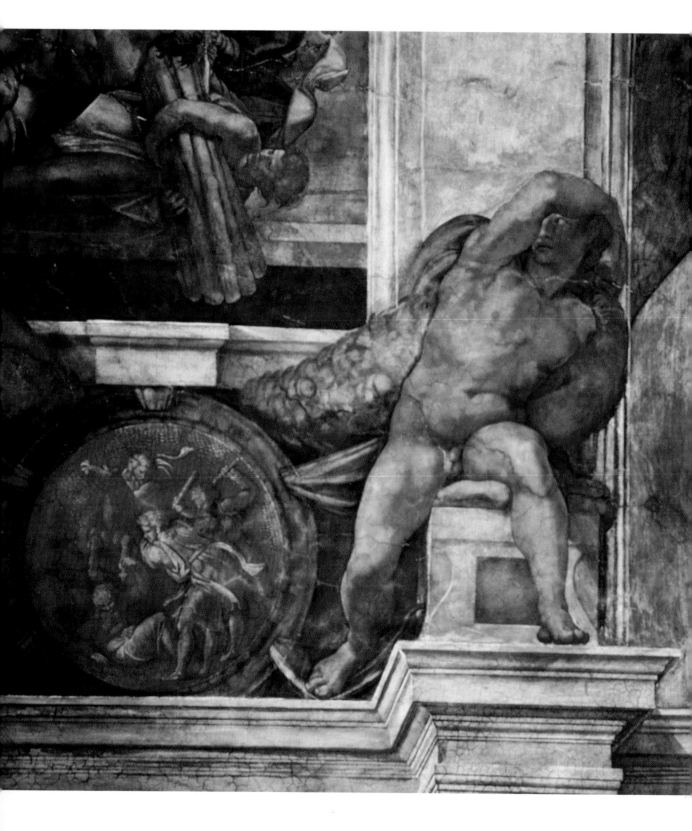

IGNUDO NEAR THE SACRIFICE OF NOAH

Courtesy of AKG London

*M*OVING along the ceiling from *The Drunkenness of Noah* through to *The Separation of Light from Darkness*, the *Ignudi* take on various extreme postures, becoming increasingly animated. This *Ignudo,* with his arm thrown across his face, seems to be trying to hide his eyes from the sight of the events taking place in the panel above him. He is precariously placed on the edge of his pedestal and his torso leans forward and to the right, as if he is trying to escape. The panel is *The Sacrifice of Noah* and Noah's son is seen holding a bundle of wood.

The placement of the *Ignudi* beneath the four corners of the panels and their frontal positioning, draws the viewer's eye into the narrative panel. The expressions of fear or agitation that some of the *Ignudi* have adds to this, causing the viewer to wonder what it is that they are pulling away from.

Once again, this *Ignudo* recalls Michelangelo's love of contorted sculptural poses, as shown in the *Dying Slave* (1513–16) which was one of the sculptures that he worked on for the *Tomb of Pope Julius II* (1505–43), before and after the Sistine Chapel.

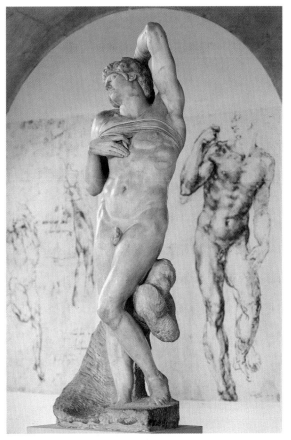

Dying Slave (1513–16)
Courtesy of AKG London/Erich Lessing. (See p. 144)

IGNUDO BY THE DRUNKENNESS OF NOAH (1508–12)
Courtesy of AKG London

SITTING in a relaxed pose, the *Ignudo* leans back against the pilaster, one hand languidly holding on to the material that contains his medallion. The other *Ignudi* that surround *The Drunkenness of Noah* also share an air of despondency, with sad, down-cast eyes, as if reflecting upon the event of mankind's return to sin that is depicted within the panel. The medallion, showing a scene from ancient biblical history, has a piece missing and a crack that also runs through the *Ignudi*. The other *Ignudo* in this panel is missing; only his head and the calves remain following an explosion at the nearby Castel Sant'Angelo in 1797, which damaged the top left corner of *The Flood*.

This was not the first time *The Flood* had been damaged. Shortly after completing the panel Michelangelo was dismayed to find a fine mold growing from the plaster. He quoted the mold as evidence to the Pope that he knew too little of the techniques of fresco painting to complete the ceiling successfully. This attempt to get himself removed from the project was ignored: his mistake at leaving the plaster too damp was pointed out to him and he was commanded to continue in his work.

The Flood (1508–12)
Courtesy of AKG London. (See p. 86)

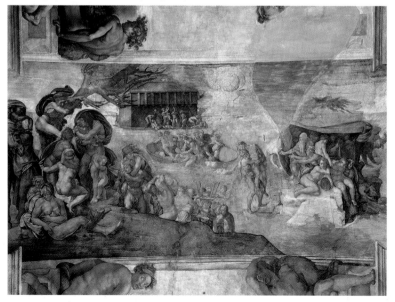

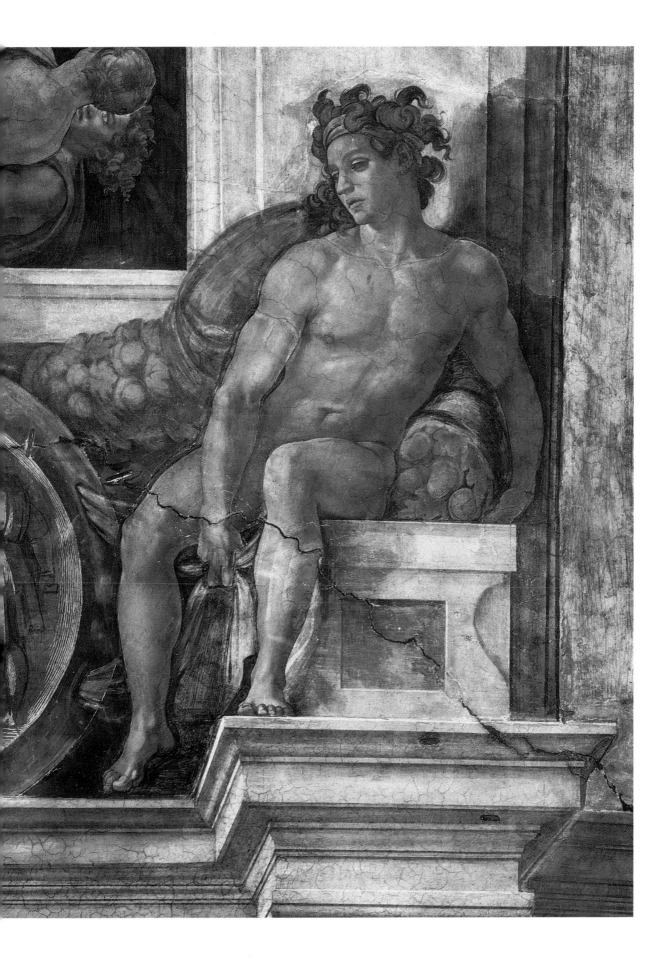

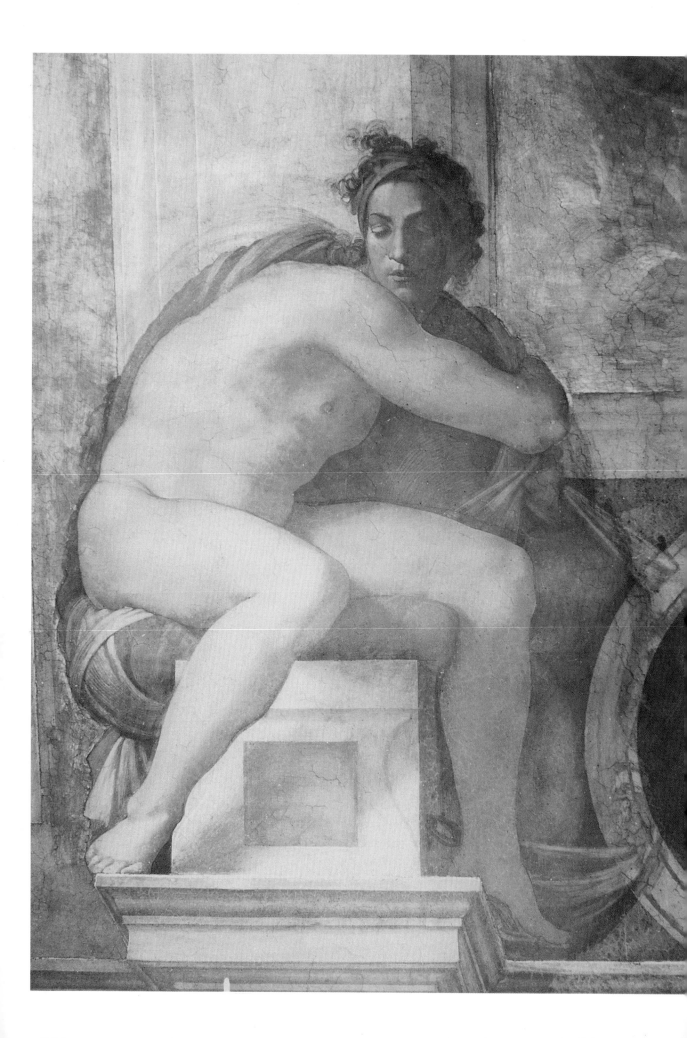

IGNUDO BY LIBYAN SIBYL (1508–12)

Courtesy of AKG London

A S well as serving to draw the viewer's eye into the panel, the *Ignudi* perform another important and practical purpose within the ceiling in camouflaging the increase in scale that occurs from the central narrative panels to the statuesque proportions of the prophets and sibyls. By placing these intermediary *Ignudi* between the prophets or sibyls and the narrative panels, Michelangelo has cleverly focused the viewer's attention away from the discontinuity in perspective that developed within the ceiling and on to the graceful figures of the *Ignudi*.

This *Ignudo* sits beneath the panel of *The Separation of Light from Darkness*, but he faces away from the events of the panel to look over his shoulder. His eyes are focused downward, nearly closed, on to the heads of the viewers beneath.

The rounded form and the feminine face of the *Ignudo* is reminiscent of the *Delphic Sibyl*, indeed it could almost be the mirror reflection of the sibyl's pose. It is possible that Michelangelo based this *Ignudo* on the same cartoon that he used for the *Delphic Sibyl*, merely reversing their position and decreasing the scale.

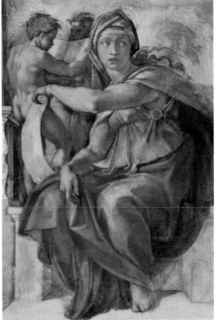

***The Delphic Sibyl* (1508–12)**
Courtesy of The Bridgeman Art Library. (See p. 116)

THE ANCESTORS OF CHRIST (1508–12)

Courtesy of The Bridgeman Art Library

AROUND the edge of the ceiling, where the vault meets the walls, spandrels are formed over the lunettes that rise above the windows. There are 12 spandrels; the four corner ones are double the size of the side ones and are used to illustrate stories in the same way as the central narrative panels. The side spandrels and the lunettes beneath them are filled with portraits of the ancestors of Christ. The idea of showing the genealogy of Christ links the spandrels to the running theme within the narrative panels —from the Genesis through to Noah's drunkenness—of events in the history of Man that anticipate the coming of Christ.

Although the figurative composition used here is the same as the *Doni Tondo (The Holy Family)* (1514), Michelangelo's treatment differs greatly. The compact and united position of the trio in the tondo, portraying the love and closeness of the family, is missing. Instead we see the three from a side view, slumped and disconnected from each other, appearing desolate and depressed. All the ancestors of Christ appear dejected and despondent, their attitude in sharp contrast to the glory and hope that Christ will bring.

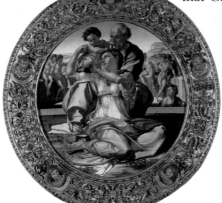

Doni Tondo (The Holy Family) (1504)
Courtesy of The Bridgeman Art Library. (See p. 34)

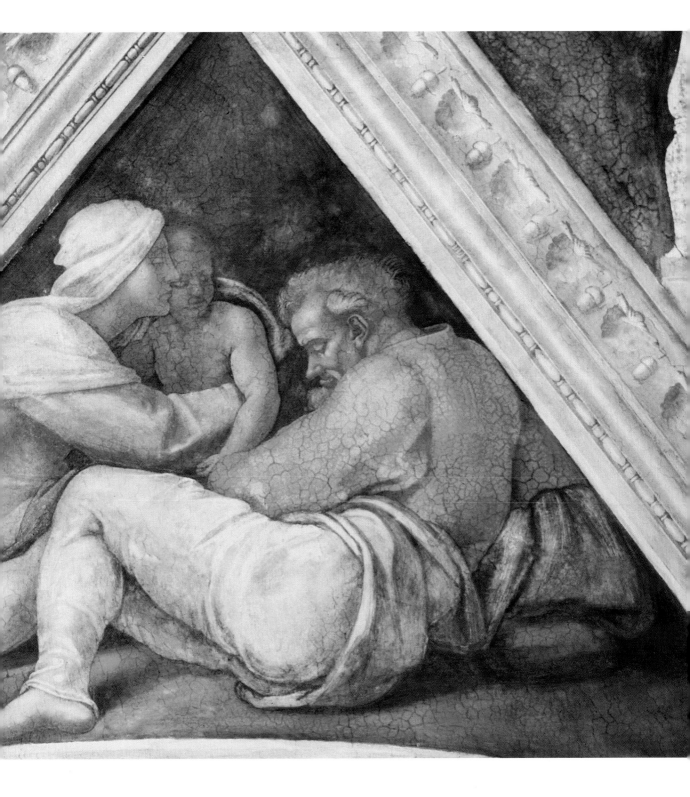

ANCESTOR OF CHRIST (1508–12)

Courtesy of The Bridgeman Art Library

*T*HE arched windows of the chapel are on the upper tier of the building. A semi-circular space, or lunette, is formed between each window arch and the top of the vaulted ceiling. The top of these lunettes form the bottom of the spandrels (the top of one spandrel can be seen in the left corner of the detail), so it was fitting that the lunettes should share the same theme as the spandrels: which was the Ancestors of Christ.

The lunette ancestors share the same despondent, hopeless attitude that the spandrel ancestors portray; suggested mostly by their apathetic postures. In the lunettes, most of the ancestors of Christ appear alone, as opposed to the family groupings of the spandrels.

This old man seems both frail and weary. He has heavily rounded

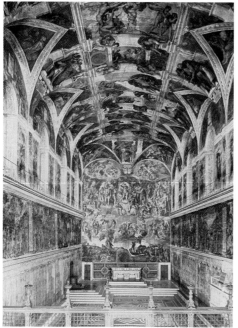

shoulders with a hunched back and leans on the stone with a hand and foot placed to steady himself. He is holding a staff, which suggests that he is a shepherd; a wind blows his beard out in front of him, giving an illusion of harsh weather. The man rests one foot against the decorative plaster that surmounts the window in a gesture that continues the architectural conceit of the illusionary setting in the ceiling.

Sistine Chapel (1508-12)
Courtesy of The Bridgeman Art Library. (See p. 61)

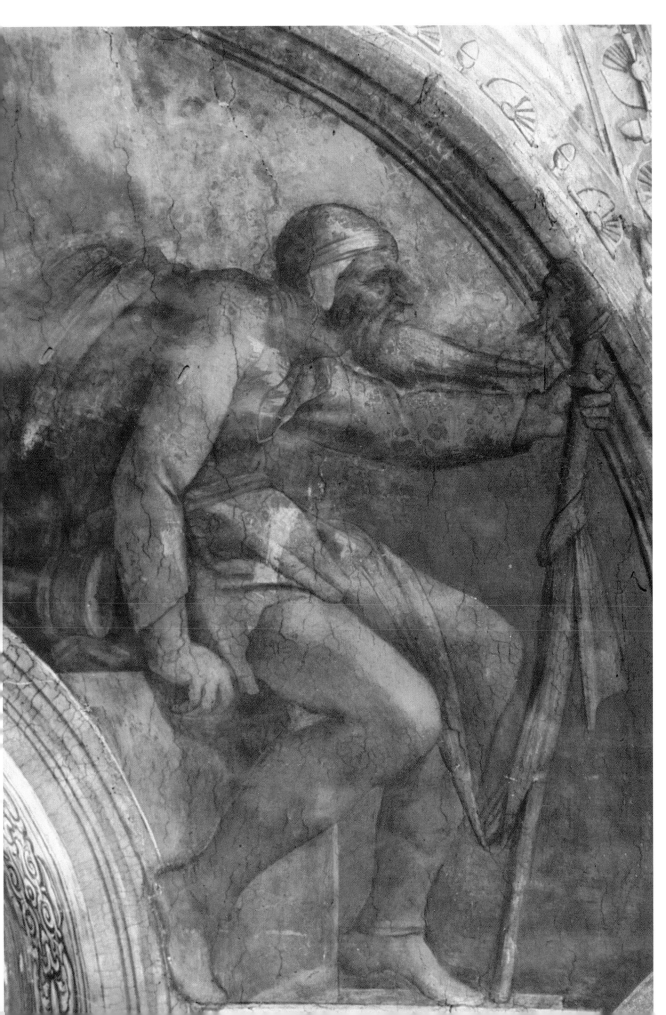

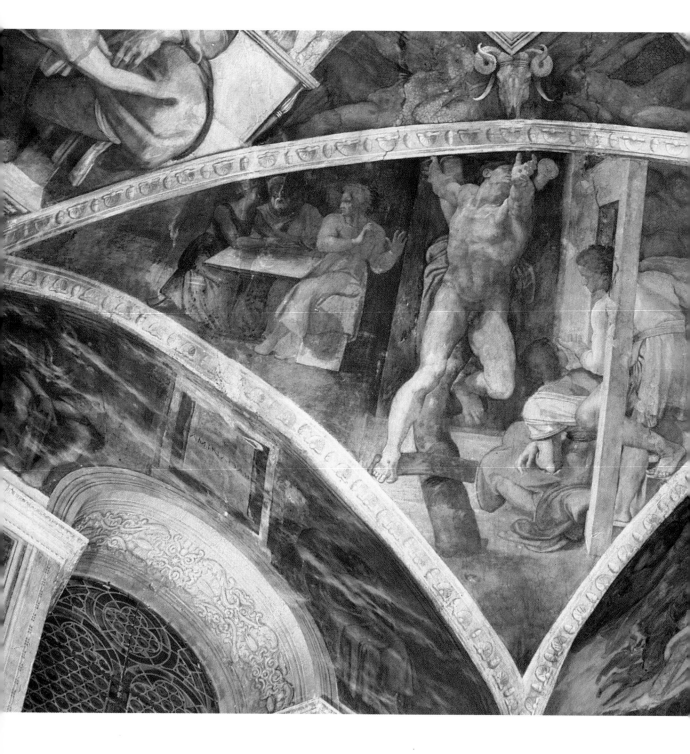

ESTHER AND HAMAN (1508–12)

Courtesy of The Bridgeman Art Library

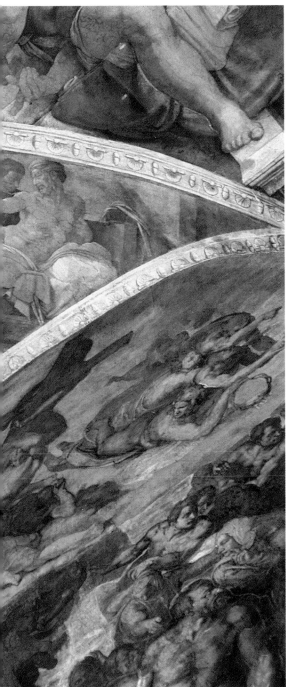

*O*NE of four corner spandrels, *Esther and Haman* tells the story of Esther, the wife of a Persian king who denied her Jewish heritage until Haman, the king's minister, planned to slaughter all Jews. Esther appealed to her king on behalf of the Jews and Haman was subsequently executed. The tale of Esther augurs Mary's pleading for mankind on Judgement Day, connecting this panel with the later fresco *The Last Judgment* (1536–41) positioned on the right.

Esther and Haman is another continual narrative: to the left of the scene Esther denounces Haman, to the right the king lies awake in bed. Next Haman is seen greeting Mordecai, who he plots to have hanged. Finally, the central, dominant image of the piece is of the contorted figure of Haman being crucified.

Michelangelo has painted the figure of Haman as if he were running; the cross he is on is twisted so that his limbs are flung out and in front of his body rather than the more usual side position, *The Crucifixion of Christ* (*c.* 1541). The suggestion of movement in the trapped body is symbollic of Haman's desperate struggle to free himself.

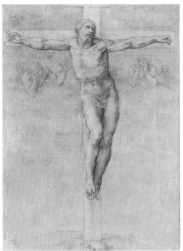

The Crucifixion of Christ (c. 1541)
Courtesy of The Bridgeman Art Library. (See p. 224)

JUDITH CARRYING THE HEAD OF HOLOFERNES (1508–12)

Courtesy of The Bridgeman Art Library

AT the corners of the ceiling are four spandrels which Michelangelo used to illustrate stories of the saviors of Jews. In the two spandrels over the lay entrance of the chapel, near the final narrative panel *The Drunkenness of Noah*, Michelangelo painted two stories of the weak overcoming their rivals: *Judith and Holofernes* and *David and Goliath*.

This scene shows Judith making her escape after killing Holofernes, the leader of the attacking forces of the Assyrians, who were holding the Israelites under siege. In the center of the painting two women leave a bed chamber in which the body of a naked man lies, with his knees bent and torso stretching away from the viewer so that his neck can not be seen. Judith looks at Holofernes' body as she lifts a sheet to cover the head that her maid carries in a tray.

The scene within the spandrel, the *David and Goliath* opposite it, is relatively simple in form by comparison to the other two spandrels at the opposite end of the ceiling, such as *Esther and Haman*.

Esther and Haman (1508–12)
Courtesy of The Bridgeman Art Library. *(See p. 105)*

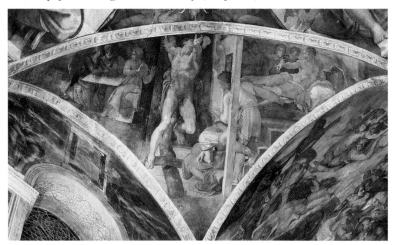

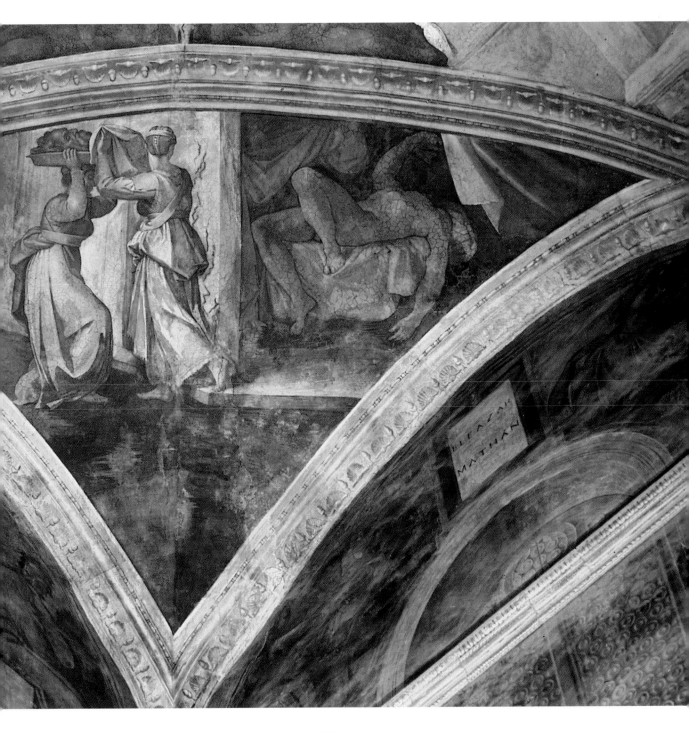

STUDY FOR HAMAN (1508–12)

Courtesy of The Bridgeman Art Library

*T*HE *Study for Haman* uses a medium of red chalk, often used by Michelangelo as it was softer than black chalk. The study reveals his working process, as does the earlier *Study for Adam* (1511). The artist has drawn the figure of Haman carefully and with great attention to detail, but he has left it incomplete; Michelangelo studied only the parts which would constitute the main focus of his chosen posture, in this case the torso and the legs.

On the right there are further drawings of the left leg, which has only been hinted at in the main sketch. Michelangelo has redrawn this heavily foreshortened leg, ensuring that he has the correct perspective, muscle shape, and shade to create the realistic illusion of the leg being stretched further away than the rest of Haman's body. In the spandrel, Haman's foreshortened leg is partially in the shade caused by his body blocking the light and Michelangelo has taken this into account in the preparatory study.

Haman's posture is dramatic and extreme. Michelangelo's use of such postures influenced the art style known as Mannerism (*c.* 1515–1610), which employed artistic tricks such as elongating a figure to heighten its dramatic impact.

Study for Adam (1511)
Courtesy of AKG London. (See p. 74)

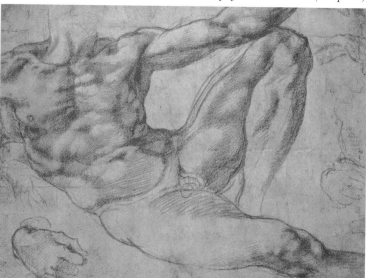

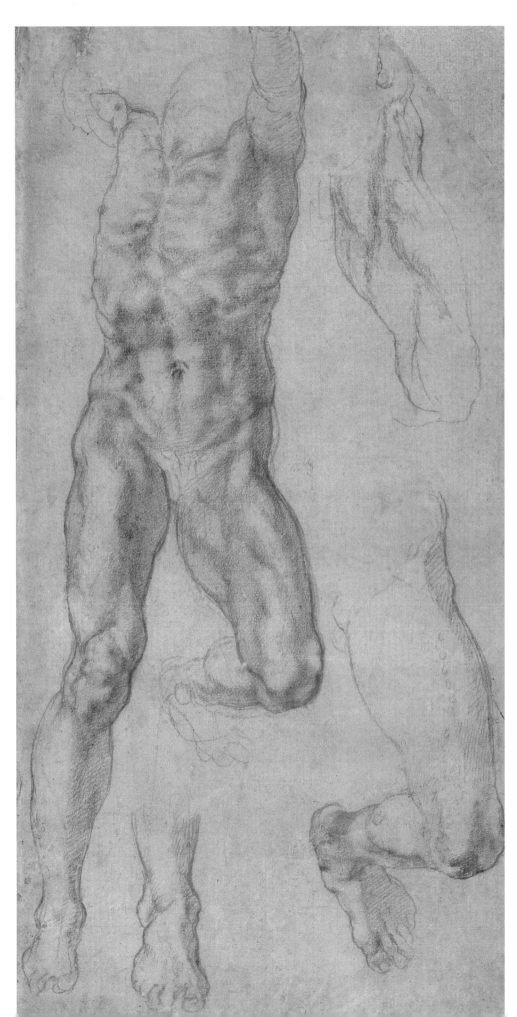

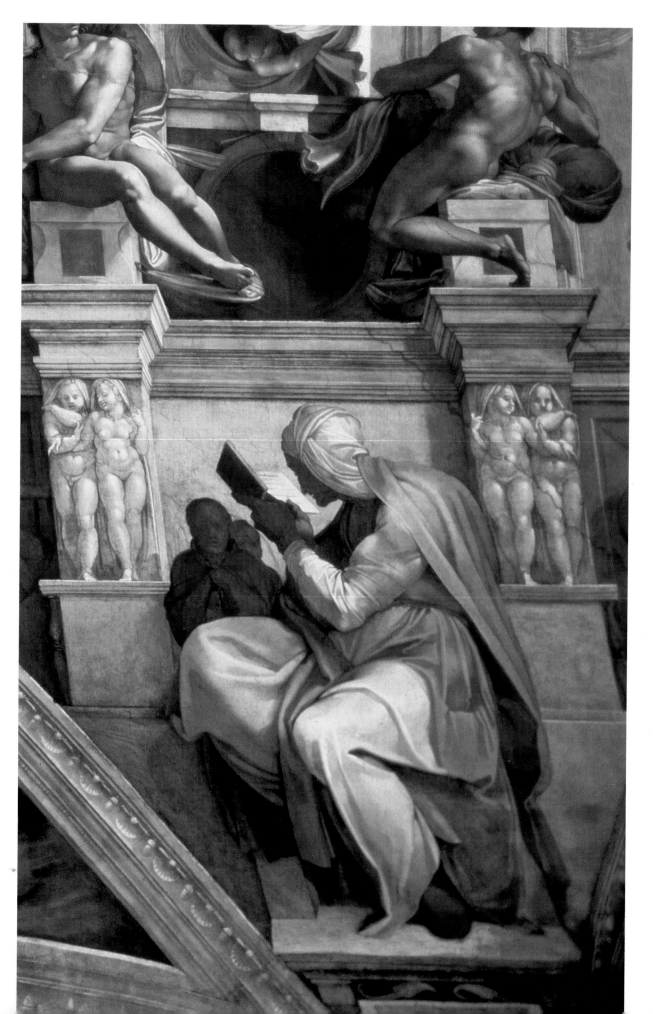

THE PERSIAN SIBYL (1508–12)
Courtesy of The Bridgeman Art Library

*A*PPEARING at opposite sides of each of the five smaller narrative panels are the massive figures of the prophets and the sibyls. There are five sibyls and seven prophets overall, with two prophets at either end of the ceiling and the rest alternating with the sibyls. The sibyls sit on the opposite side of a panel to a prophet; the old *Persian Sibyl* sits opposite the young *Prophet Daniel*.

The sibyls were female prophets from ancient times, so their appearance here could seem at odds with the Christian theme of the ceiling. They were included because they foretold the coming of Christ and so are symbolic links between the ancient pagan civilizations and the Christian world. The inclusion of the sibyls also represented the non-Jewish tradition of oracles, ensuring that the ceiling was not dominated by Jewish symbols and stories such as those of the prophets.

The Persian sibyl is credited with the prophesy of the Virgin Mary conquering the Beast of the Apocalypse. Very little of her face can be seen as she turns away to study her predictions in the book she holds.

THE CUMAEAN SIBYL (1508–12)

Courtesy of The Bridgeman Art Library

THE *Cumaean Sibyl* illustrates a failing of Michelangelo's that many critics have highlighted: although he was a master of the male nude his skill at handling the female form was not parallel to this. In *The Creation of Eve* the figure of Eve seems bulky, servile and somewhat misshapen compared to the grace, poise, and dignity of Adam in the preceding panel.

The *Cumaean Sibyl* shares this awkward portrayal; she has the heavily, muscular body of a man, with a head too small for her massive body. Her breasts, seen through the sheerness of her clothes, do not seem realistic for such a masculine frame. This inability of the artist to portray the female form may be attributed to his lack of knowledge of women: at the time it was hard to recruit female models for fear of them being regarded as prostitutes, so he only used male models. In addition, it is likely that he was homosexual; Michelangelo once opined in a poem that the grace of the male body was superior to the female. Despite the flaws, the *Cumaean Sibyl* is still an impressive figure as she leans over her book of prophesies, her face frowning with apprehension at what she foresees.

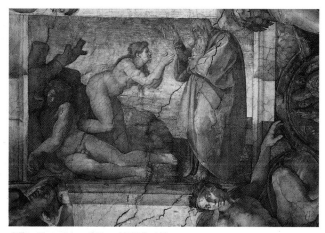

The Creation of Eve (1508–12)
Courtesy of AKG London. (See p. 76)

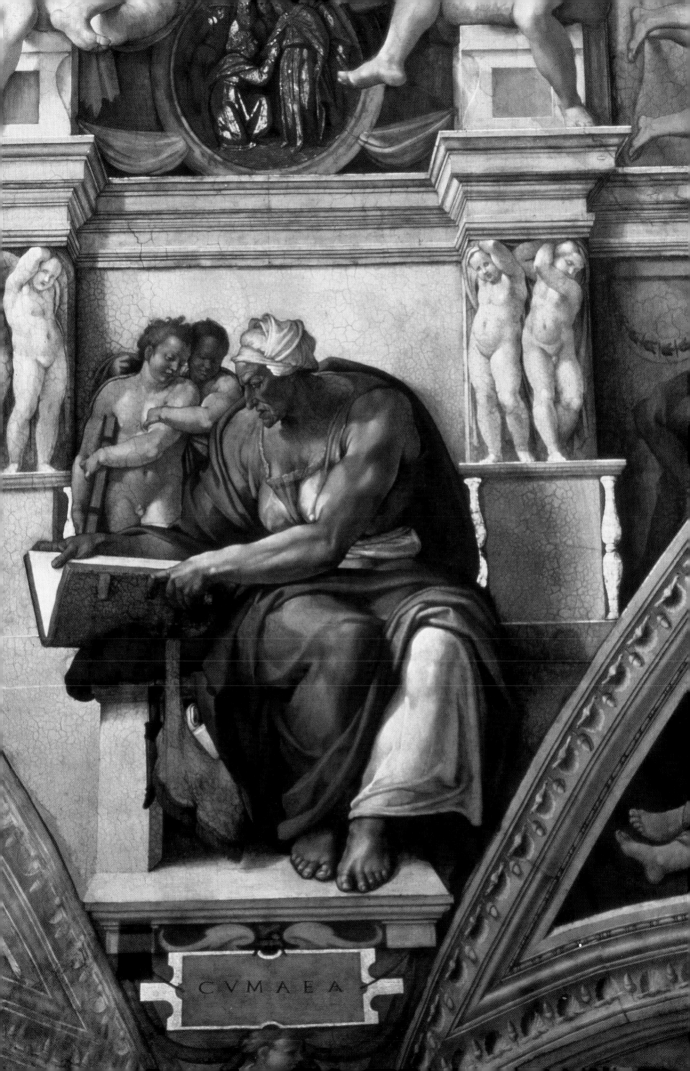

CVMAEA

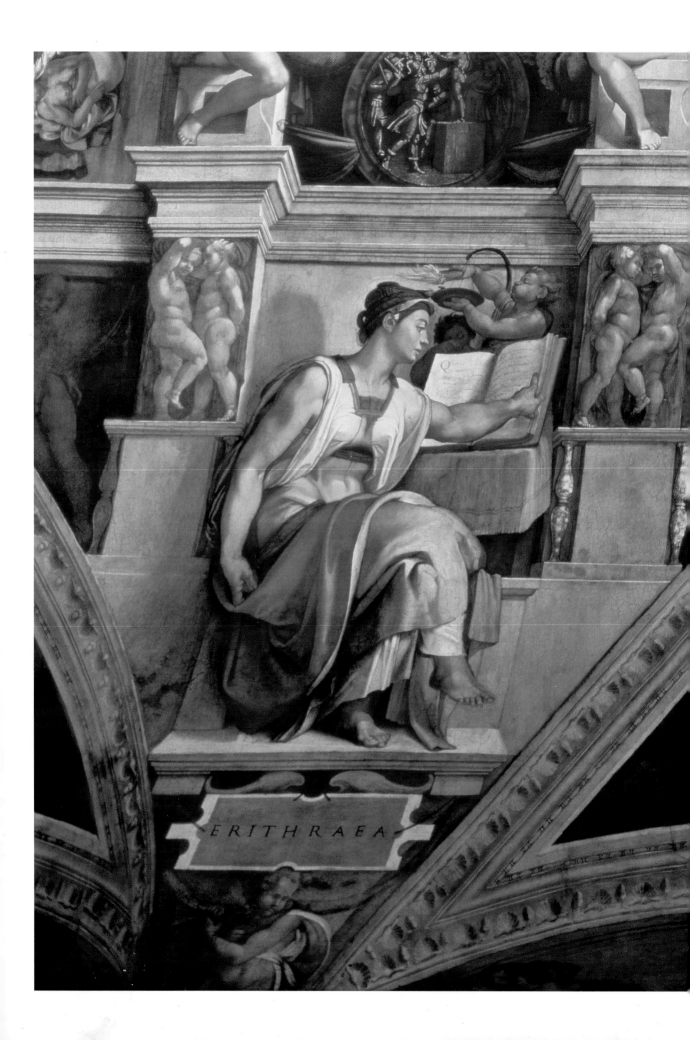

ERITHRAEA

THE ERITHRAEAN SIBYL (1508–12)

Courtesy of The Bridgeman Art Library

THE *Erithraean Sibyl*, placed beneath the narrative panel of *The Sacrifice of Noah*, reiterates the fact that she was Noah's daughter-in-law; it was she who foresaw the coming of Judgment Day. As well as symbolizing the link between the ancient Classical and Christian worlds, the sibyls also function as representatives of the ancient civilizations from which they came: Erithraea represents Ionia, Delphica Greece, Persica the Persian Empire, Cumaea Rome, and Libya the continent of Africa.

Erithraea sits with her legs crossed and her face towards that of the neighboring prophet, Ezekiel. With one muscular arm, she reaches forward to turn the pages of her book, while the other is relaxed by her side. This posture leaves the upper half of her body in an open, frontal position in contrast with the twisted, closed lower half of her body.

Above her book are two genii, one hidden in shadow. These genii appear in pairs next to all of the prophets and sibyls. Their significance is believed to be related to the neo-platonic philosophy that every person is born with two such spirits that reflect the dual nature of their spiritual and material sides. The genii blow upon the flames of a torch to enable the sibyl to read her book.

The Sacrifice of Noah (1508–12)
Courtesy of The Bridgeman Art Library. (See p. 85)

THE DELPHIC SIBYL (1508–12)

Courtesy of The Bridgeman Art Library

THE Delphic sibyl foretold the coming of a great prophet who would be born to a virgin who knew nothing of the corruption of man. A wind is blowing over the prophetess; her hair trails out behind her and her cloak billows out around her shoulders. The hair of her two genii that stand behind her, mimicking her actions, also seems ruffled by this wind. This sense of the blowing wind together with the sibyl's wide-eyed and fearful expression, with her mouth ajar as she looks out past the viewer to see the future that approaches, gives the *Delphic Sibyl* a grave air of import.

Like the *Cumaean Sibyl*, the *Delphic Sibyl* is placed in a frontal position, while the other sibyls are all seen in varying degrees of a twisted, half-turned position. The *Delphic Sibyl* is far more confident rendering of the female form: she has delicate, feminine features and a well-proportioned body.

Michelangelo used startling colors in the robes of the *Delphic Sibyl*, creating a vivid contrast of burnt orange and lime green.

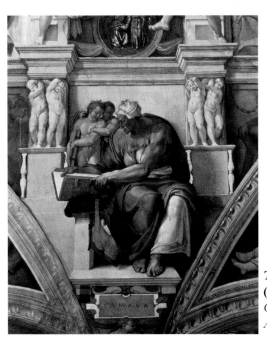

The Cumaean Sibyl (1508–12)
Courtesy of The Bridgeman Art Library. (See p. 112)

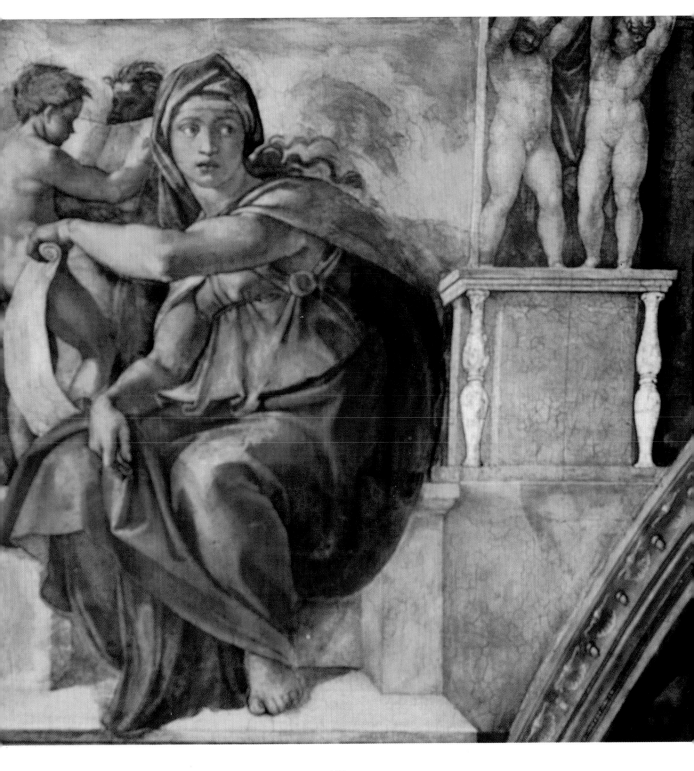

THE LIBYAN SIBYL (1508–12)

Courtesy of The Bridgeman Art Library

THE *Libyan Sibyl* is placed beneath the panel of *The Separation of Light from Darkness* and opposite the morose figure of the prophet Jeremiah. In Classical mythology Libyca was the daughter of Zeus and Lamia, the prophetess who foretold the "coming of the day when that which is hidden shall be revealed."

The *Libyan Sibyl* sits in a very complicated pose with her feet showing under her dress, perching forward with her weight on her toes as she twists her body to lean backwards to lift up the huge book from behind her. Michelangelo has used foreshortening techniques in the sibyl's arms to create the impression that they move further away from us as she reaches ahead of her. The genii to her left mirrors her position with his turned head and twisted shoulder—a reminder to us that he is one part of a dual reflection of the sibyl's nature.

Ideal Head (c. 1533)
Courtesy of The Bridgeman Art Library.
(See p. 188)

The features of the sibyl are similar to those in the *Ideal Head* (c. 1533), completed almost 20 years later. As well as sharing the same features, the two have a similar posture; looking over one shoulder with downcast eyes.

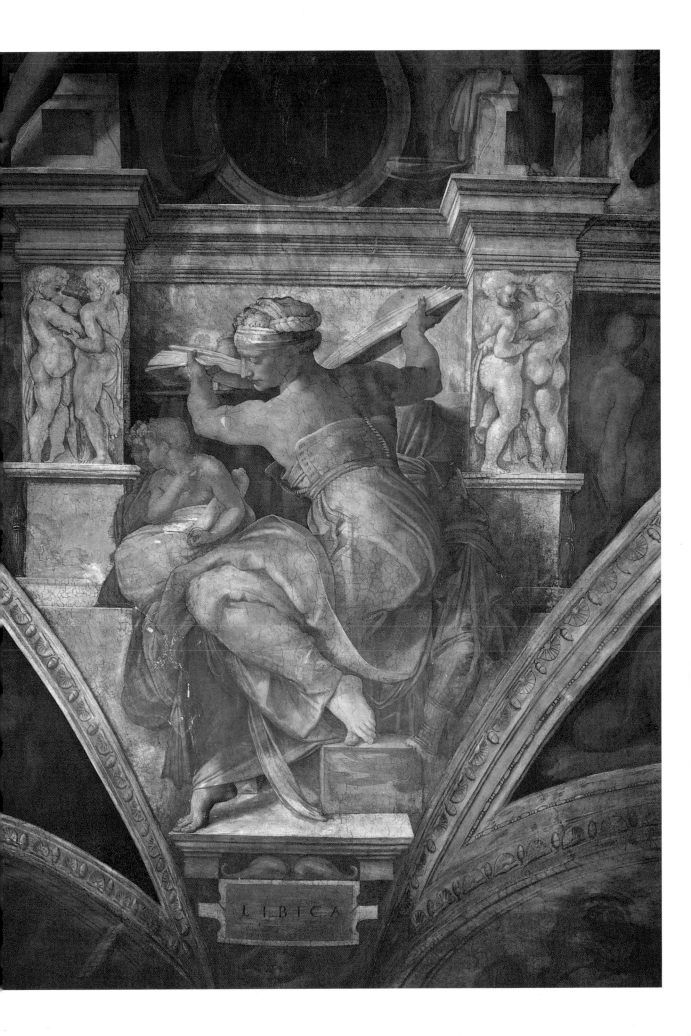

LIBICA

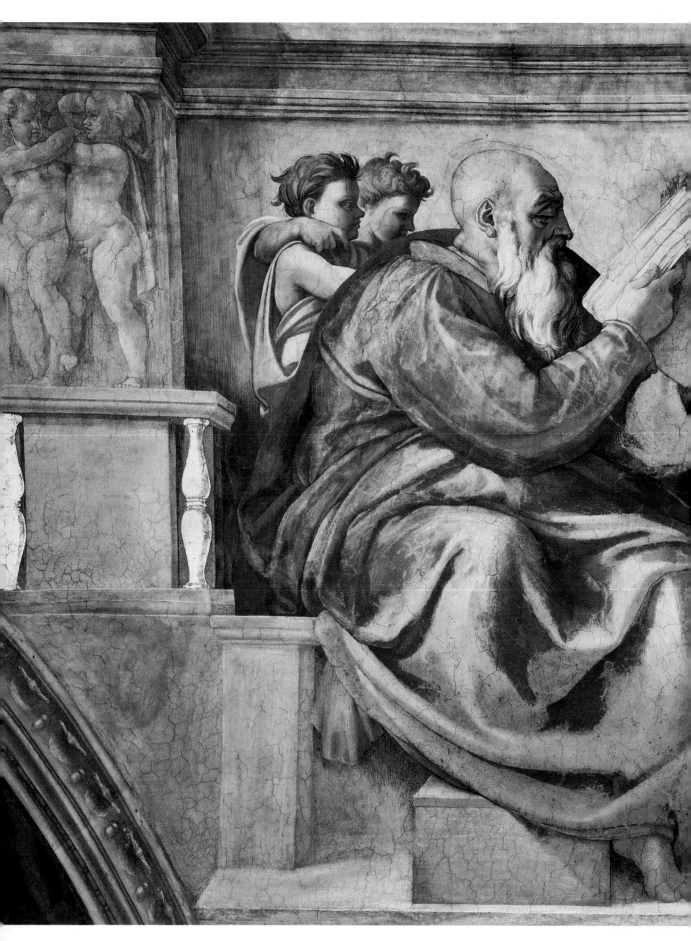

THE PROPHET ZACHARIAH
Courtesy of AKG London

THE prophets appear in the Old Testament. They are the inspired men of Israel, through whom the Holy Spirit tells of the coming of Christ and of the Christian era. Of the seven prophets that appear in the Sistine Chapel, four are major prophets and three are minor. *Zachariah* is one of the three minor prophets and is positioned at the end over the lay entrance to the chapel; at the altar end is the prophet *Jonah*. Zachariah had eight apocolyptical visions, one of which was of four chariots colored red, black, white, and piebald, that represented the four winds carrying God's judgment to the four corners of the earth. Zachariah also predicted the coming of the Messiah and the crucifixion.

Gold paint has been used on the decorations adorning the pilasters on either side of the prophets. Originally it was planned that there would be much more gilding within the ceiling fresco, but Michelangelo stopped painting following an argument with Pope Julius II. Julius wanted Michelangelo to carry out further gilding, saying that the fresco would look "poor" without it. Michelangelo replied that "those who are painted there were poor men", and so the gilding was left as it now stands.

THE PROPHET EZEKIEL (1508–12)

Courtesy of AKG London

OF all the prophets and sibyls, it is *Ezekiel* that is charged with the most energy and movement. A wind is apparent in the painting that blows the prophet's hair and robes, adding to his animated appearance. Clutching his scroll of prophecies in one hand, he twists in his seat, turning his head to one side as his massive body leans forward. One hand is held open in a gesture of questioning as he gazes with a severe intensity to his right. *Ezekiel* appears beneath the panel *The Creation of Eve*, opposite the *Cumeaen Sibyl*, but he faces towards the *Erithraean Sibyl*. While the Erithraean sibyl foresaw the Judgment Day, in a vision Ezekiel saw the skeletal dead rising to assume flesh and clothing, which was interpreted as the resurrection of the dead on Judgment Day. Michelangelo later illustrated this vision in his *Last Judgment* fresco.

With his wild, grey beard and dominating presence, Ezekiel bears much resemblance to the figure of God as Michelangelo portrayed him in his narrative panels. The intense frown here is especially reminiscent of God's fierce expression in the panel *The Creation of the Plants, and the Sun, and the Moon*.

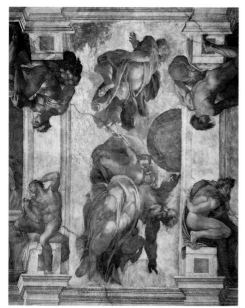

The Creation of the Plants, and the Sun, and the Moon (1508–12)
Courtesy of AKG London.
(See p. 67)

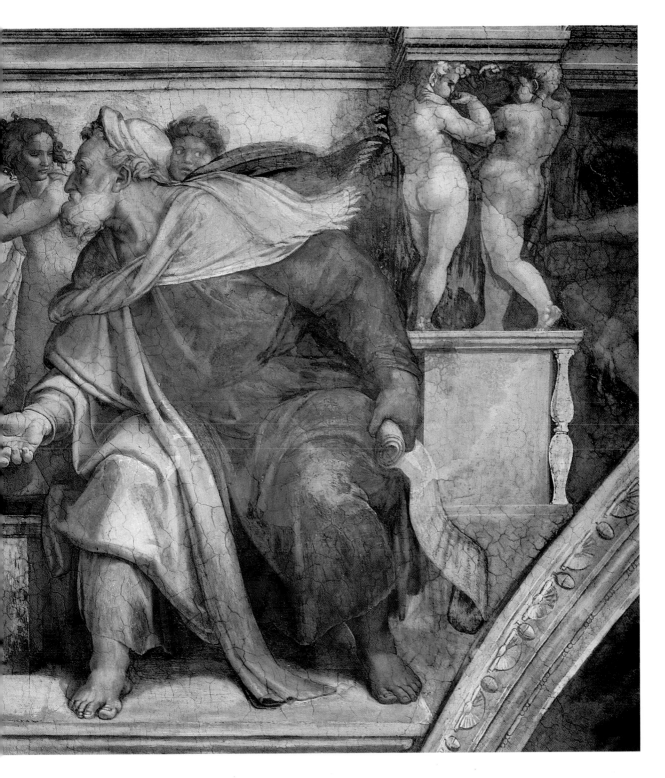

THE PROPHET JOEL

Courtesy of The Bridgeman Art Library

*J*OEL is one of the 12 minor prophets. His predictions included the arrival of Judgment Day and a plague of locusts devouring the earth, blotting out the sun, moon, and the stars. Michelangelo portrayed Joel as an old man: his face is lined, his expression serious and attentive as he reads from the scroll that he holds. The genii behind him on the left is mimicking his pose and also reading from the scroll with a solemn face. The other genii carries a book of prophecies while he points to the distance, his mouth open as if he himself is uttering a prophecy. The two nearest caryatid on the pilasters also turn to read the scroll that Joel carries.

Joel appears beneath the panel of *The Drunkenness of Noah* as well as opposite the *Delphic Sibyl*, and so was one of the first prophets to be painted. The increase in scale that Michelangelo employed in the later panels of the ceiling can also be seen in the prophets and sibyls. Joel sits in a simple, relaxed pose, easily fitting within the confines of his setting, while the later prophet *Jeremiah* leans forward out of his throne.

The Prophet Jeremiah (1508–12)
Courtesy of The Bridgeman Art Library. (See p. 127)

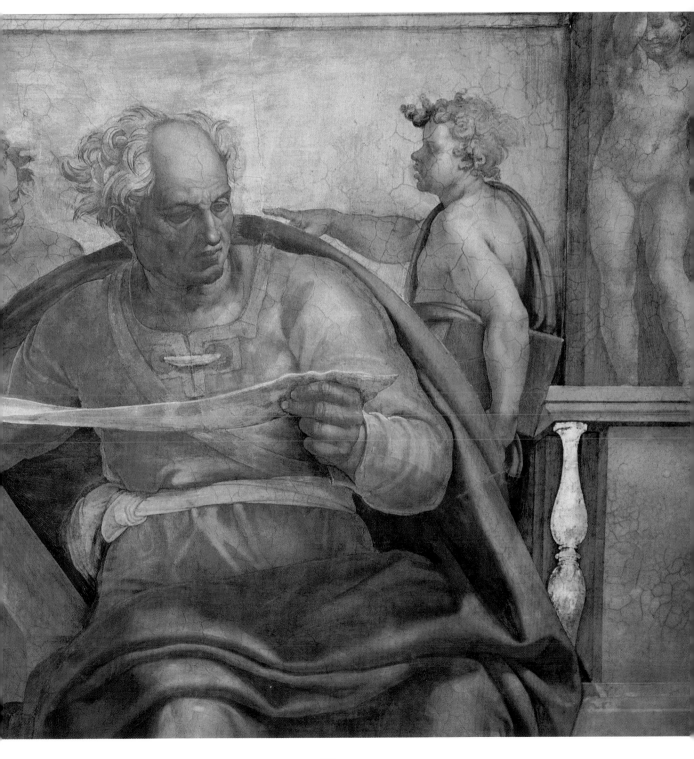

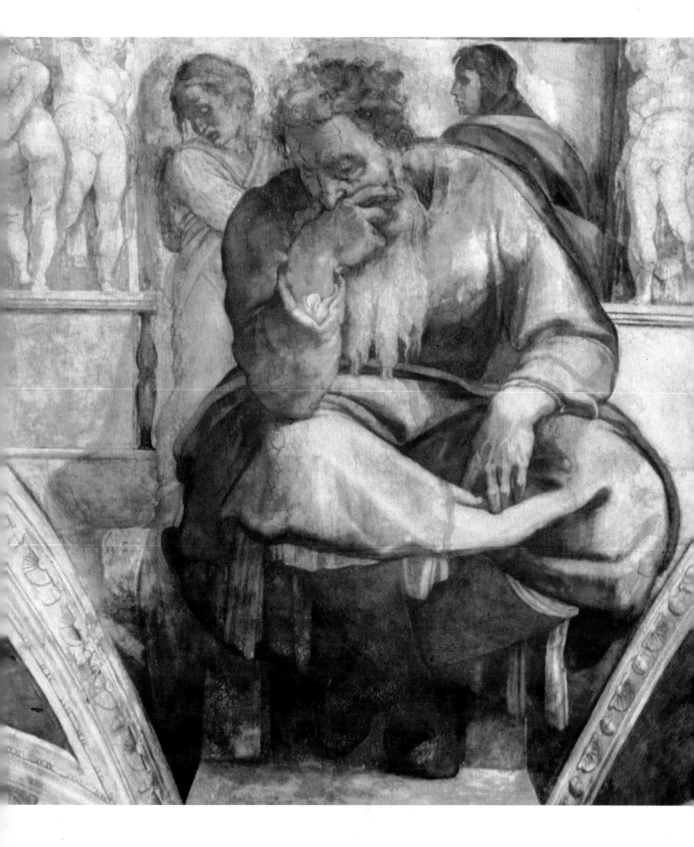

THE PROPHET JEREMIAH (1508–12)

Courtesy of The Bridgeman Art Library

*J*EREMIAH appears under the panel of *The Separation of Light from Darkness* and opposite the *Libyan Sibyl*. One of the four major prophets, Jeremiah wrote the "Lamentations" and is often referred to as the "dismal" prophet, being renowned for his despondent manner. Jeremiah repeatedly complained to the various kings of Israel, threatening them with disaster and pestilence if they were to go against the praise of one God alone. He was also known for his repeated diatribes against evil. To reflect his supposed character of gloom, Michelangelo gave Jeremiah a suitably despondent pose. He sits forward in his throne, leaning his head on his right hand, which is covering his mouth. This gesture was used again by Michelangelo in his sculpture *Lorenzo de' Medici* (1520–34). As here, the pensive gesture was used to give the impression that Lorenzo was in deep thought.

Unusually, Jeremiah's genii are clothed women, differing from the cherubic genii that appear behind most of the prophets and sibyls. One genii has the same depressed stance as the prophet, while the other looks to the distance, symbolic of his prophetic nature.

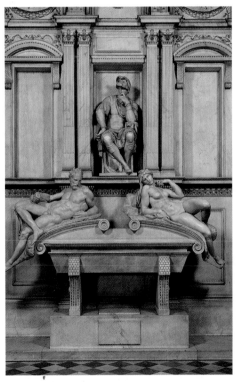

Lorenzo de' Medici (1520–34)
*Courtesy of AKG London/S. Domingie–
M. Rabatti. (See p. 163)*

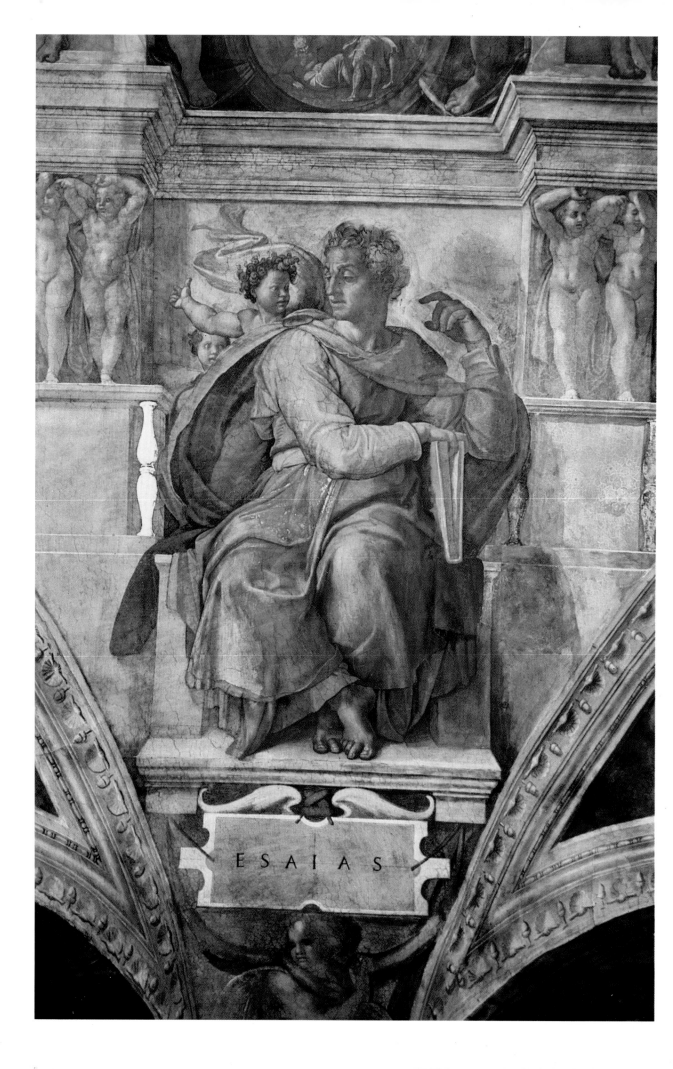

ESAIAS

THE PROPHET ISAIAH (1508–12)

Courtesy of The Bridgeman Art Library

*I*SAIAH is a major prophet and has an Old Testament book that bears his name. His prophecies refer to the coming of Christ, the inauguration of the Messianic age, and the Virgin Birth. Through his prophesies Isaiah gave the assurance of universal peace.

It has been suggested that besides their prophesies, the seven prophets are also illustrations of the Seven Gifts of the Holy Spirit. Isaiah described these as Wisdom, Understanding, Counsel, Fortitude, Knowledge, Compassion, and Fear of God. The various expressions and poses of the seven prophets can indeed be seen to reflect these attributes. Isaiah turns to listen to the genii that whispers in his ear, suggesting that he is considering the genii's Counsel or advice. The mighty figure of Ezekiel is easily interpreted as Fortitude, while Zachariah's studious pose evokes Wisdom. A fearful Jonah looks up towards the figure of God creating light from darkness, illustrating the Fear of God. The gloomy prophet Jeremiah, with his air of despair, can be seen as representative of Compassion or Pity, leaving the figures of Daniel and Joel to portray Knowledge and Understanding respectively.

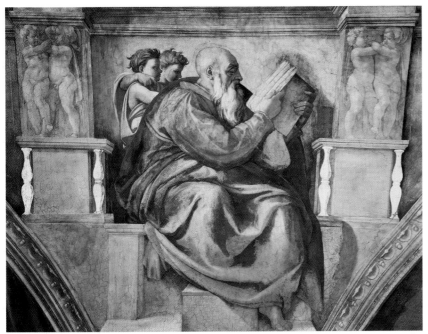

The Prophet Zachariah (1508–12) Courtesy of AKG London. *(See p. 121)*

THE PROPHET DANIEL (1508–12)

Courtesy of The Bridgeman Art Library

*D*ANIEL is one of the four major prophets, along with Ezekiel, Isaiah, and Jeremiah, and here represents Justice, one of the four cardinal virtues. During his lifetime, Daniel's prophetic gifts brought him much success and honor at the courts of kings. One of his most famous prophecies came from the interpretation of the writing that mysteriously appeared upon the walls during a feast at Belshazzer's court, the prediction of Belshazzar's death and the subsequent division of his kingdom. This incident has been passed in to everyday use with the saying "seen the writing on the wall."

Of all the prophets in the fresco, *Daniel* has been given the most youthful appearance and his pose and expression, like that of *Ezekiel*, suggests energy and movement. He leans forward from his throne, the curve of the ceiling means that he appears to be looking down on to the chapel floor. He writes with one hand while holding his book of prophecies in the other. Placed between Daniel's legs is his genii, who bears the weight of the large book upon his head and shoulders. His other genii hides in shadow behind him, barely seen.

The Prophet Ezekiel (1508–12)
Courtesy of AKG London. (See p. 122)

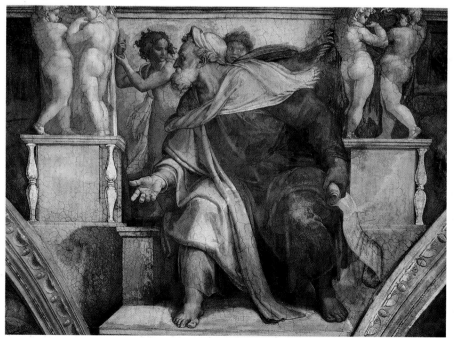

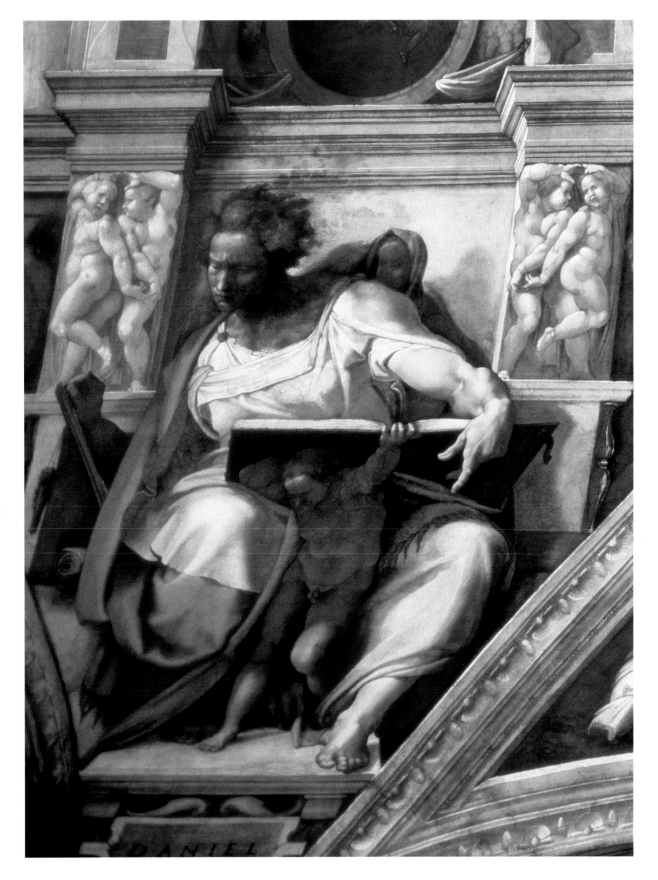

FIGURES ABOVE THE SPANDREL BY
THE CREATION OF ADAM (1508–12)

Courtesy of The Bridgeman Art Library

BETWEEN each prophet and sibyl are the spandrels that Michelangelo filled with his illustrations of the Ancestors of Christ. Above each spandrel, leaning against the steeply sloping sides, are two figures. The symbolism of these figures is unclear. They are painted in deep golden or bronze colors and display a variety of complicated, dramatic poses. Most of the figures seem to be imprisoned within their niches, straining against the walls with their bodies. The niches in which they sit are shadowy and their features are difficult to see. It has been suggested that these dark, foreboding figures are intended to be representative of pre–Christian societies.

With their contorted positions and cramped attitudes these figures could also be reflective of the artist's working conditions in the Sistine Chapel. The ceiling fresco took over four years to complete, during which time Michelangelo spent many of his days in convoluted contortions upon the scaffolding. He made a joke of the physical trials that he had endured in a poem to a friend:

> *"My beard turns up to heaven; my nape falls in,*
> *Fixed on my spine: my breast-bone visibly*
> *Grows like a harp: a rich embroidery*
> *Bedews my face from brush-drops thick and thin."*

The Ancestors of Christ (1508–12)
Courtesy of The Bridgeman Art Library. (See p. 100)

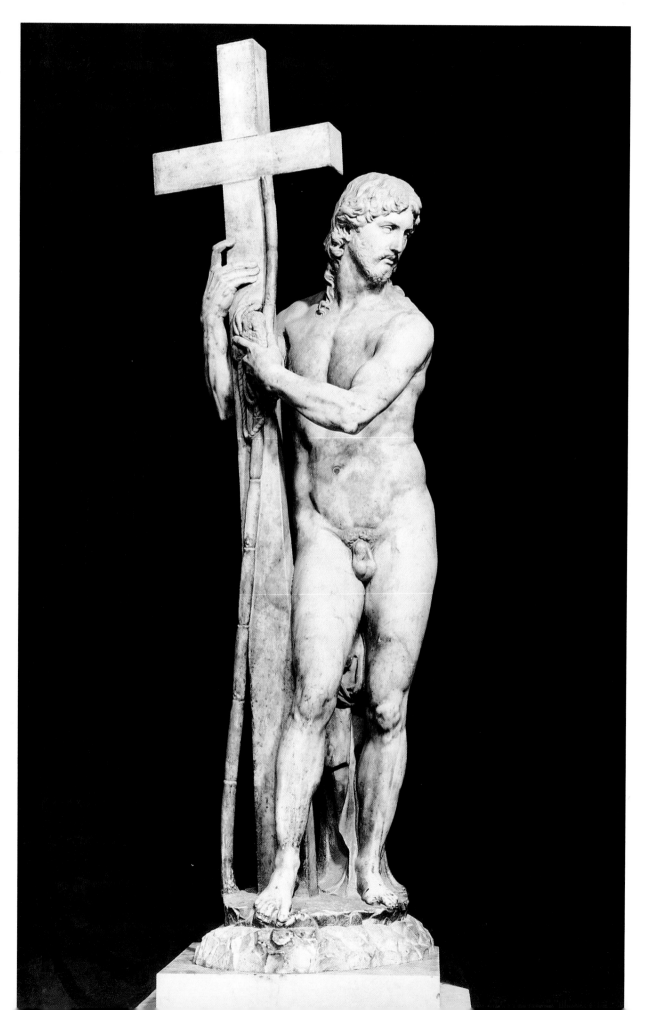

THE RISEN CHRIST (1519–20)

Courtesy of The Bridgeman Art Library

*T*HE *Risen Christ* was commissioned in 1514 by three of Michelangelo's patrons. The sculpture is also known as *Christ of the Minerva* because it is located in the Santa Maria sopra Minerva church, in Rome. Upon nearly completing the piece, Michelangelo realized the marble was flawed by veins of black, so the piece had to be started again from scratch.

In 1921, the artist sent *The Risen Christ* to his assistant Pietro Urbano in Rome to install in the church and make some finishing touches. He damaged the toes, fingers, hair, and face of the scultpure; in a letter to Michelangelo, Urbano's touch was likened to a baker rather than a sculptor. Consequently, Michelangelo gave the statue to the sculptor Federigo Frizzi to complete. Deeply dissatisfied with the results, he offered to carve another *Risen Christ*, but the patrons refused, saying they were satisfied with the sculpture.

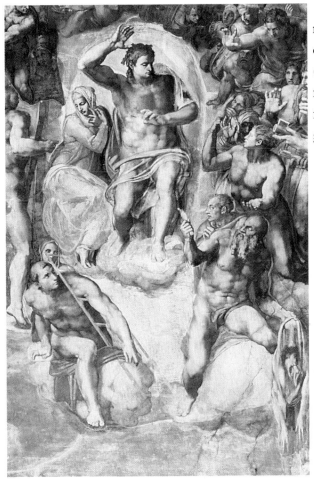

The figure of Christ here resembles the warrior-like figure of Christ in *The Last Judgment* (1536–41) and has been criticised for being too much like a heroic fighter and too little like the gentle son of God.

Detail of Christ from
The Last Judgment (1536–41)
Courtesy of AKG London. (See p. 203)

TOMB OF POPE JULIUS II (1505–45)

Courtesy of The Bridgeman Art Library

ST Julius II, known as the Warrior Pope after his campaigns to reclaim lost papal states and fiefdoms, was a great patron of the arts. Julius wanted a suitably grand design to commemorate his tomb and so he called Michelangelo to Rome in March 1505 to discuss possible designs. From the beginning, the relationship between Michelangelo and Julius was a tempestuous one, peppered by many arguments between two equally volatile and determined men. A deep-rooted respect for each other eventually grew between the two men and this survived in Michelangelo long after the death of Julius II.

The tomb project proved to be a millstone about Michelangelo's neck. He had hoped that it would be a grand and astonishing master-piece, a magnificent reminder—not just of a great and powerful pope but also of his own genius. Michelangelo was never to be allowed to dedicate himself to the tomb, he was repeatedly taken off the project to work on others. The first such occasion was by Julius' own insistence that he should work on the Sistine Chapel, temporarily abandoning the tomb. The later uprisings in Florence also contributed to Michelangelo's inability to fulfil the contract.

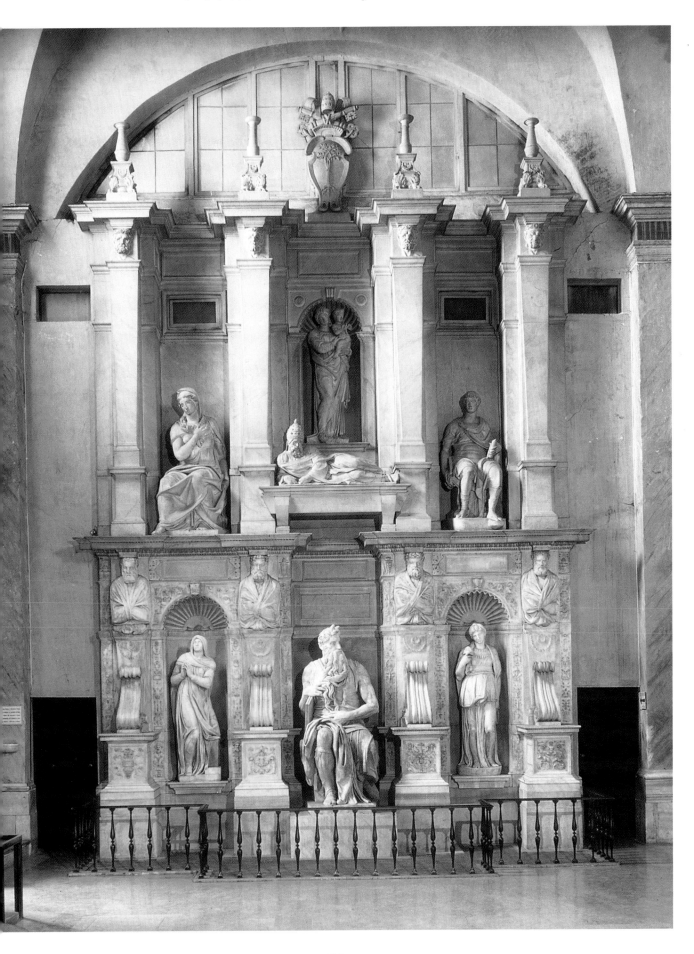

STUDY FOR THE TOMB OF POPE JULIUS II (1505–45)

Courtesy of The Bridgeman Art Library

T HE original design for the tomb of Julius was for a free-stand-ing block about 50 ft (15 m) high, with three stories containing niches which were to house over 40 statues. There was to be an internal room for the remains of the pope. The top storey was to have gigantic statues, twice life-size, of figures such as *Moses* (1513–16).

Condivi, one of Michelangelo's biographers, called the project "the tragedy of the tomb" and Michelangelo himself felt that he wasted his youth over it, intermittently spending 40 years on the project. Following the pope's death in 1513, the contract for the tomb was taken up by his family and there were allegations that Michelangelo had cheated Julius out of a substantial amount of money. This upset Michelangelo deeply, particularly as the fate of the tomb had largely been taken out of his hands; often one of his patrons would wrangle

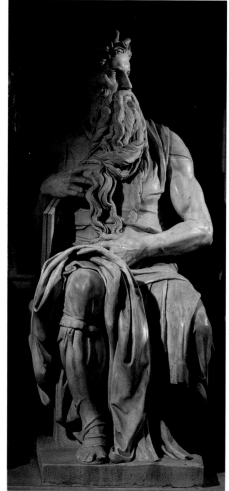

with another over which project he was to take on next.

After many revisions, arguments, and court cases, the tomb was completed with only three statues by Michelangelo: *Moses, Rachel,* and *Leah*; the latter were produced between 1542 and 1559.

Moses (1513–16)
Courtesy of AKG London/Erich Lessing.
(See p. 141)

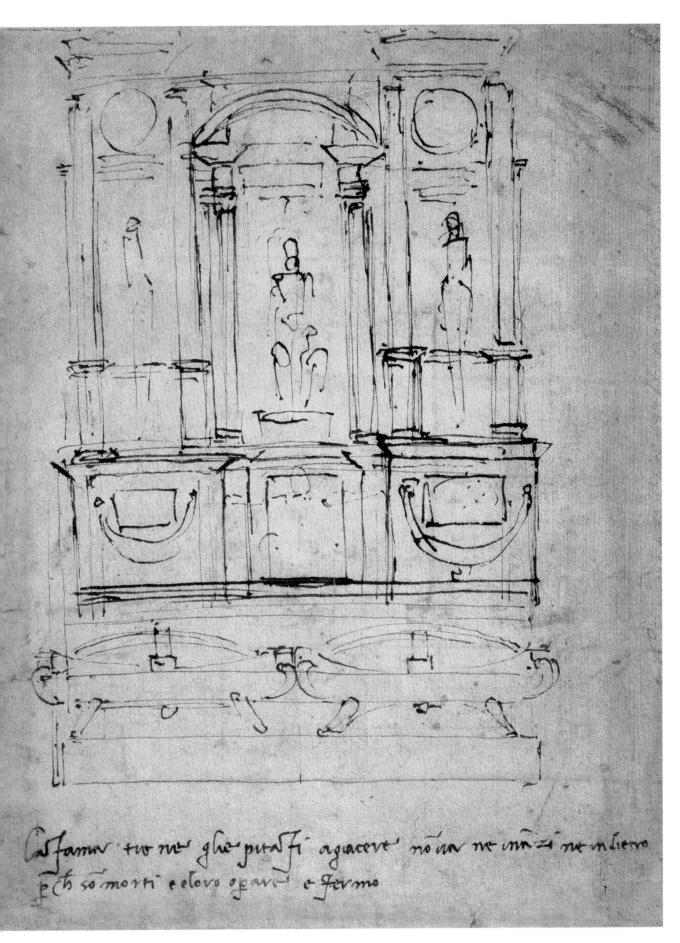

MOSES (DETAIL FROM THE TOMB OF POPE JULIUS II) (1513–16)

Courtesy of AKG London/Erich Lessing

ASILY the most impressive piece on the tomb of Pope Julius II is the majestic *Moses*. Reminiscent of *The Prophet Ezekiel* (1508–12) with his fierce expression and gigantic proportions, *Moses* stands out against the other more diminutive and tame statues on the tomb. Completed between 1513 and 1516, this huge statue is over twice life-size. In the earlier designs for the tomb, *Moses* was initially intended to take a place on the second tier of what was to be a three-tier, 50-ft (15-m) structure among five other statues of the same size. This intention explains the incongruous size and the fierce expression of *Moses*: he was meant to be seen at a distance, from below, which would have made these factors less apparent.

The Prophet Ezekiel (1508–12)
Courtesy of AKG London. (See p. 122)

Moses was the greatest figure of the Old Testament, deliverer of the Children of Israel out of Egypt to the Promised Land. Under his right arm he holds the tablets of law given to him by God. On his head are two horns; this convention dates from medieval times as a result of a mistranslation of Hebrew text. He should have rays of light emanating from his head.

RACHEL AND LEAH (DETAIL FROM THE TOMB OF POPE JULIUS II) (1542–55)

Courtesy of The Bridgeman Art Library

IN the Old Testament, Rachel was the younger and more attractive daughter of Laban. Jacob loved her and worked for seven years under Laban in order to marry her. He was deceived into marrying her sister, Leah, and served Laban for a further seven years before being finally allowed to marry Rachel, only to find that she was barren. After persuading Jacob to sleep with both Leah and her servant Bilhah, Rachel prayed to God, who heard her pleas and "opened her womb"; she died in childbirth.

Aside from the biblical description of this story, Michelangelo derived much from the interpretation that Danté Alighieri (1265–1321) gave the two sisters in *Purgatorio*; that of Active and Contemplative life. To illustrate the idea of contemplation, Michelangelo shows a

Giuliano de' Medici (1520–34) Courtesy of The Bridgeman Art Library. *(See p. 166)*

serene Rachel gazing up towards heaven with her hands clasped in
prayer. He also used the notion of Active life in his sculpture of *Giuliano
de' Medici*. With *Leah*, the Active element is portrayed by the mirror she
holds, symbolizing the sentiment with which we must contemplate our
actions. While *Giuliano de' Medici* embodies the idea of the Active life
through his expression and posture, Leah's posture seems more to
embody the Contemplative life, as she is slightly slumped and seems
deep in thought.

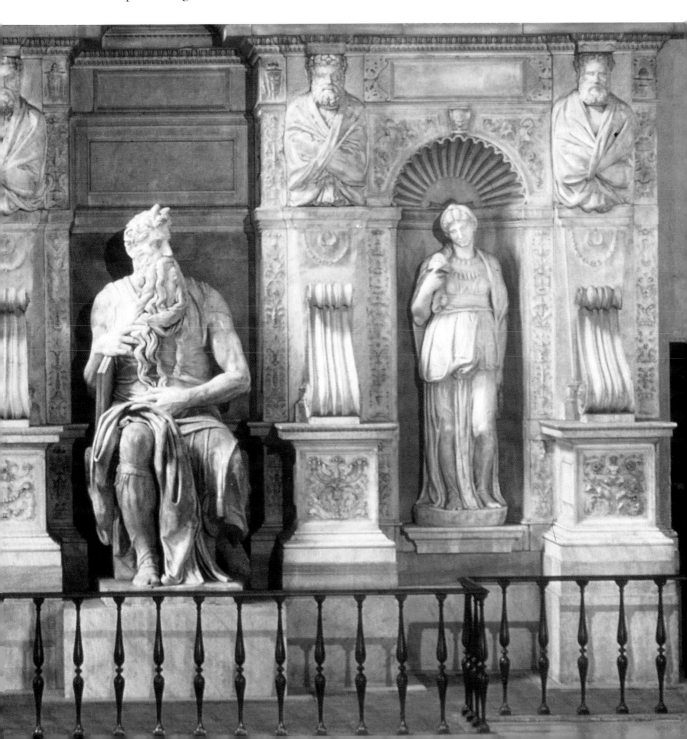

DYING SLAVE (1513–16)

Courtesy of AKG London/Erich Lessing

THE *Dying Slave* was one of 12 sculptures of slaves that Michelangelo originally intended to be housed in the *Tomb of Pope Julius II*. This statue, together with the *Rebellious Slave* (1513–16), are the only two that appear near completion; both sculptures are now in the Louvre in Paris.

The *Slaves*, much like the *Ignudi* in the Sistine Chapel, were designed to be decorative figures along the base of the tomb as it was originally designed. They were to be placed against columns and pilasters or on the corners of the tomb, but after many revisions and re-scalings, the figures were found to be too big for their planned niches. The figures of *Rachel* and *Leah* (1542–55) were carved and the rest, such as the *Young Slave* (1520–30), were abandoned in what may be their incomplete state, although many critics believe that Michelangelo intended them to be left freely carved.

The sculpture of the *Dying Slave* has a sensual, erotic quality. Michelangelo has created the semblance of a reclining figure in a verical position. The left arm is held above the tilted head and the other arm lies limply upon the breast—the figure appears to be in a dream-like state rather than actually dying.

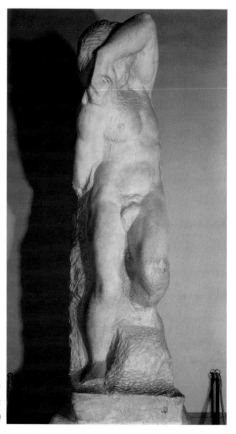

Young Slave (1520–30)
Courtesy of The Bridgeman Art Library. (See p. 150)

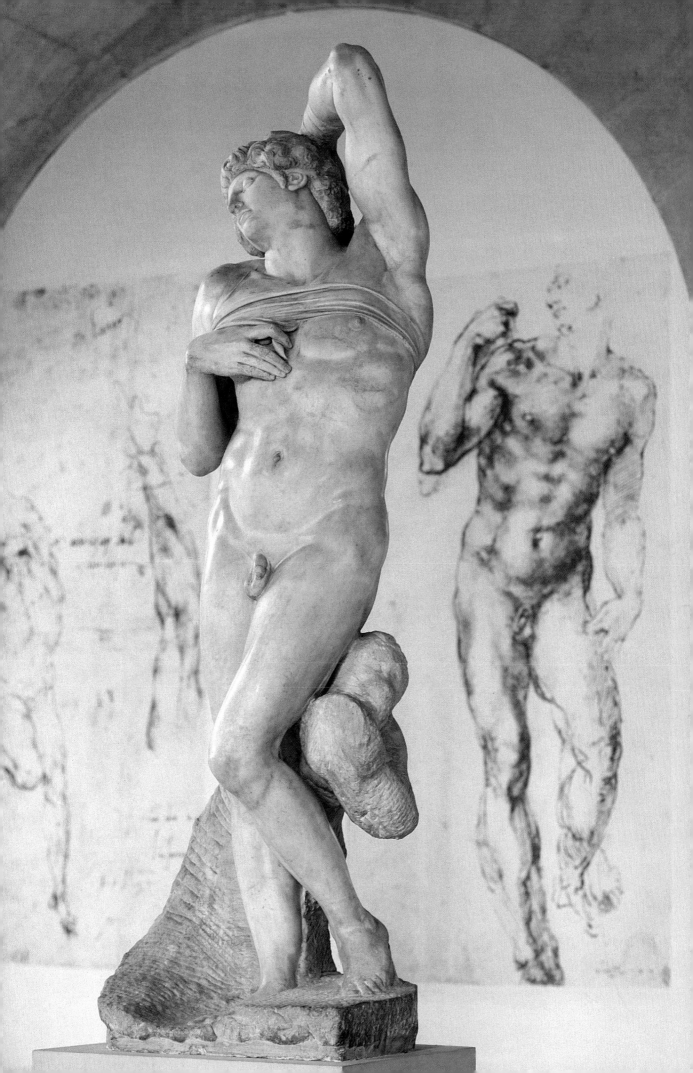

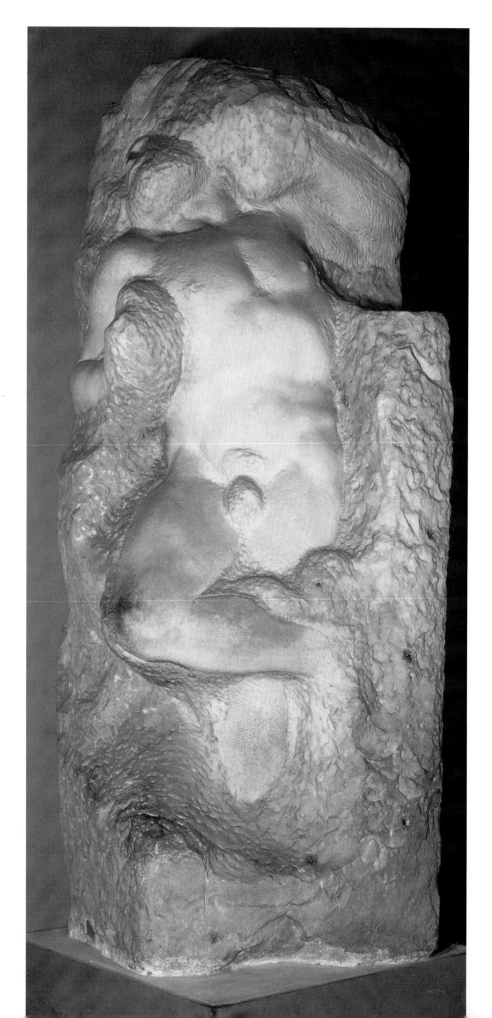

AWAKENING SLAVE (1520–30)

Courtesy of The Bridgeman Art Library

IN their various stages of completion, the slave sculptures are perfect examples of Michelangelo's techniques in sculpture, as is the *Taddei Tondo* (*c.* 1504). Several of this series are now in the Galleria dell' Academia in Florence, where they are keenly studied by students. The *Awakening Slave* is barely formed: only his heavy torso and one giant leg have been worked on to any extent, the rest of the figure appears to have sunk within the marble. Michelangelo described the process of sculpture as releasing a form that was trapped within the block of marble; when viewing the *Awakening Slave* this observance seems especially apt.

He would first make a wax life-size model of his sculpture, then draw an outline of this on to the marble in charcoal. He chiseled from the front of the marble block, then chipped from all sides. For the carving of the *Slaves*, it is recorded that the wax model was sunk horizontally in a bath of water so that just the highest parts of it would emerge. He would then decrease the water level little by little so that he could see more and more of the figure appearing, as if it were the *Slave* freed from the marble block.

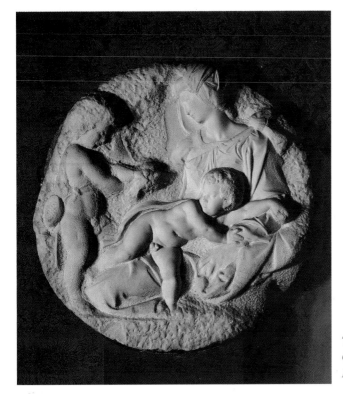

Taddei Tondo (c. 1504)
Courtesy of The Bridgeman Art Library. (See p. 46)

BEARDED SLAVE (1520–30)

Courtesy of The Bridgeman Art Library

ANOTHER of the Academia *Slaves*, the *Bearded Slave* has been given a similar pose to that of the *Dying Slave* (1513–16), but expresses a potently different quality. This sculpture has been left in a much lesser state of completion; the hands are still sunk in to the marble, giving him the appearance of struggling, not against his bonds, but against the marble itself. He is thick-set and muscular compared to the *Dying Slave*, who seems lithe by comparison. Due to his beard and furrowed brow, the *Bearded Slave* seems older than the others; his solidity of form adds to this illusion.

As well as an excellent opportunity for Michelangelo to show his advanced skill at handling the male nude, the *Slaves* were intended to symbolize the Arts. As Pope Julius II had been a strong patron of the arts during his lifetime, the sculptures were created to represent the idea that the Arts had become enslaved by the death of such a vital patron. Above the *Slaves*, on the top tier of the original design for the tomb, were to have been the figures of Heaven and Earth; the latter mourning the passing of Julius and the former rejoicing in his arrival in eternity.

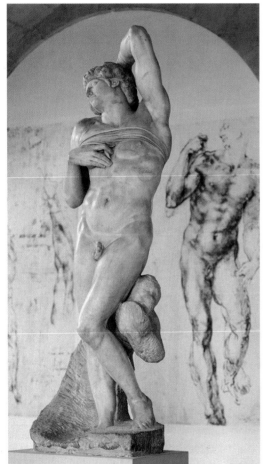

Dying Slave (1513–16)
Courtesy of AKG London/Erich Lessing.
(See p. 144)

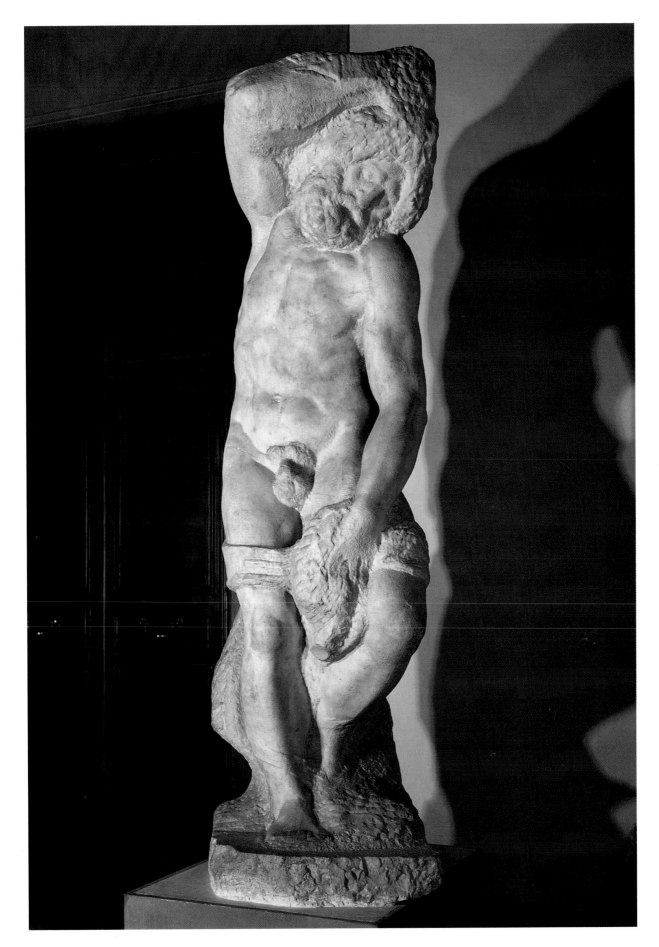

YOUNG SLAVE (1520–30)

Courtesy of The Bridgeman Art Library

*L*IKE the *Dying Slave* (1513–16), the *Young Slave* seems to be slumbering. His head is hidden in the crook of his arm, with his hand loosely clenched, appearing to be softly described within the rough marble. Michelangelo's method of working from the front of the block of marble first is demonstrated here by the protrusion of the *Young Slave*'s bent leg. The angle of the leg means that the calf is behind the knee, and therefore still within the block of marble, waiting for Michelangelo's chisel to bring it into being.

By the positioning of his raised arm, the *Young Slave* appears to be struggling, as if held behind his back by unseen forces. His torso twists with the movement of his arm so that it is slightly off-center.

Although the *Slaves* share the similarly contorted poses of the *Ignudi* (1508–12), this particular statue lacks the elegance of the latter; the limbs of the figure are thick and heavy. Whether this is to do with the incomplete state of the figure or Michelangelo's attempt to represent a slave trapped in marble is a question for endless debate.

***Ignudo near the Sacrifice of Noah* (1508–12)**
Courtesy of AKG London. (See p. 95)

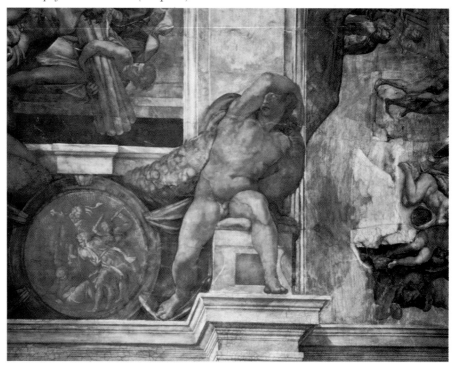

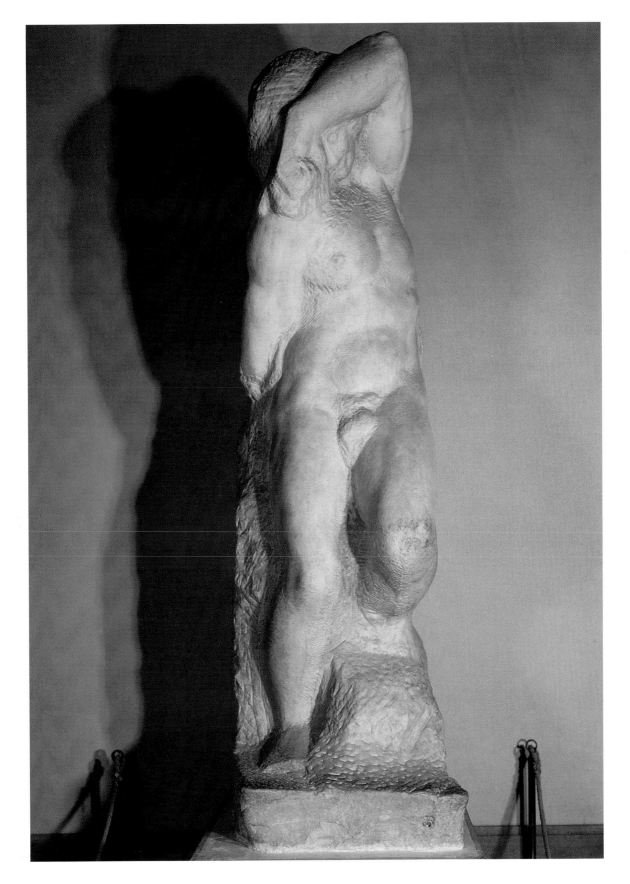

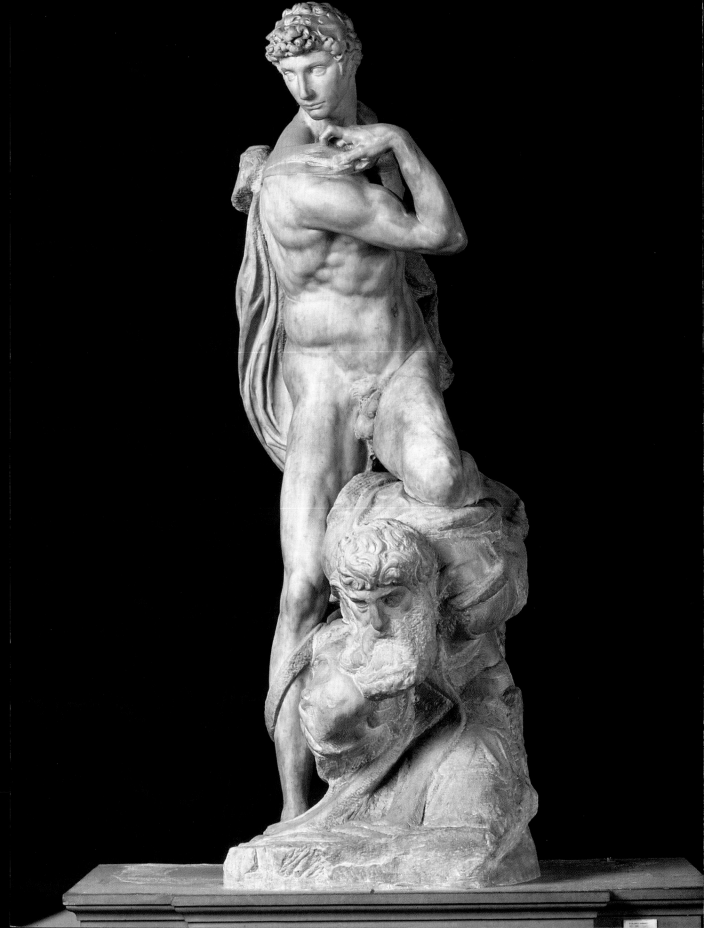

VICTORY (1519–30)

Courtesy of The Bridgeman Art Library

*T*HE *VICTORY* statue may have been intended as another *Slave* for the *Tomb of Julius II* (1505–45), but was carved later than the others, after another revision of the contract for the tomb with Pope Leo X. *Victory* is one of Michelangelo's most influential sculptures; the spiral form and the unnatural, self-conscious pose were much simulated among the Mannerist artists that he helped to inspire.

The sculpture has a triangular configuration like that of the *Doni Tondo (Holy Family)* (1504). The spiral movement can be seen starting with the defeated, crouched figure, rising through the knee of the victor and carrying on through his twisted torso to his turned head. This mimics the form and movement of a serpent and gained the name *figura serpentinata*.

A spiralling form in sculpture encourages the creation of a free-standing piece that can be viewed from every angle. However, with *Victory*, this was not to be the case. It was planned to stand against the tomb of Julius II. Michelangelo may have intended his sculpture to be viewed from the front only, but now it can be viewed freely all round and stands up well to that scrutiny.

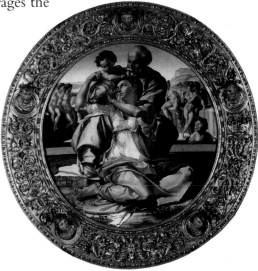

Doni Tondo (The Holy Family) (1504)
Courtesy of The Bridgeman Art Library. (See p. 34)

HEAD (DETAIL FROM VICTORY) (1519–1530)

Courtesy of The Bridgeman Art Library

AS with much of Michelangelo's work, many opinions have been offered as to the meaning behind the *Victory* statue. The victorious, but curiously mild-looking, youth has been put forward as the soul who has conquered the old man, thus representing mortality. Other opinions suggest that the old man is Michelangelo himself and that the young man symbolizes the suffocating demands of his patrons. The head of the old man does indeed bear some resemblance to the Michelangelo we see in portraits and he did suffer endless problems with demanding patrons changing their minds about his commissions or fighting among themselves and with him.

Another suggestion from critics is that the statue may symbolize youth conquering the progress of age. Michelangelo was approaching middle age when this piece was carved; the youth's arrogant and overly self-confident appearance, with his vacuous stare and conceited pose, have been used to back up this theory.

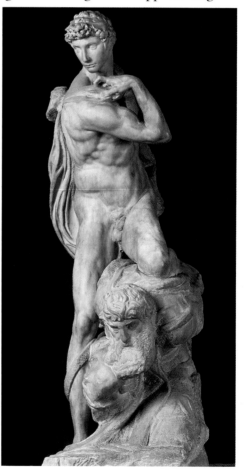

Victory (1519–30)
*Courtesy of The Bridgeman
Art Library. (See p. 153)*

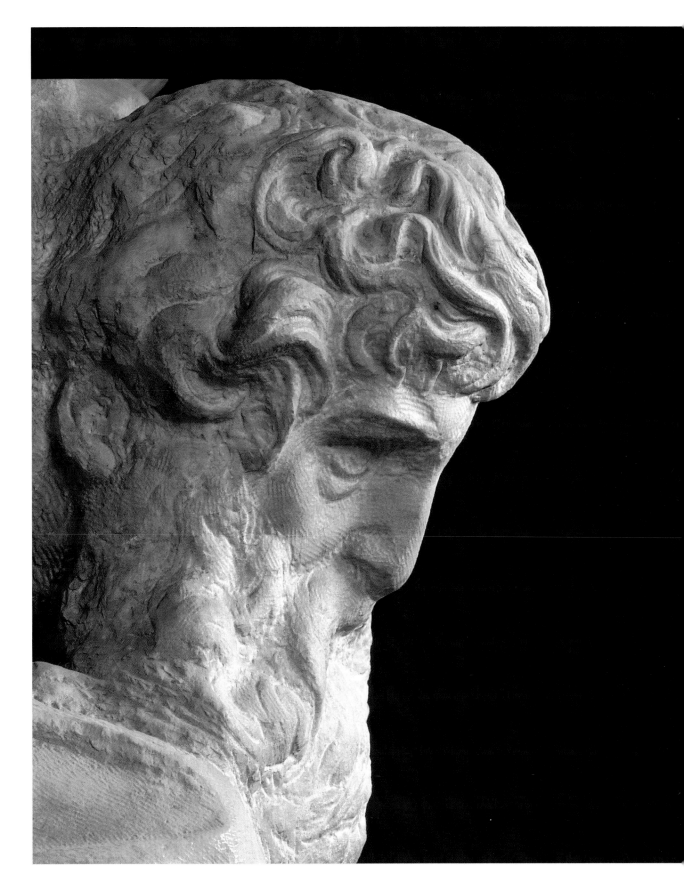

STUDY OF THREE MALE FIGURES (DATE UNKNOWN)

Courtesy of The Bridgeman Art Library

*D*URING the High Renaissance, the three outstanding artists were Leonardo da Vinci, Raphael (1483–1520), and, of course, Michelangelo. All three Italian artists worked within similar areas, shared the same patrons and, often, the same locations. In his *Study for the Doni Madonna* (1503), Michelangelo successfully recreated the manner and techniques of Leonardo da Vinci and this study is a reproduction of work by Raphael.

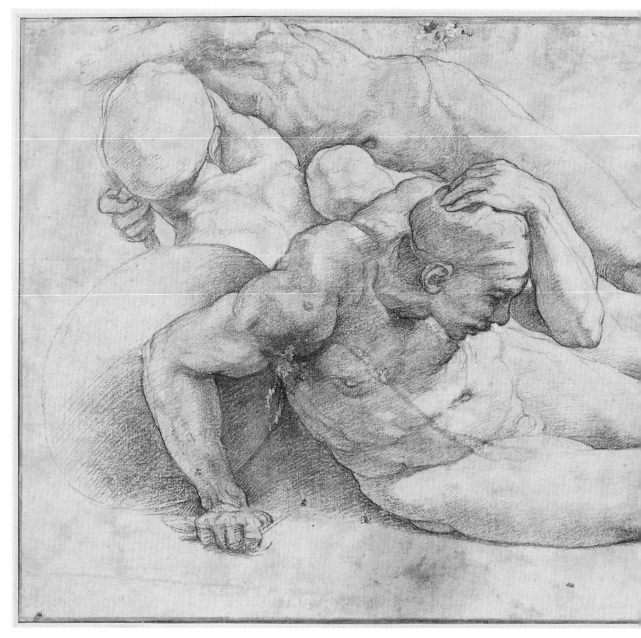

While Michelangelo worked on the Sistine Chapel ceiling, Raphael was painting frescoes for one of the papal rooms in the Vatican, the Stanza della Segnatura (1508). Michelangelo viewed Raphael as an enemy; he was the nephew of his professional rival, Bramante, and, with his sociable, extravagant lifestyle, was the antithesis of Michelangelo's meager, isolated life; during this period the latter claimed "I have no friends, nor do I want any."

After Michelangelo had completed the narrative panels in the Sistine Chapel, Bramante sought permission for his nephew Raphael to complete the work; a request that both distressed and angered Michelangelo. In a letter dated 1542, over 20 years after the death of Raphael, Michelangelo claimed that all the arguments between himself and Julius II were caused by Bramante and Raphael, blaming them for his inability to complete the pope's tomb, and saying of Raphael "all he had of art he owed to me."

Study of a Male Nude Leaning (date unknown)
Courtesy of The Bridgeman Art Library. (See p. 56)

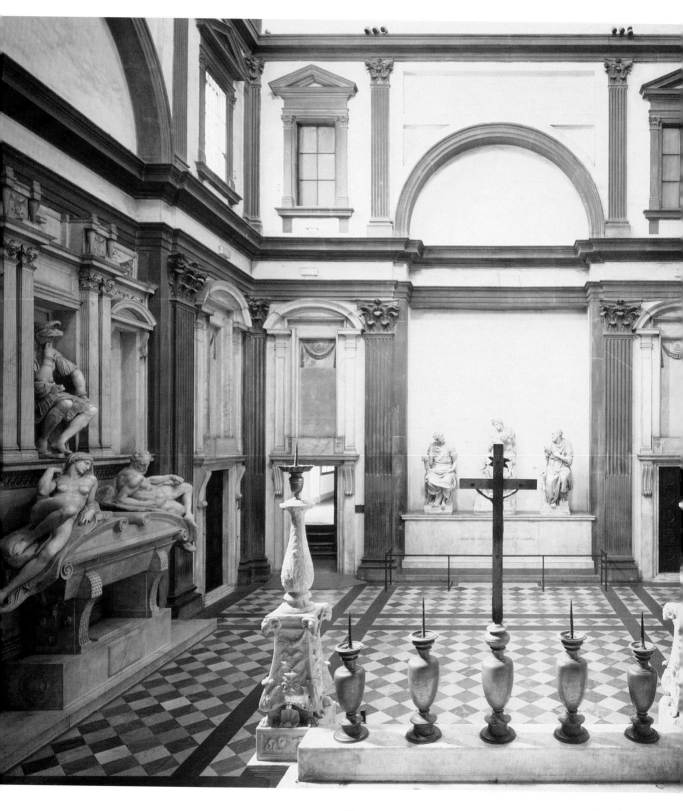

INTERIOR OF THE MEDICI CHAPEL (1519–34)

Courtesy of The Bridgeman Art Library

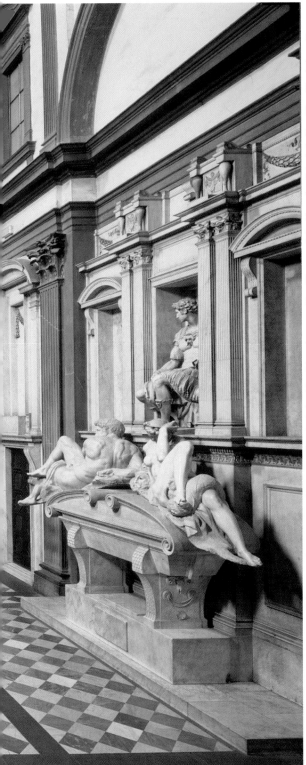

IN 1520, Michelangelo began work, at the request of Pope Leo X, on the interior of the New Sacristy of the San Lorenzo Chapel in Florence. San Lorenzo was the private chapel of the Medici family and the New Sacristy was built to house the bodies of four of the Medici clan, of which Leo X himself was a member. Michelangelo kept the design for the New Sacristy in line with Filippo Brunelleschi's (1377–1446) design of the Old Sacristy in the same church, built about 100 years earlier.

The chapel has eight doors, two on each wall, of which five are façades that were added to make the remarkable symmetry of the interior possible. Above each door is a niche created purely for decoration. The windows in the second story of the chapel have been given heavy pediments and are narrower at the top than at the bottom; this gives them an increased perspective to make the walls appear higher than they are.

The pilasters, cornices and pediments are all a dark-grey *pietra serena*, a fine-grained sandstone, to accentuate the white marble of the walls. The contrast between the two is enhanced by the light that enters through the many windows of the three-tiered building.

STUDY FOR THE MEDICI CHAPEL (C. 1520)
Courtesy of The Bridgeman Art Library

*W*ORK on the Medici Chapel, like the *Tomb of Pope Julius II* (1505–45), was interrupted and redesigned several times; the Republican uprisings in Florence halted work, as did changes in popes. The Medicean Pope Leo X died in 1521, to be replaced by Pope Adrian VI who had no interest in the arts, but he was succeeded by another Medici, Giulio, who became Pope Clement VII, and work on the chapel was recommenced.

Michelangelo's plans developed and changed over the years. As originally designed, the chapel was to house the bodies of four of the Medicis: Michelangelo's first patron, Lorenzo the Magnificent and his brother Giuliano, as well as Giuliano, Duke of Nemours, and Lorenzo, Duke of Urbino. The tombs of Lorenzo the Magnificent and his brother were never made and the chapel only houses the tombs of the two Medici dukes. The sketch shown is for a double tomb; it is possibly an early design for the one that now houses their remains.

With his plans for the Medici Chapel, Michelangelo was hoping to achieve his long-standing ambition of creating the perfect fusion of architecture, painting, and sculpture.

***Study for the Tomb of Pope Julius II* (1505–45)**
Courtesy of The Bridgeman Art Library. (See p. 138)

❋ STUDY FOR THE MEDICI CHAPEL ❋

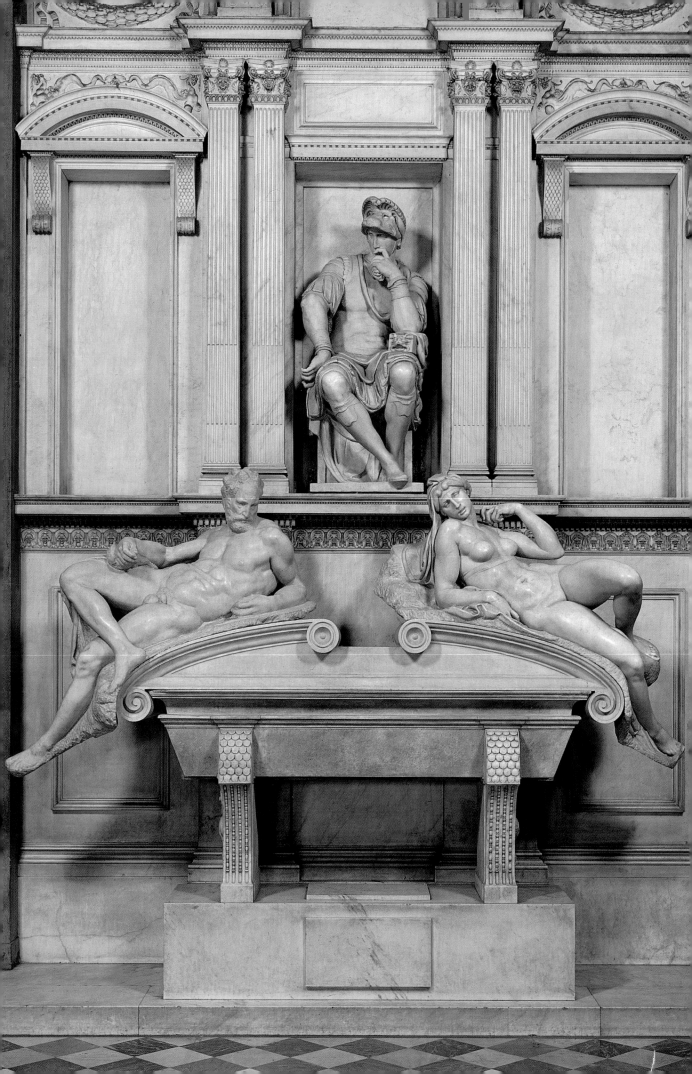

TOMB OF LORENZO DE' MEDICI (1520–34)

Courtesy of AKG London/S. Domingie-M. Rabatti

IN 1534, Michelangelo left Florence and returned to Rome, thereby abandoning any further work on the Medici Chapel. Some time after this, the unfinished statues were placed upon the sarcophagi of the two dukes. It is unclear what was intended to fill the niches on either side of Lorenzo of Urbino, although it is mentioned that for Giuliano of Nemours, the niches were to be filled with representations of Heaven and Earth. Earth was to mourn Giuliano's passing and Heaven rejoice in his arrival—an idea taken from the *Tomb of Pope Julius II* (1505–45).

One of the earlier designs for the tombs included the figures of river gods to be placed on both of the sarcophagi. These river gods were to represent the underworld and also important Italian rivers, such as the Arno. The statues on top of the sarcophagi, *Twilight* and *Dawn*, were to symbolize human mortality and the corporeal state, leaving the statue of the Duke to represent Heaven, or the afterworld to which he had now gone. This symbolic layering of sculptures is reminiscent of the original plans for the *Tomb of Pope Julius II*. The Medici tombs mix both pagan and Christian symbolism, elements of Classical architecture and Michelangelo's own innovative touch.

Interior of the Medici Chapel (1519–34)
Courtesy of The Bridgeman Art Library. (See p. 159)

MADONNA AND CHILD (1520–34)

Courtesy of AKG London/Erich Lessing

THE *Madonna and Child* statue sits opposite the altar in the Medici Chapel, flanked by statues of the Medici family's patron saints, *Cosmas* and *Damian*, which were not carved by Michelangelo. *Madonna and Child* is a larger work than the two saints beside it, and the figures of the two dukes, because it was originally designed to go on the double tomb of Lorenzo the Magnificent and his brother Giuliano. It was abandoned when Michelangelo returned to Rome and the marks of his chisel are still clear.

The Madonna is seated with her left leg crossed over her right, leaning back on her right arm as if to counterbalance the weight of her struggling child. She shares the same resigned, despondent expression as the Madonna of the *Pietà* in St Peter's (1497–99). She stares sadly past her son towards the floor, almost appearing unaware of the child. The child turns in his mother's lap so that his face can not be seen. This is a symbolic pose inferring that Jesus hides his face so that he does not see the mortality that surrounds him in this funeral chapel.

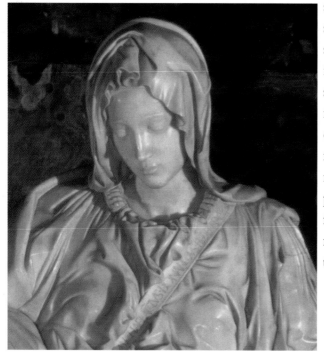

Detail of Pietà, St Peter's (1497–99)
Courtesy of The Bridgeman Art Library. (See p. 26)

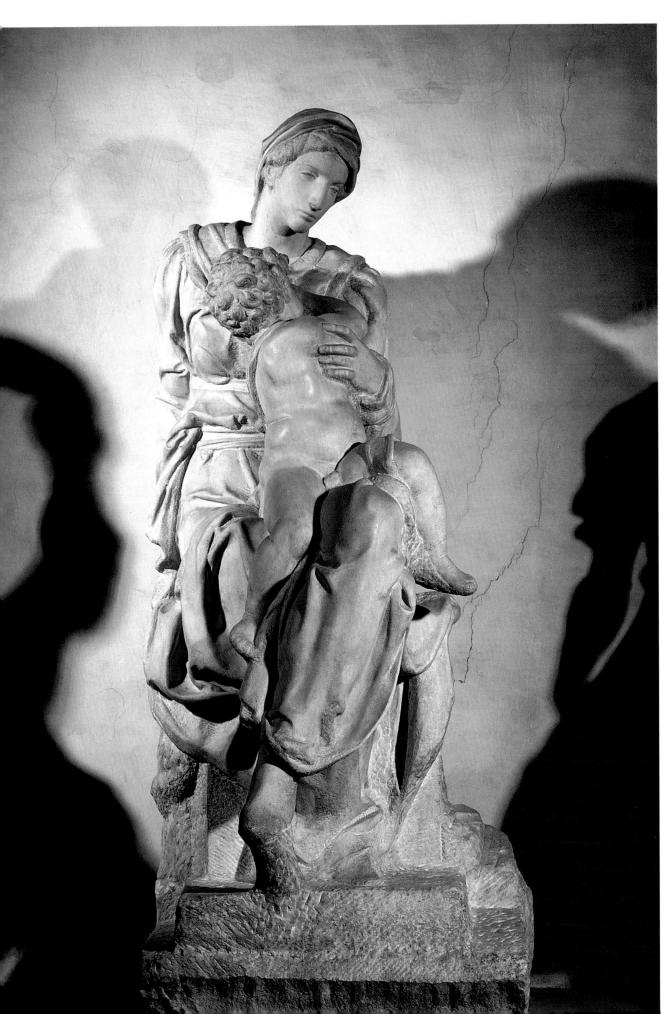

GIULIANO DE' MEDICI (1520–34)
Courtesy of The Bridgeman Art Library

PERCHED in an alcove above the figures of *Night* and *Day*, *Giuliano de' Medici* stares across to the *Madonna and Child* that sits opposite the altar. Michelangelo was criticized for not creating a more recognizable likeness; Giuliano is given curled hair and handsome features which have an idealized Classical origin. Of all the sculptures within the chapel, *Giuliano* is the only one that has been finished to such a high degree—his body armor was carved to the finest detail in every tassel and ribbon.

 Giuliano has the same pose as *Moses* in the *Tomb of Pope Julius II* (1505–45), with his head turned to one side while his body faces forward, the limbs positioned to leave the body open. This alert position gives the statue the impression that he is poised for action and ready to move from his niche.

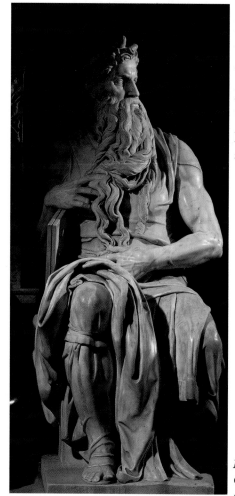

Giuliano, the Duke of Nemours, died in 1516. Along with Lorenzo, Duke of Urbino, he was the last direct ancestor of the patriarch Cosimo Medici, and so the connection to an illustrious past and years of patronage of the arts died with him.

Moses (1513–16)
Courtesy of AKG London / Erich Lessing.
(See p. 141)

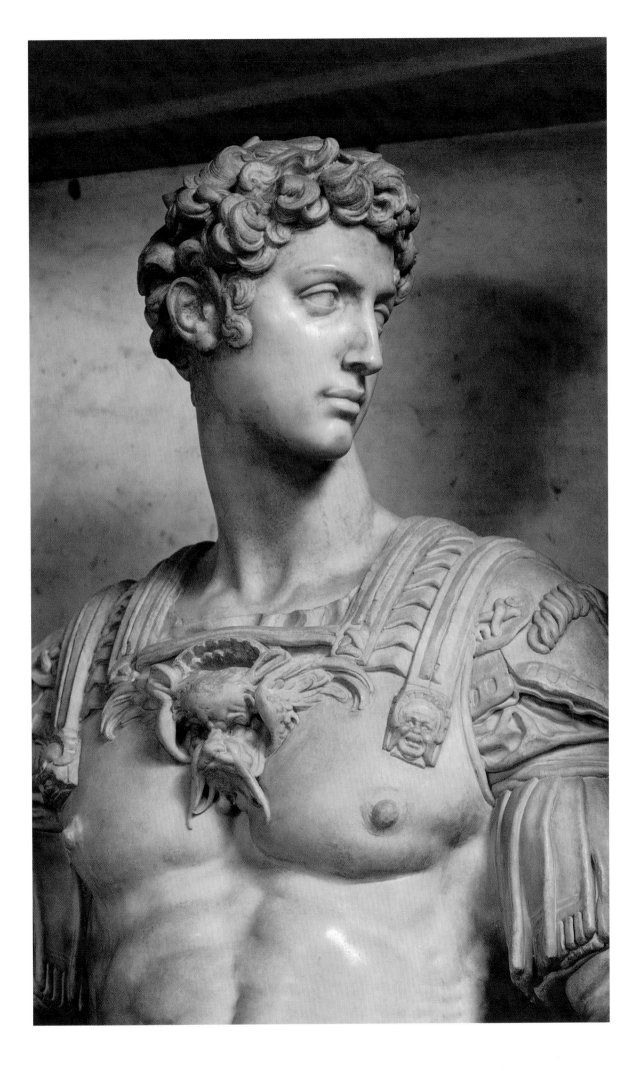

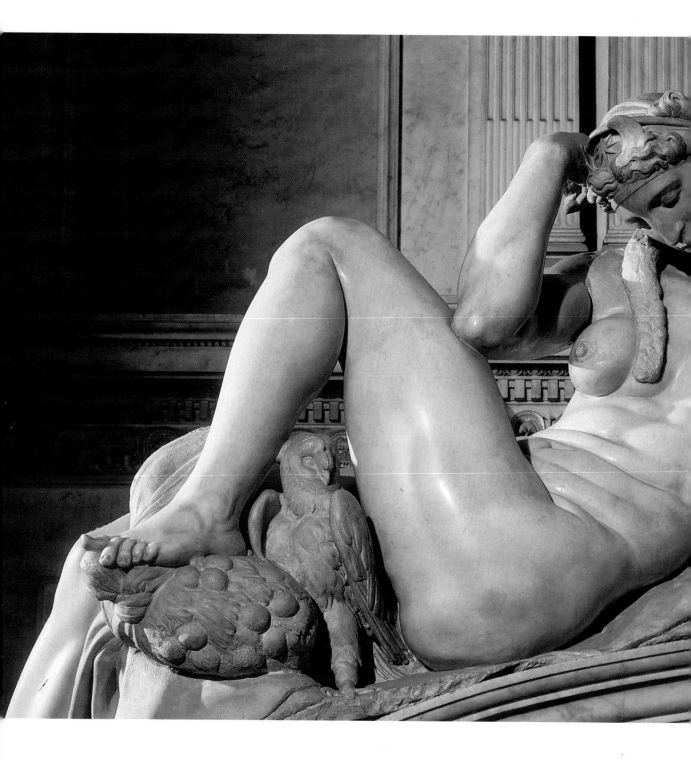

NIGHT (1520–34)

Courtesy of AKG London/Erich Lessing

THE figure of *Night* sits on the sarcophagus of Giuliano de' Medici. She lies with her eyes closed, as if asleep, her head bowed, resting against her hand. She wears a crown decorated with a moon and star. Crouched in the crook of her leg is an owl, a further allusion to the state of night. Night-time and sleep have long been poetically linked to—and used as euphemisms for—death, so the sculpture of *Night* is a particularly apt one for a funeral chapel.

This figure, although graceful and exquisitely poised, again shows Michelangelo's misunderstanding of the female form through the unrealistic, misshapen breasts of the statue, which are too far apart. As with the *Cumaean Sibyl* (1508–12), the flaw in his depiction of the female form can be blamed on the fact that he did not use female models in his work and probably never slept with a woman.

In response to admiration of the statue, Michelangelo wrote the following poem:

> *"Dear to me is sleep, and better to be stone,*
> *So long as shame and sorrow is our portion.*
> *Not to see, not to feel is my great fortune;*
> *Hence, do not wake me; hush, leave me alone."*

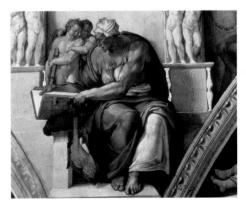

The Cumaean Sibyl (1508–12)
Courtesy of The Bridgeman Art Library. (See p. 112)

DAY (1520–34)

Courtesy of AKG London / S. Domingie-M. Rabatti

THE partner to the statue of the slumbering *Night* is the ponderous figure of *Day*. With his huge head raised to look over one muscular shoulder, *Day* echoes the impression of alertness that *Giuliano* above him gives. His posture is the opposite of his partner *Night*: where her legs are closed to the viewer and her chest is open, *Day's* legs are open and the chest is closed. These postures reflect the different attributes of the sculptures; in sleep we are exposed and vulnerable while awake we can control our vulnerabilities.

Day is sitting in a complicated, crossed, and twisted position; his left arm can be seen behind his back, the hand pointed towards the viewer. This huge figure seems impossibly balanced upon the sarcophagi, as if he is in danger of sliding off. As with all of the statues on top of the tombs, *Day's* feet hang precariously over the edge. The base of the statue remains rough and unfinished, in contrast to the smooth limbs and torso. A further more noticeable contrast lies in the unfinished head of the piece, only barely formed, seeming to suggest in stone the vagaries of light and the ambiguity of time, reminiscent of the face of the *Bearded Slave* (1520–30).

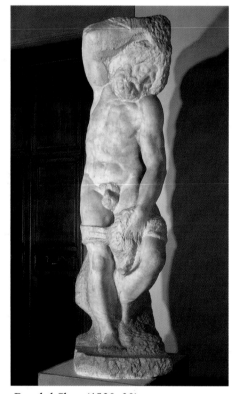

Bearded Slave (1520–30)
Courtesy of The Bridgeman Art Library.
(See p. 148)

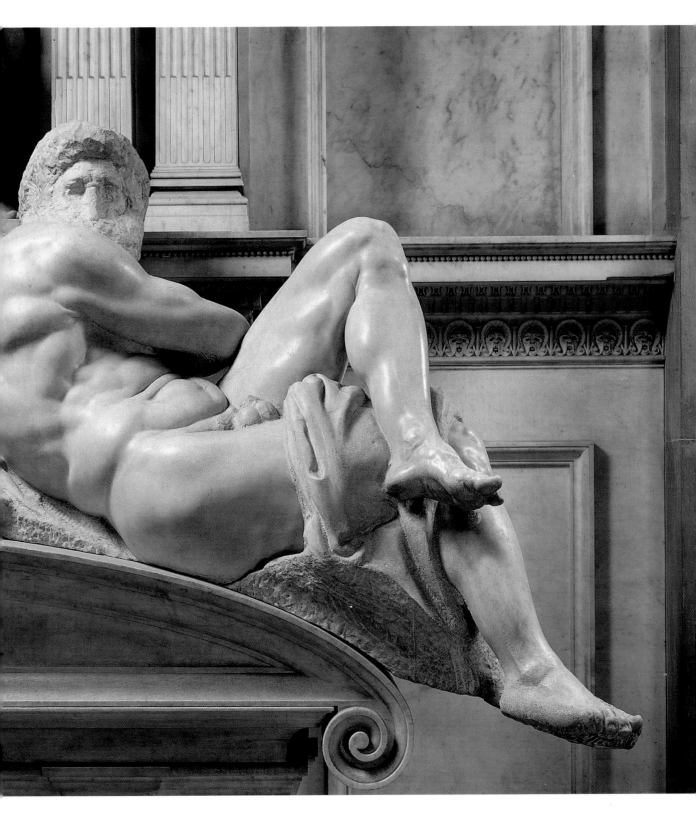

LORENZO OF URBINO (1520–34)

Courtesy of AKG London/S. Domingie-M. Rabatti

*L*ORENZO of Urbino, like *Giuliano of Nemours*, sits in his niche with his gaze directed towards *Madonna and Child* (1520–34). As Giuliano is alert and appearing ready to move towards the Madonna, Lorenzo's pose is somber and introverted. He has one hand to his mouth and his head is bowed, as if he is deep in thought as he gazes at the Madonna. The *Madonna and Child* was originally planned to adorn the tombs of Lorenzo the Magnificent, the grandfather of the two dukes, and his brother Giuliano, so the fact that they are both gazing in that direction may have as much to do with deference towards their ancestors as religious piety.

Michelangelo again used Classical idealized features on the statue, rather than attempting a likeness of the duke. The slightly larger figure of Lorenzo sits less easily than Giuliano within the confines of his niche; his posture means that he takes up more space. *Lorenzo of Urbino* also shares the Roman body armor of his counterpart. His helmet is positioned low on his head so that his eyes are almost lost within the shadows of the niche he occupies.

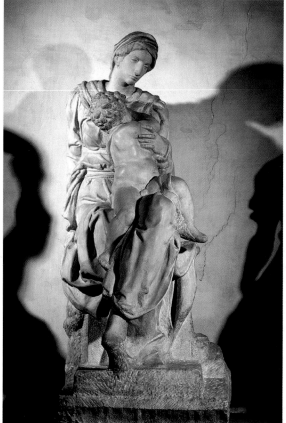

Madonna and Child (1520–34)
Courtesy of AKG London/Erich Lessing. (See p. 164)

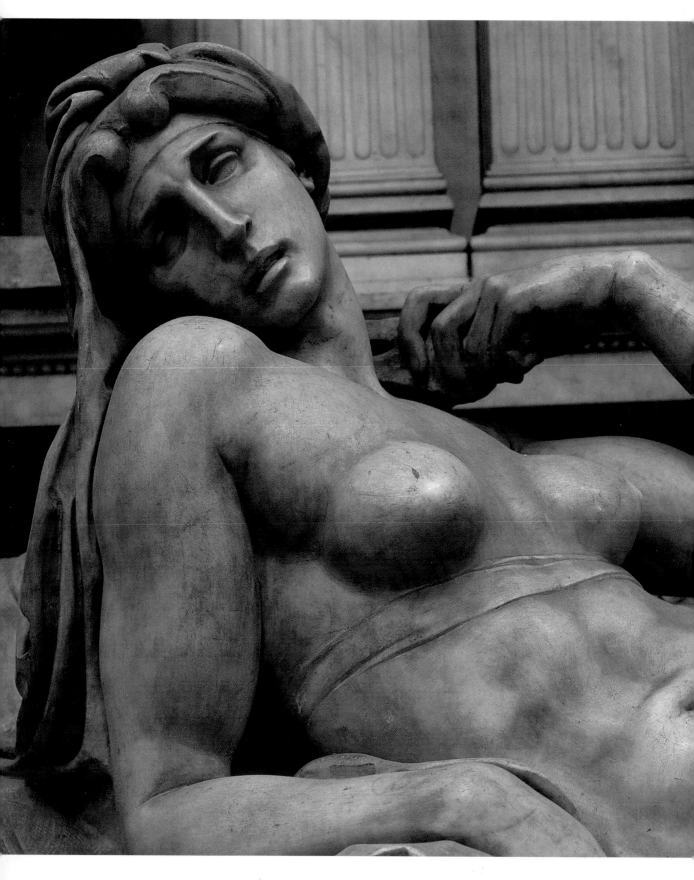

DAWN (1520–34)

Courtesy of AKG London/Erich Lessing

To reflect the representation of *Lorenzo of Urbino* as contemplative, Michelangelo placed the figures of *Dawn* and *Dusk* underneath the statue. The personification of these indeterminate, hazy times of day, act to symbolize the hesitant, inactive nature of Lorenzo as Contemplative life. To emphasize the aspects of *Dawn* and *Dusk,* the original lighting in the chapel was dimmed by the use of shaded windows on the side of Lorenzo's tomb. These shadings have since been removed so that light in the chapel is now consistent.

Dawn exudes a most baleful air. Seemingly full of woe, she also appears confused, as if she has just awoken and is bitterly disappointed to be in a conscious state again. The band around *Dawn*'s chest and the veil on her head were both signs of mourning which, together with her expression of dismay, gives us the impression that she is in the throes of grief. Perhaps *Dawn* is grieving over the death of Lorenzo, whose sarcophagus she reclines upon, or maybe she grieves over the existence and inevitability of death itself. *Dawn* opens her eyes from her disturbed dreams to see the symbol of death, *Night*, as she lies asleep on the tomb opposite her.

***Night* (1520–34)**
Courtesy of AKG London/Erich Lessing. (See p. 169)

DUSK (1520–34)

Courtesy of AKG London/S. Domingie-M. Rabatti

*D*USK, like the statue of *Day*, may be incomplete. The body has been highly finished and the smooth marble is polished, but his face is still pitted with the marks of Michelangelo's chisel. This lack of finish does nothing to detract from the magnificence of Michelangelo's creation.

Dusk lies with his legs stretched out in front of him and his arms relaxed down by his sides in an open posture, leaving his body softened and exposed. His partner *Dawn* shares this position and both figures act to contrast the contorted poses of *Night* and *Day* that appear opposite them. Both *Dawn* and *Dusk* seem even more precariously balanced upon the sarcophagi than the figures of *Night* and *Day* do, as their relaxed legs extend further over the edge.

The age of *Dusk* reflects the time of day he represents, while the figure of *Dawn* is young. *Dusk*'s head is bowed, *Dawn*'s uplifted—is alluding to the rising and setting of the sun. The four statues represent the inexorable passing of time and the inevitability of death.

Day (1520–34)
Courtesy of AKG London/S. Domingie-
M. Rabatti. (See p. 170)

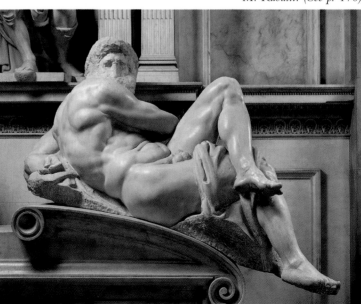

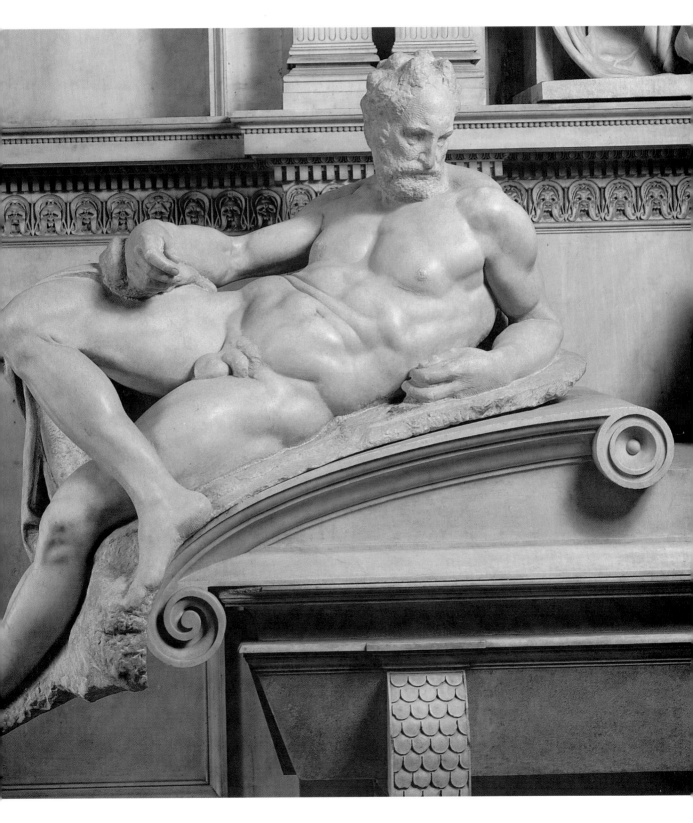

LAURENTIAN LIBRARY, READING ROOM (C. 1524–34)

Courtesy of The Bridgeman Art Library

*T*HE Medici family were not only great collectors of art, between them they had also compiled an extensive library of precious books and rare manuscripts. In 1519, the Medicean Pope Clement VII decided that a suitably grand library should be built to house this collection, which had been started by Cosimo de' Medici during the 15th century.

The design of the Laurentian Library above the refectory in the San Lorenzo monastery followed that of the library in San Marco convent, also in Florence. Situating a library on the upper floor of the building meant that the natural lighting was improved and any potential damage from damp was limited.

As the library was to be built on top of the existing refectory as an extra story, it was necessary to make the structure as light as possible in order to minimize the strain on the building below. The walls of the reading room are very thin, painted in a white stucco. Michelangelo used the same *pietra serena* sandstone for the supporting structures, pilasters, cornices, and window frames of the reading room that he used in the Medici Chapel (1519–34). The tilted, ornate wooden desks were also designed by Michelangelo.

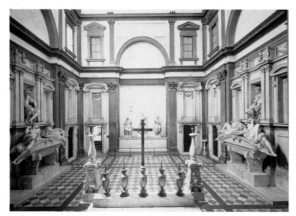

Interior of the Medici Chapel (1519–34)
Courtesy of The Bridgeman Art Library. (See p. 159)

LAURENTIAN LIBRARY, STAIRCASE (C. 1524–34)

Courtesy of The Bridgeman Art Library

*T*HE entrance hall, or vestibule, of the Laurentian Library is higher than the long, narrow reading room. Michelangelo chose the same *pietra serena* sandstone to accentuate the supporting structures and the same contrasting white stucco walls that he used for the reading room. The thick columns set into niches along the walls and beside the entry door may look purely decorative but are in fact essential, weight-bearing structures.

Work on the library began in 1524, but the staircase was completed much later. There are studies by Michelangelo which record the development of his ideas for the staircase, which was originally planned as two side stairs that would meet centrally, similar to the grand staircase that he later designed for the Senate in the *Piazza del Campidoglio* (*c.* 1538) in Rome.

The staircase could easily have been just the one central flight; the addition of the two rectangular flanking flights of stairs that stop abruptly two-thirds of the way up, gives the staircase the

***Piazza del Campidoglio* (c. 1538)**
Courtesy of The Bridgeman Art Library. (See p. 218)

illusion of spilling, or flowing freely from the entry door to the floor below. The three middle-bottom steps are oval and the steps above curve along their outer edge so that they echo this unusual oval design.

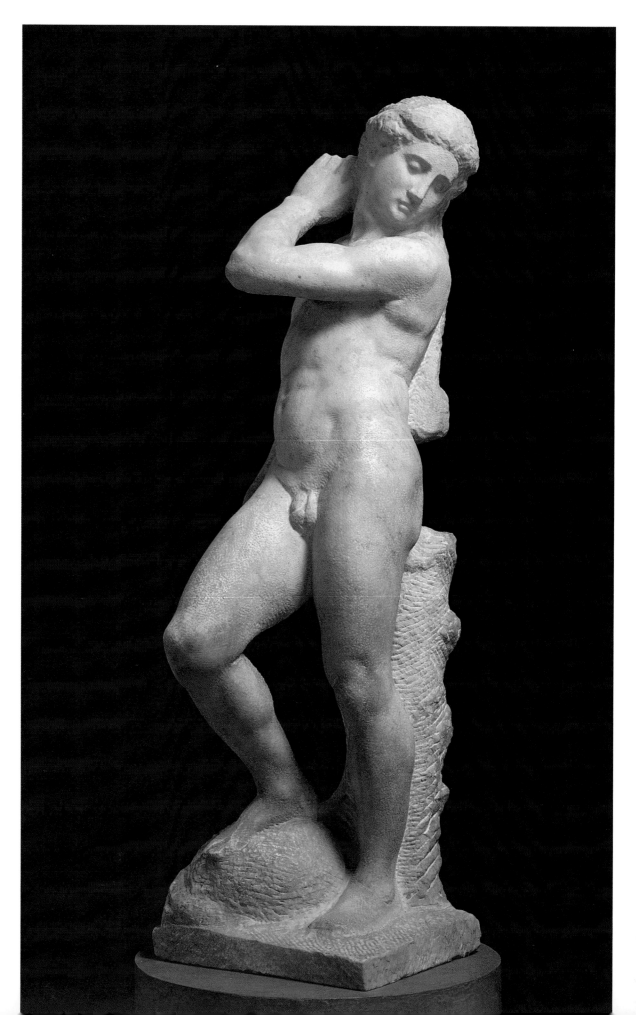

APOLLO (C. 1530)

Courtesy of The Bridgeman Art Library

SOMETIMES alternatively called *David*, Michelangelo began this statue of *Apollo* between the years 1528 and 1530, for Baccio Valori, who was a political nominee of the Medici family. In 1530 they fought to regain power over the city of Florence from the republican government that had formed after they were expelled in 1527. Michelangelo had allied with the Florentine republicans and helped their cause by building fortifications for the besieged city and consequently was not popular with the Medici. *Apollo* may have been a diplomatic commission to appease any feelings of resentment that Valori held against Michelangelo. The piece was left in an unfinished state when he returned to Rome following the death of his father in 1534; it was never completed.

The sculpture employs a twisting form, a lesser *figura serpentinata* than *Victory* (1519–34), but still evidently serpentine—from the bent leg through to the tilt of the torso and the turn of the head. The artist had explored bodies in twisted movement with the *Ignudi* (1508–12) in the Sistine Chapel and in much of his sculpture.

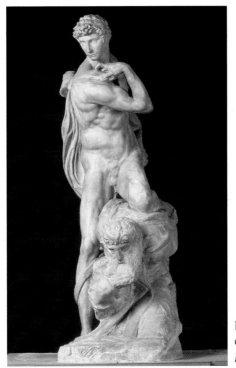

***Victory* (1519–30)**
Courtesy of The Bridgeman Art Library. (See p. 153)

DETAIL FROM APOLLO (C. 1530)

Courtesy of The Bridgeman Art Library

GIORGIO Vasari, a biographer of Michelangelo, claimed that the unfinished *Apollo* has one arm raised to reach and pull out an arrows from a bag that was to be positioned on his back. Seen from this angle, there is a noticeable block of marble still remaining unformed but unremoved across and down Apollo's shoulder, which could possibly have been intended to be a bag of arrows.

When *Apollo* is seen in entirety, the lack of finish of the sculpture does not detract from the graceful, liquid stance and the perfect naturalism used for the body of the god. Observed in detail, however, the lack of finish becomes more obtrusive. The head of *Apollo* is pitted with Michelangelo's chisel marks. His features are lacking in expression and character, his eyes sealed blindly shut.

The face of the bearded man in the statue of *Victory* (1519–30) has been completed to a much higher degree than *Apollo*. In comparison, it becomes clear that the facial expressions of Michelangelo's marble statues were created at a late stage in their metamorphosis.

Head (Detail from Victory) (1519–30)
Courtesy of The Bridgeman Art Library.
(See p. 154)

HERCULES AND CACUS (1525–28)

Courtesy of The Bridgeman Art Library

*I*N Classical mythology, Cacus, the son of Vulcan, stole Hercules's cattle, hiding their destination by dragging them by their tails. Upon finding his herd, Hercules fought and strangled Cacus. This is a classic tale of good triumphing over evil, and the piece was commissioned by the Signoria (republican governors) of Florence following the ousting of the Medici family in 1527. Likewise *David* had been commissioned following the republican uprisings of 1494, and it was intended that the two pieces should be placed together as a permanent reference to the might of the the republic over the fallen Medici.

The block of marble intended for the piece had been quarried in Carrara before 1508 and was assigned to Michelangelo. He never used this marble as it was later given to Baccio Bandinelli (1493–1560), an arch-rival of Michelangelo, who made the flawed *Hercules and Cacus* that now stands in front of the Palazzo Vecchio in Florence.

Michelangelo usually used small, three-dimensional models in wax and clay as part of his sketching process. This figure of *Hercules and Cacus* shows that Michelangelo intended to create a statue to be viewed from every angle. The arm of Cacus wraps around the legs of Hercules, whose legs point in the same direction, encouraging the viewer to walk around the piece.

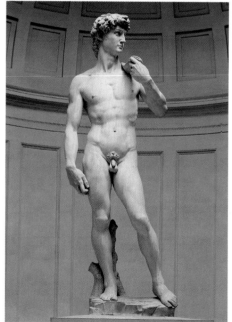

David (1501–04)
Courtesy of AKG/Erich Lessing. (See p. 31)

IDEAL HEAD (C. 1533)
Courtesy of The Bridgeman Art Library

THE *Ideal Head* is one of many drawings made by Michelangelo for his friend and probable lover, Tommaso de' Cavalieri, a beautiful young nobleman. He was one of the few people that Michelangelo drew, claiming that most people's features were too imperfect, but Cavalieri's beauty made him exceptional. The drawings were intended to help Cavalieri as an artist, so that he could study the master's hand. *Ideal Head* is a black-and-red chalk drawing of Michelangelo's concept of the ideal of beauty. The features are drawn from his imagination, as with the similar drawing of *Zenobia* (*c.* 1533).

During Michelangelo's lifetime, love (platonic or otherwise) between men was not deemed as subversive as it was by the end of the century; even so there were caustic comments about his affections for the young nobleman. His poems to Cavalieri were altered by later publishers to decrease the amorous affection within them, in lines such as:

"Your will includes and is the lord of mine;
Life to my thoughts within your heart is given;
My words begin to breathe upon your breath:
Like to the moon am I, that cannot shine
Alone."

Zenobia, Queen of Palmyra (c. 1533)
Courtesy of The Bridgeman Art Library.
(See p. 194)

THE DREAM OF HUMAN LIFE (C. 1533–34)

Courtesy of The Bridgeman Art Library

ANOTHER drawing made for Tommaso de' Cavalieri, *The Dream of Human Life* dates from around 1533–34. The drawing's connotation is unknown. The sleeping man in the foreground reclines against a box full of theatrical masks, one of which is a mask of old age with a long, flowing beard. On top of the box the man leans against a globe that appears to represent the world. From the sky, a winged angel blows a trumpet into the ear of the man; it is the figure of fame calling to him.

***The Fall of Phaeton* (*c.* 1533)**
Courtesy of The Bridgeman Art Library. (See p. 197)

In a circle around the dreaming figure are brief sketches that each portray one of the deadly sins. Greed (avarice) appears as a pair of hands holding a bag of money. To the left, a couple are seen in an embrace, personifying Lust. Only six of the seven sins have been portrayed and so it has been suggested that the dreaming man represents the missing sin of Pride, as he is holding the world possessively and also controls the illusionary masks.

As with the figure of Eridamius in the *Fall of Phaeton* (*c.* 1533), the dreamer appears to be old, with a thick-set waist, which perhaps represents the artist's own increasing years.

STUDY OF A MAN SHOUTING (C. 1533)

Courtesy of The Bridgeman Art Library

*T*HE *Study of a Man Shouting* is a good example to art students on how to create vivid and intense expressions. The sketch shows in great detail the movement of every muscle that takes place when shouting. The veins on the man's neck stand out angrily, as does his Adam's apple. The muscles on his forehead are clenched together in a frown. Michelangelo evoked the form of the face using charcoal as a medium.

By drawing material and hair swirling as if they are being blown around the man's face, Michelangelo has given the impression that he is attempting to shout into a violent wind. This is a simple device that was used on the Sistine Chapel ceiling to create the illusion of movement or, as with the *Delphic Sibyl* (1508–12) to give the idea of a foreboding wind blowing through the scene.

The fierce facial expression that many of Michelangelo's older men wear, also seen in the *The Creation of the Plants, and the Sun, and the Moon* (1508–12), has been termed the *terribilatia*, and is generally interpreted as a reflection of Michelangelo's own tormented, turbulent emotions.

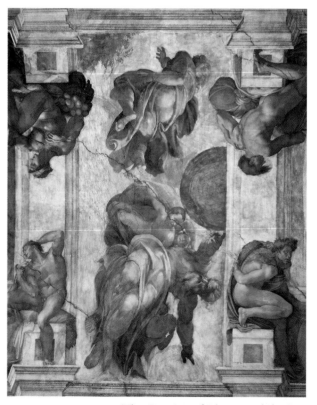

The Creation of Plants, and the Sun and the Moon (1508–12)
Courtesy of The Bridgeman Art Library. (See p. 67)

ZENOBIA, QUEEN OF PALMYRA (C. 1533)

Courtesy of The Bridgeman Art Library

ESPITE his meticulous attention to the detail and form of the body, Michelangelo most frequently created his faces with idealized features. The artist rarely made portraits or took facial characters from his models, saying that no one would remember the true details of these faces in a thousand years. Instead he preferred to create his version of a perfect or ideal face, with symmetrical, aligned features and Classical beauty. This is typified in the face of *David* (1501–04), which itself is reminiscent of Classical statues depicting Greek athletes, and is also demonstrated in the drawing of *Zenobia*.

Made using charcoal on paper, *Zenobia* is another example of the drawings that Michelangelo made for Tommaso de' Cavalieri. Facially Zenobia bears much resemblance to the *Ideal Head* (*c.* 1533), another drawing which in turn is much like the *Ignudi* (1508–12) in the Sistine Chapel. All three are drawn from Michelangelo's ideals of beauty.

Portrayed with exposed and impossibly positioned breasts, *Zenobia*'s face is typical of Michelangelo's women. The masculinity of her features gives Zenobia the appearance of a warrior queen, an impression enhanced by the decoration on her head and her fierce stare.

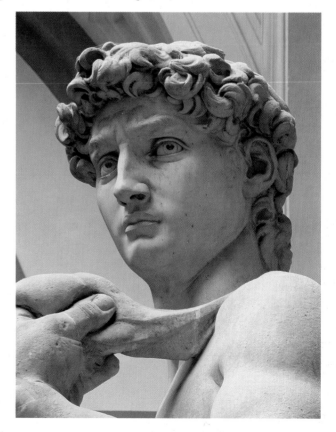

Face (Detail from David) (1501–04)
Courtesy of AKG/
S. Domingie-M. Rabatti. (See p. 32)

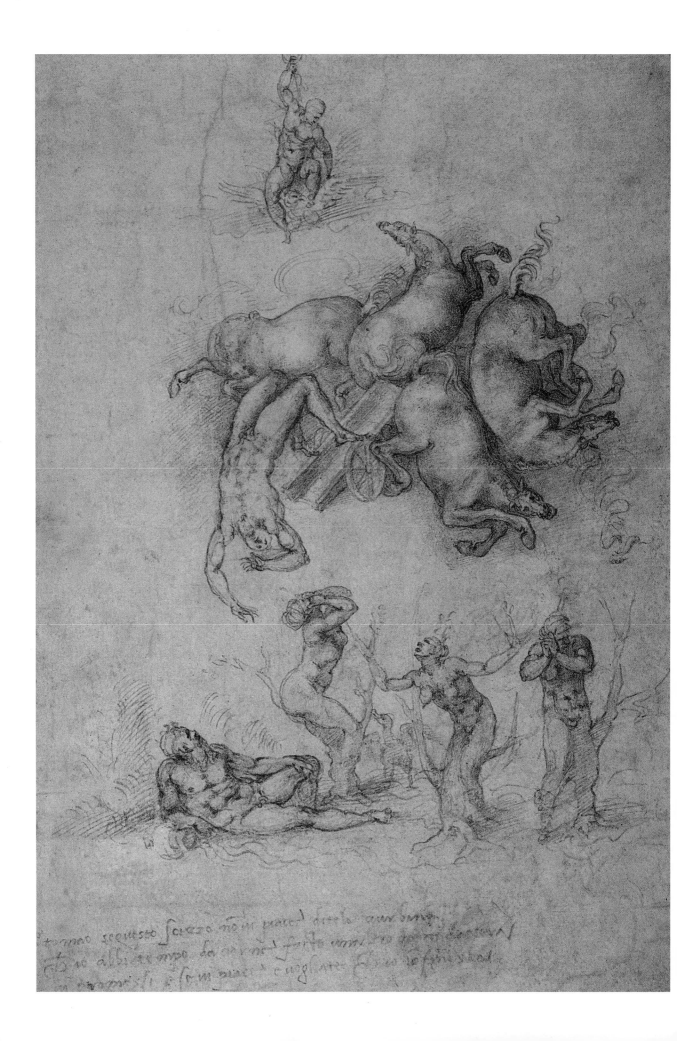

THE FALL OF PHAETON (C. 1533)
Courtesy of The Bridgeman Art Library

*L*IKE the *Ideal Head* (*c*. 1533) this sketch is another Cavalieri drawing. *The Fall of Phaeton* illustrates the Classical myth of Phaeton, seen here tumbling out of his cart, as told in Ovid's *Metamorphosis*. Michelangelo drew three versions of *The Fall of Phaeton* and each is given three layers of figures that form a triangle against a blank background.

Phaeton was the son of Phoebus, the god who mistakenly allowed his son to ride the Chariot of the Sun. Phaeton drove the cart so badly that he was in danger of destroying Heaven and Earth. To stop the impending disaster Zeus, seen at the top of the drawing riding upon a great bird, had to kill Phaeton with a thunderbolt.

The three women at the bottom are Phaeton's sisters, the weeping Heliades. Zeus transformed these three into poplar trees; their legs have taken the shape of tree trunks, while their arms are changing into branches. Phaeton's friend Cygnus has already been transformed into a swan, flapping his huge wings behind the sisters. At the bottom of the sketch, the reclining figure of the river god Eridamius calmly looks up to see the body of Phaeton hurtling towards him.

Ideal Head (c. 1533)
Courtesy of The Bridgeman Art Library. (See p. 188)

VANITY

Courtesy of The Bridgeman Art Library

MICHELANGELO'S drawings and rough sketches tell us a great deal about his techniques and superb draftsmanship. The figures in *Vanity* are formed using the technique of cross-hatching, using many fines lines that mesh together and concentrate in certain areas to create shade and delineate form. This was a technique that Michelangelo also employed in his sculpture. *Vanity* shares the topic of the deadly sins with *The Dream of Human Life* (*c.* 1533–34), although only the one sin is shown here. Vanity is portrayed here by a woman who sits staring at her reflection in a mirror, oblivious of the children that play around her. Vanity must have been an incomprehensible attribute for Michelangelo, who rarely spent money on clothes or material possessions. He lived meagerly, giving much of his earnings to his family and friends. Towards the end of his life he told his friend and biographer Condivi that, "however rich I may have been I have always lived like a poor man." He often slept in his clothes and boots, not removing them for long periods of time, stating that he preferred to keep them on because if he did take them off his "skin came away like a snake with the boots."

The Dream of Human Life (*c.* **1533–34**)
Courtesy of The Bridgeman Art Library. (See p. 191)

SKETCH OF A MALE HEAD AND TWO LEGS (C. 1536)
Courtesy of The Bridgeman Art Library

*T*HIS charcoal sketch demonstrates Michelangelo's frugality. As with all his material possessions, he was very careful with the amount of paper he used, making as much use as possible out of any one piece. Here he has taken up the main part of the paper with a sketch of a grizzled, old man in profile, while beneath are two brief sketches of legs, bent at the knee as if the leg is in a lunging position.

The face has sunken cheeks, insinuated by a dab of shading. The protruding frown of the brow, the heavy bags underneath the small eyes, and the down-turned mouth with a slight overbite all create a disgruntled, irritated expression on the man's face. It is thought that this might be a self-portrait. All these facial features, together with the misshapen nose, are reminiscent of a description of Michelangelo, and the face does indeed bear more than a passing resemblance to him. As a teenager, his nose was broken by a fellow apprentice at the Medici court after being taunted by him. Michelangelo added a few self-portraits within some of his works, such as *Study for the Holy Family* (c. 1533).

Study for The Holy Family
(c. 1553)
Courtesy of The Bridgeman Art Library. (See p. 242)

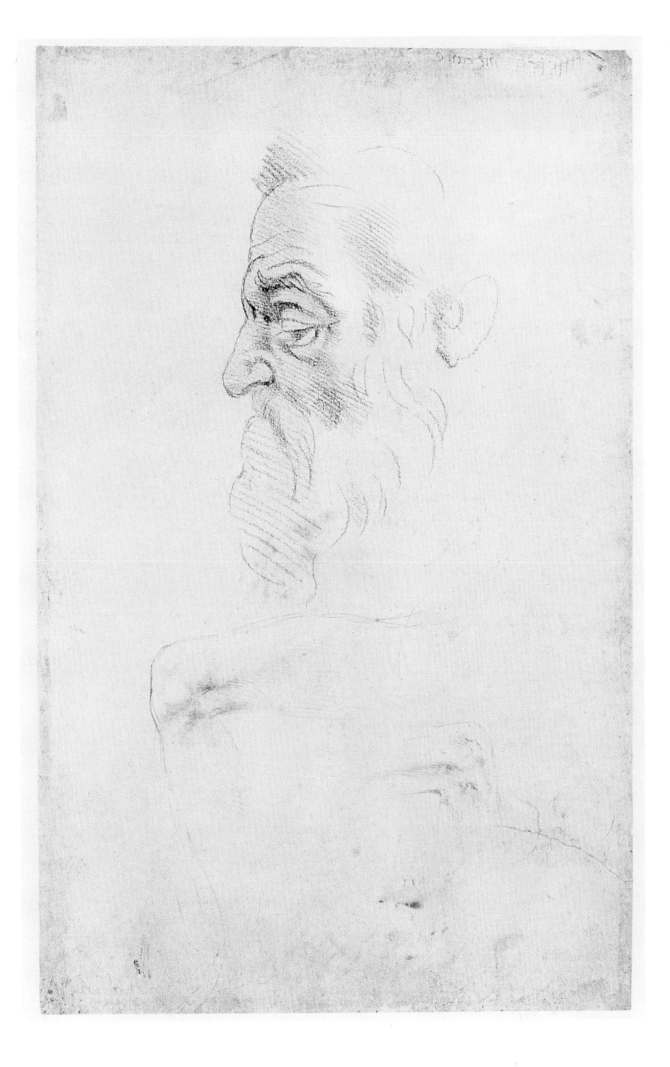

THE LAST JUDGMENT (1536–41)
Courtesy of AKG London

POPE JULIUS II had originally conceived the idea of covering the altar wall of the Sistine Chapel in St Peter's, Rome, with a depiction of the Resurrection of Christ, a theme that would have complimented the ceiling's overall theme of the creation and downfall of Man. The plans for the altar wall re-emerged following a fire which damaged the altarpiece by Pietro Perugino. Pope Paul III, who appointed Michelangelo as his chief painter, sculptor, and architect, gave him the commission for the fresco in 1534. At the time, Michelangelo was yet again trying to complete the doomed project of the *Tomb of Pope Julius II* (1505–45), but Paul III intervened, insisting that the artist should work on his projects instead.

The altar wall is 40 ft (12 m) wide by 45 ft (13.5 m) high, making *The Last Judgment* the largest single undivided work of art to be undertaken by a single individual. At what point the theme of the Resurrection became *The Last Judgment* is unclear, although it is most probable that Pope Paul III, a strong reformist, influenced the change. The theme was a fitting one for Rome, recovering as it was from several murderous attacks both on the city and on the papacy, that had led to famine, poverty, and plague.

DETAIL OF CHRIST FROM THE LAST JUDGMENT (1536–41)

Courtesy of Scala/Art Resource, New York

*T*HROUGHOUT the many representations of Christ that Michelangelo produced, most were either scenes of the crucifixion or of his death, as with the thin, bearded figure in the *Duomo Pietà* (c. 1547–55). In *The Last Judgment* we are shown neither a gentle nor a suffering Christ. Here, on the last day of the world, he has returned to earth to pronounce his judgment upon humanity as a muscular, beardless young man. Charged with a powerful energy that glows about him, he epitomizes the idea of a vengeful God.

Michelangelo has placed Christ centrally, near the top of the painting with the circular movement in the piece revolving around him. A dense ring of figures has formed about Christ; these are the souls that have already risen and are bound for Heaven. The massive figures closest to him are the saints and apostles. Those on the right of the picture underneath the saints are the dammed, and on the left the blessed. Almost hiding against Christ, beneath his right arm sits Mary, who is turning her head away as he raises one robust arm in the gesture of making his final judgment.

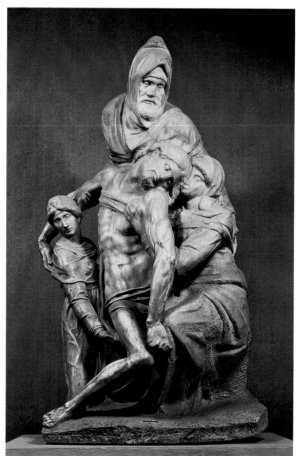

***Duomo Pietà** (c. 1547–55)*
Courtesy of AKG London. (See p. 238)

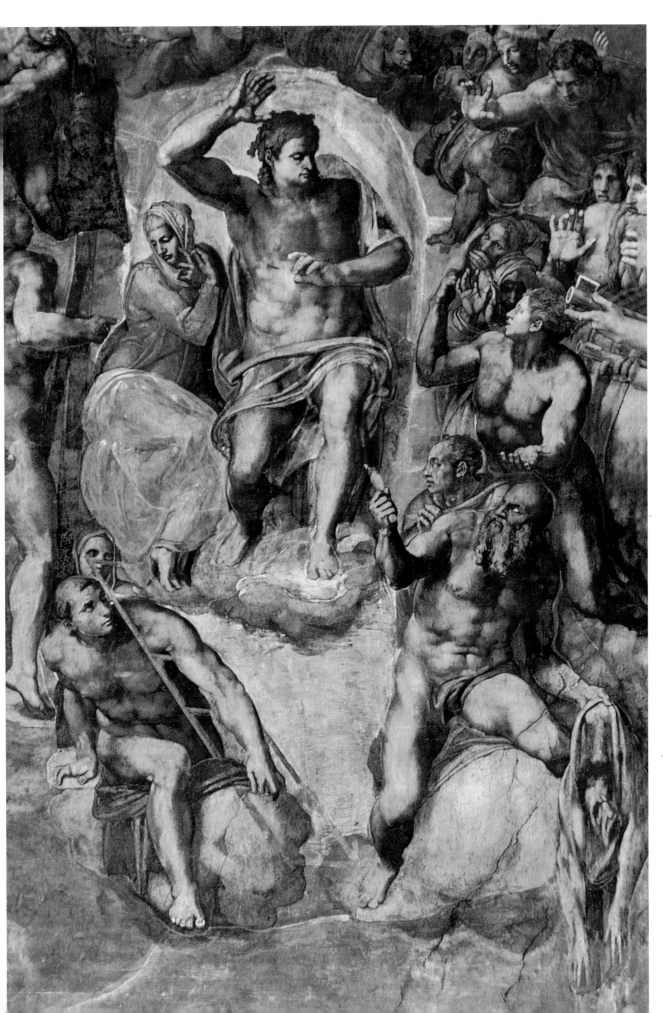

DETAIL OF THE BLESSED FROM THE LAST JUDGMENT (1536–41)

Courtesy of AKG London

WITHIN the mass of crowded figures in *The Last Judgment* there is much movement; bodies are seen struggling, fighting, and tumbling in various directions, but the whole painting has a definite sweeping circular movement which is clearly visible. The main motion within the piece begins on the bottom left, with the dead rising up from their graves, floating up to join the blessed on their ascent to Heaven, circling the figure of Christ, then swarming down with the sinners as they descend into Hell. This gives the huge fresco a sense of order.

Among the crowd of the blessed, some figures float upwards with no apparent effort, while most have to struggle to make their ascent or are pulled up by the figures standing on the clouds. On the right, a figure pulls two people up using a rosary, an obvious allusion to the salvation of prayer. The varying efforts of the blessed, while ensuring that the left side of the fresco did not appear static in comparison with the violent movement on the right, illustrates the belief that the path to heaven is a difficult one, although for a few it seems naturally easy.

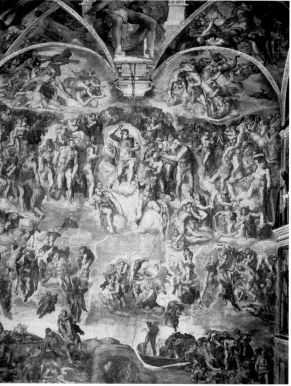

***The Last Judgement** (1536–41)*
Courtesy of AKG London. *(See p. 203)*

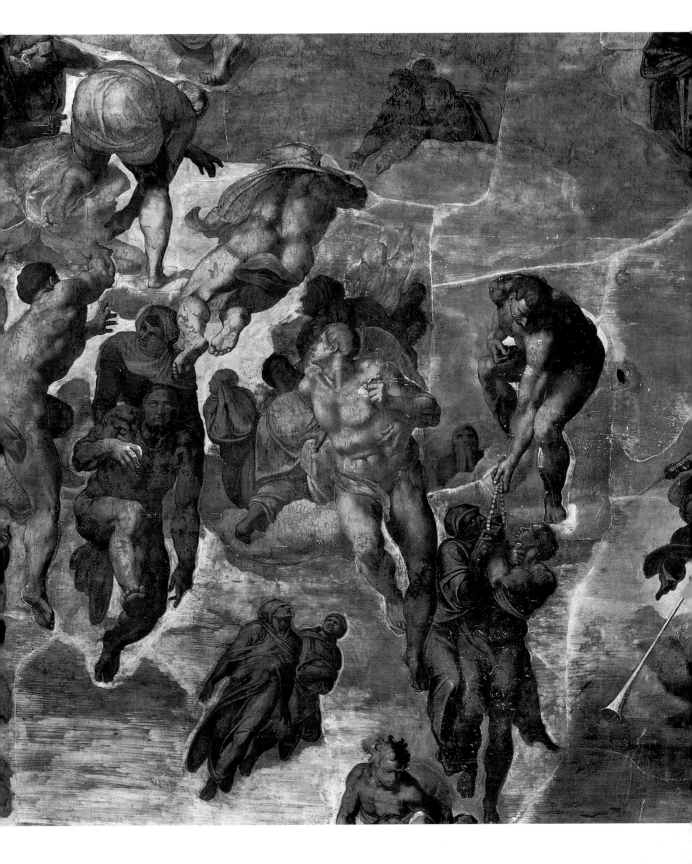

DETAIL OF ANGELS FROM THE LAST JUDGMENT (1536–41)

Courtesy of Scala/Art Resource, New York

AT the very top of *The Last Judgment* are two lunettes that once contained frescoes of the *Ancestors of Christ* by Michelangelo, but these were removed to gain more space for the dramatic vision of *The Last Judgment* to unfold. The lunettes now show flying angels that carry the objects of Christ's suffering. In the left lunette, an angel carries Christ's crown of thorns as he looks over his shoulder towards the angels that struggle to keep a hold of the cross. The angels' difficulty with carrying the cross, serving as a reminder to the congregation of Christ's burden and strength in carrying the cross alone.

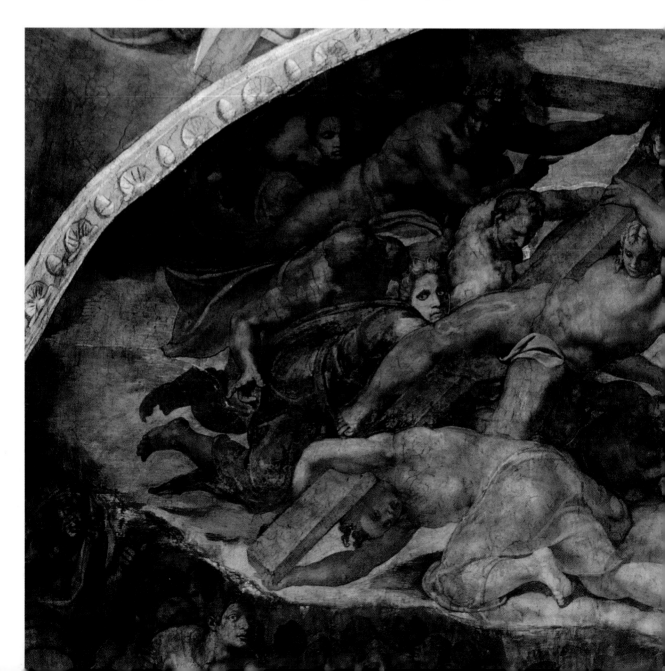

Above the lunettes are the two end spandrels of Michelangelo's ceiling fresco, the left illustrating *Esther and Haman* (1508–12) and on the right-hand side *The Brazen Serpent* (1508–12). Viewed from this angle, Michelangelo's staggering understanding of perspective becomes evident.

In between the spandrels is the massive figure of the prophet *Jonah* (1508–12), leaning back to stare up in awe at the sight of *The Separation of Light from Darkness* (1508–12). The original idea of a Resurrection fresco for the altar wall was apt as the figure of *Jonah* was himself resurrected after his encounter with the whale.

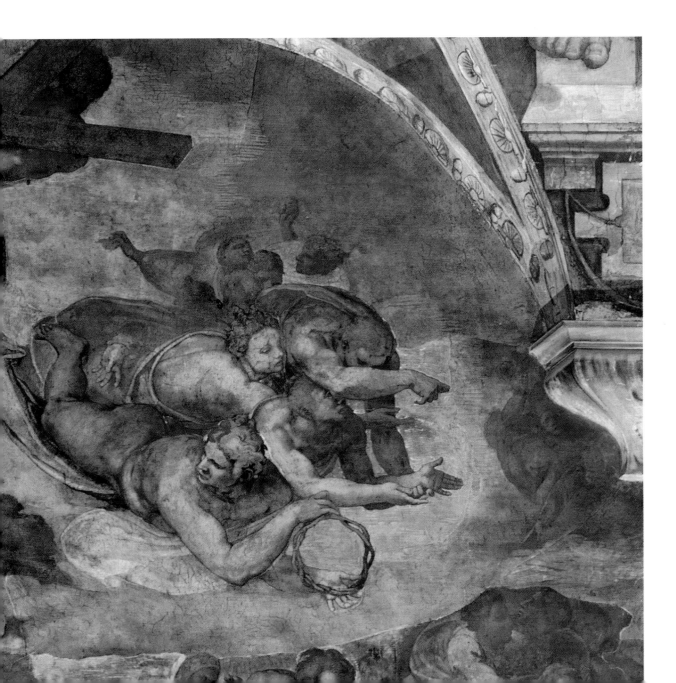

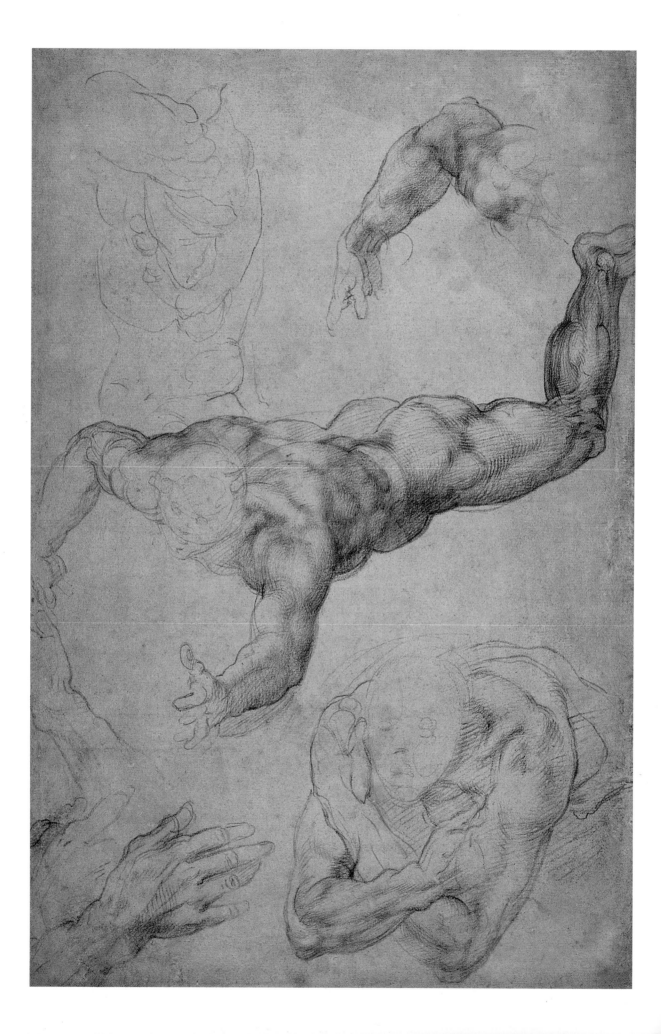

STUDIES FOR A FLYING ANGEL FOR
THE LAST JUDGMENT (1536–41)
Courtesy of The Bridgeman Art Library

MICHELANGELO employed the same preparatory habits for *The Last Judgment* fresco that he used while painting the ceiling frescos. Several studies have survived that demonstrate his habit of sketching a figure in the position envisioned, before copying this outline on to fresh plaster and then painting. He studied the movement of muscles that occurred in the chosen pose, as well as the perspective and shading necessary to portray the body in that position realistically.

This study is for the flying angel that appears in the right lunette of the fresco, moving towards the column that several angels are straining to hold. Michelangelo has drawn the main figure, then used the corners of the sheet of paper for additional considerations of the left arm and torso in order to create the perfect form.

The theme of *The Last Judgment* as Michelangelo has handled it, with the mass of flying, tumbling, twisting bodies, gave the artist an ideal arena to explore the varying movements and postures of a body in motion. Michelangelo once claimed that he never used the same pose twice, and the huge variety of figures in *The Last Judgment* would seem to back up this claim.

Detail of Angels from The Last Judgment (1536–41)
Courtesy of The Bridgeman Art Library. (See p. 208)

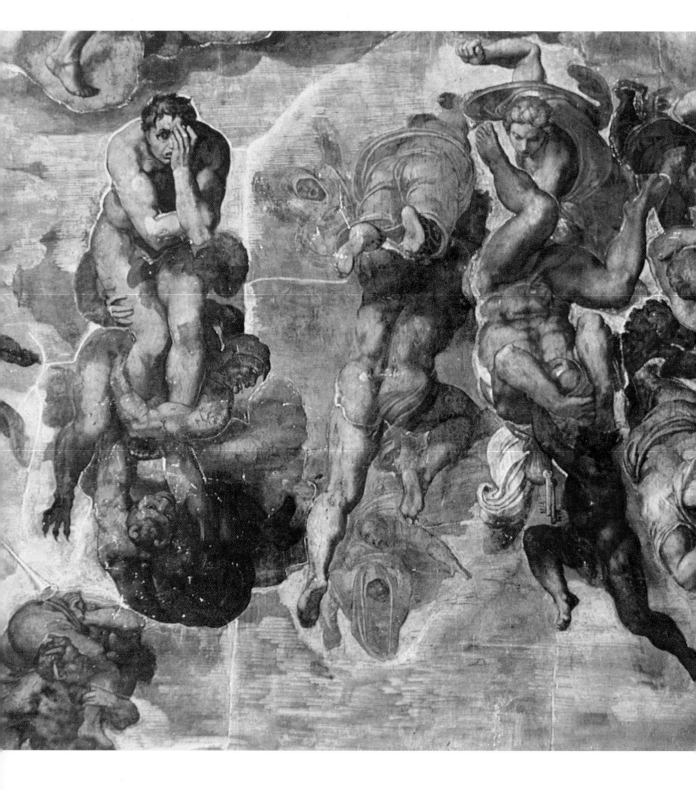

DETAIL OF THE SINNERS FROM THE LAST JUDGMENT (1536–41)
Courtesy of The Bridgeman Art Library

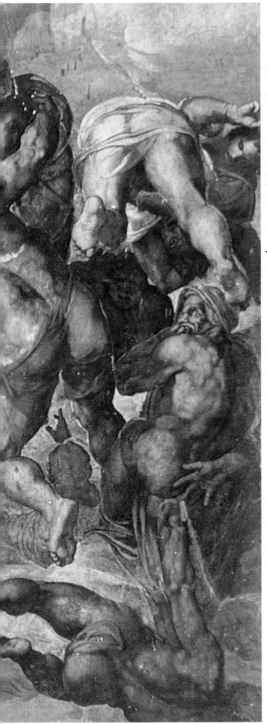

ON the far left, isolated from the throng of the dammed, a man holds one hand to his face as he is clasped by devils and dragged down to Hell. While the nearby figures fight with each other and the devils as they tumble towards the ground, this man offers no resistance, his anguished face showing the recognition of his fate. Beneath the man is a golden trumpet that belongs to the Seven Angels of the Apocalypse, who herald the arrival of the Judgment Day and hold the books that record the life of every individual so that all sinners can read and judge their sins for themselves. *The Last Judgment* shows a change in Michelangelo's compositions; the figures are heavy, bulky, and far removed from the beauty of form that Michelangelo strove to achieve in earlier works in the Sistine Chapel such as the *Ignudi* (1508–12). Michelangelo's chief concern had become the sharing of his religious vision.

From the moment of its unveiling in 1541, *The Last Judgment* had proved to be controversial, with criticism raised over the nudity of most figures. Shortly before Michelangelo's death, the decision was made to paint coverings on the figures.

DETAIL OF ST BARTHOLOMEW FROM THE LAST JUDGMENT (1536–41)

Courtesy of The Bridgeman Art Library

*T*HE saints appear huge, looming over the twisted masses beneath them. Their appearance is partly due to techniques of perspective: as they were painted higher up the wall, their size was increased so they would not appear too small to the viewer on the floor. Each of the saints holds the instruments of their martyrdom; here St Bartholomew sits astride a cloud holding his own skin—he was flayed to death.

As the saints look up towards Christ they thrust the tools of their martyrdom towards him, demanding recognition for their suffering. Although they are already among the blessed, it appears that the saints are fearful of Christ's judgments. Their expressive angst serves to increase the tensions within the piece.

The flayed, gray skin that St Bartholomew holds contains a self-portrait of Michelangelo. This ironic gesture proves to be prophetic when viewed in the light of the arguments that surrounded *The Last Judgment*. When he was asked by Pope Paul III to make the fresco "more suitable", following comments that it would be more fittingly displayed

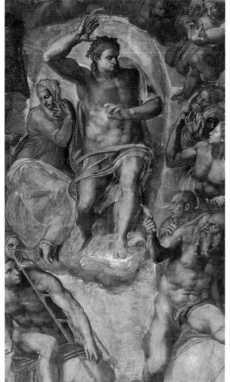

in a brothel, Michelangelo replied, "make the world a suitable place and the painting will follow suit."

Detail of Christ from *The Last Judgment* (1536–41)
Courtesy of The Bridgeman Art Library.
(See p. 204)

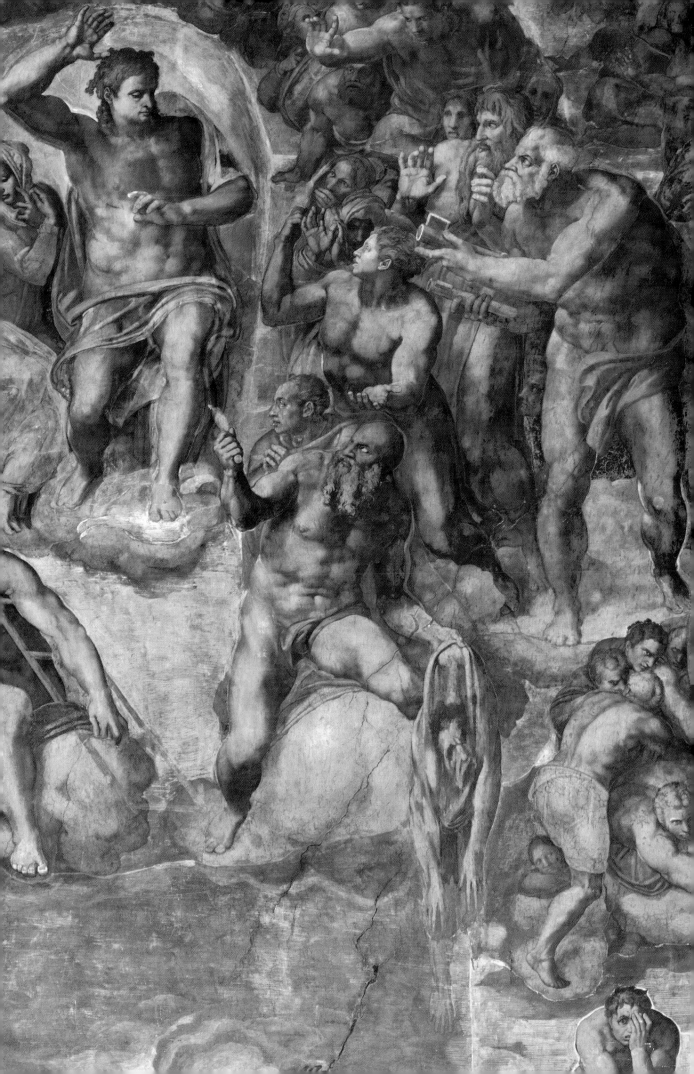

216

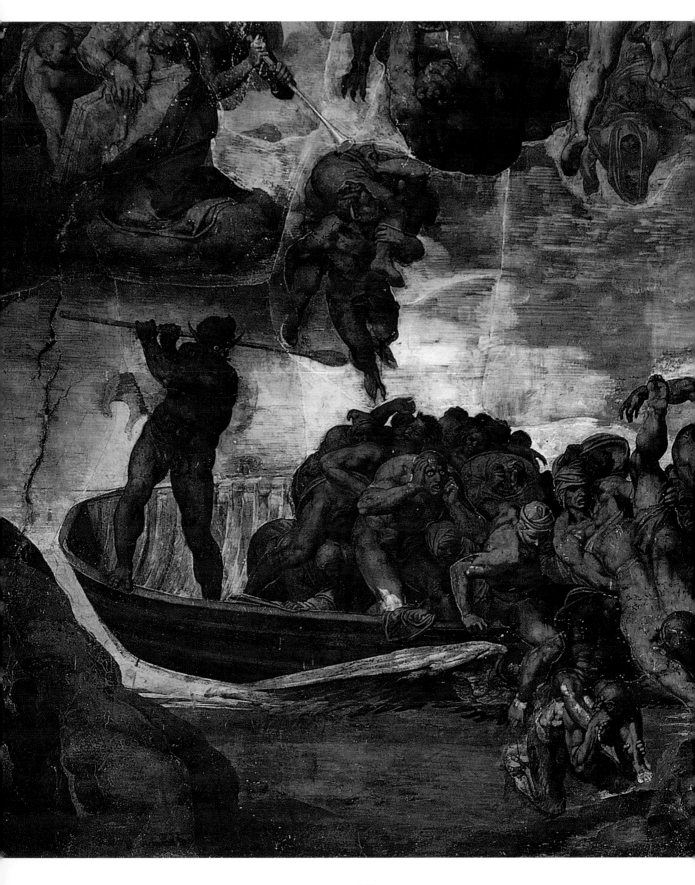

DETAIL OF CHARON FROM THE LAST JUDGMENT (1536–41)

Courtesy of The Bridgeman Art Library

MICHELANGELO'S affection for the literature of Danté Alighieri (1265–1321) is seen in the bottom right of *The Last Judgment*. On the far left of this detail is the figure of Charon, portrayed as Danté described him, standing in his boat with an oar raised about to strike. In Classical mythology, he was the ferryman of the dead over the marsh of Acheron; here he is the herder of the dammed in to Hell.

The devils in *The Last Judgment* are not portrayed as inhuman or demonic monsters; instead those that appear here have human form, albeit with the traditional horns and clawed feet. These devils, seen dragging struggling bodies down towards Charon, retain human form to emphasize the human failings of the sinners.

Before the fresco was completed, Pope Paul III's Master of Ceremonies, Biagio da Cesana, visited the fresco and complained upon seeing the amount of nudity, reporting that the work was obscene and unfitting for the chapel. In an act of revenge, Michelangelo painted a portrait of Cesana among the sinners in the far bottom right, with horns on his head and a snake entwined around him.

PIAZZA DEL CAMPIDOGLIO (C. 1538)

Courtesy of The Bridgeman Art Library

THE *Piazza del Campidoglio* sits upon the Capitoline Hill in Rome. While St Peter's is the heart of the religious center of the city, the Campidoglio is the heart of the civic center. Michelangelo's designs for the Campidoglio reclaimed Rome's glorious past; the Capitoline Hill was the center of the Roman Empire, but by the Renaissance it had fallen into ruins.

Michelangelo began working on the Piazza del Campidoglio in 1537–38. He was initially asked by Pope Paul III to create a new pedestal for the Classical statue of Emperor Marcus Aurelius. The statue was then placed in the center of the piazza and became the central focus of Michelangelo's plans, with an oval of patterned pavement spreading out around it, although the pavement was not completed to Michelangelo's design until the 20th century.

At the back of the piazza is the Senate building which was the Roman Tabularium; on the right is the 15th-century Palazzo Conservatori. To create symmetry within the piazza, Michelangelo designed a third palace on the left and façades for the Senate and the Conservatori. This idea of a symmetrical, balanced town center was novel at the time, yet it was perhaps Michelangelo's most influential architectural design and has been widely copied throughout the world.

St Peter's Basilica (**Begun 1546**)
Courtesy of The Bridgeman Art Library.
(See p. 253)

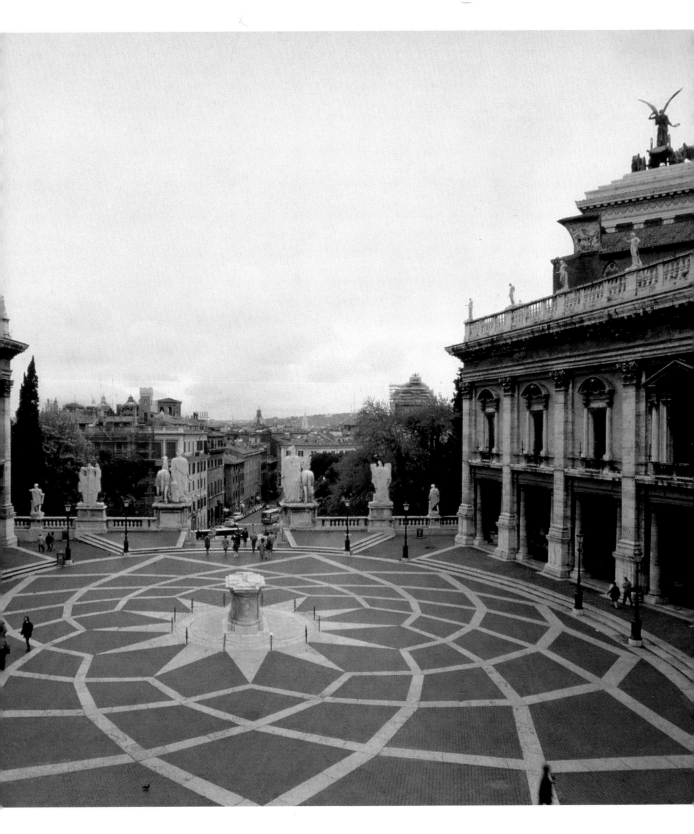

BUST OF BRUTUS (C. 1542)

Courtesy of AKG London / S. Domingie-M. Rabatti

WHILE still working on *The Last Judgment*, Michelangelo began to work on a marble bust in the Classical Roman Imperialist style that had previously been reserved for emperors and the wealthy. The bust was commissioned by a friend of Michelangelo who, like himself, had helped defend the city of Florence from the siege by the Medicis. It is thought that the bust may have been made to commemorate the murder of tyrannical Alessandro de' Medici by his cousin Lorenzino in 1537. Alessandro was hated by the Florentine exiles in Rome, who fled the city after the Medici regained their power, and his murder was likened to that of Caesar's by Brutus in 44 BC. An alternative inspiration is noted as an imperial portrait bust of the Roman emperor Caracalla, who reigned from 211–217 AD.

The features for the face were taken either from an ancient portrait believed either to be of Brutus or the bust of Caracalla. The piece is unfinished and as a result the thick neck appears strangely large if viewed from the front, set as it is against such finely draped robes. With the Classical Roman features and side profile, the bust bears some resemblance to the statue of *Giuliano de' Medici* (1520–34), but Brutus appears stronger, more determined, and lacks the slight arrogance seen in the face of Giuliano.

Giuliano de' Medici **(1520–34)**
Courtesy of The Bridgeman Art Library.
(See p. 166)

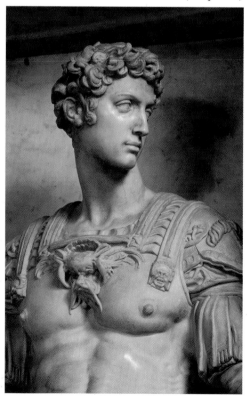

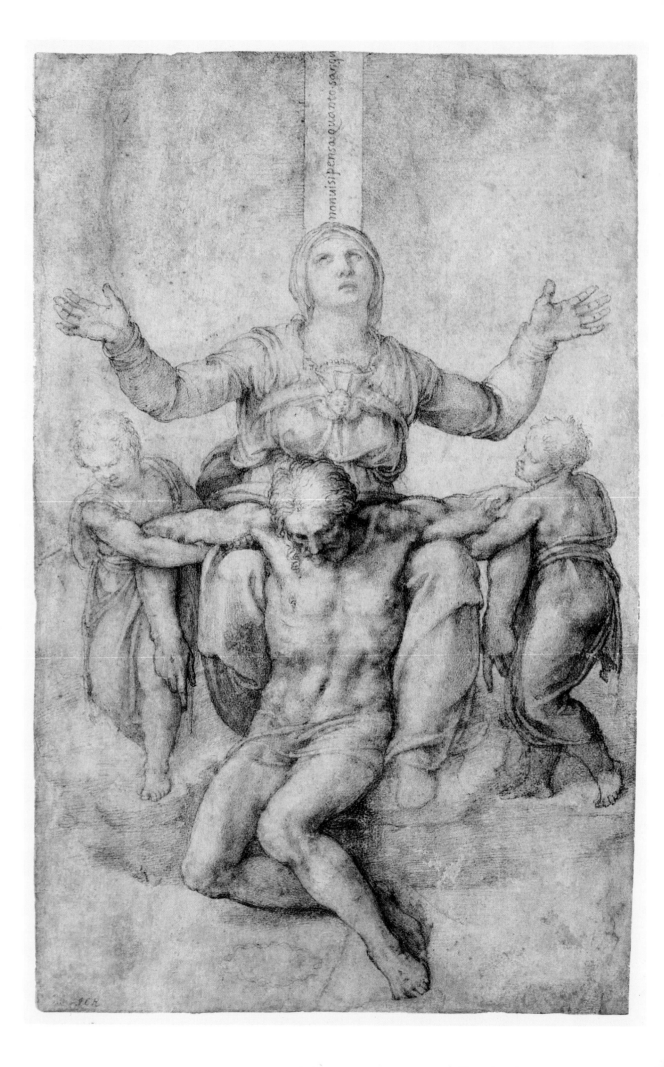

PIETÀ (DRAWING) (1538–40)

Courtesy of The Bridgeman Art Library

THE *Pietà* drawing, along with several others sharing a religious theme, were made by Michelangelo for his friend and (some think) possible lover, the Marchesa di Pescara, Vittoria Colonna. She was of noble descent and spent much of her time in retreat at a convent in Viterbo following the death of her husband, Ferrante Francesco d'Avalos, at the Battle of Pavia in 1525. Vittoria shared a close bond with Michelangelo and there have survived many letters and sonnets that passed between them. Through his relationship with Vittoria, Michelangelo's spiritual beliefs grew immensely.

Another exploration of the Pietà scene, Mary is seen at the bottom of the cross with the body of her son at her feet. Unlike other Pietàs, she does not try to hold the body, but his arms are draped over her legs and he leans against her. Two small child-like angels take hold of Christ under the arms to support him while Mary raises her upturned hands to heaven as if asking for pity.

The inscription upon the cross is a reference to Danté, being a quote from his *Paradiso*: "You little think how much blood costs." The placement of these words infer that it was issued from Mary and aimed at God.

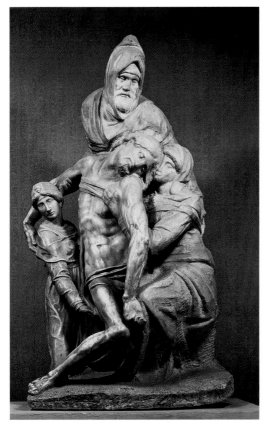

Duomo Pietà (c. 1547–55)
Courtesy of AKG London. (See p. 238)

THE CRUCIFIXION OF CHRIST (C. 1541)

Courtesy of The Bridgeman Art Library

*T*HE *Crucifixion of Christ* is another of the religious pictures made for Vittoria Colonna in the 1540s that are collectively known as presentation drawings. They were made *c.* 1541 using the medium of black chalk on paper. Michelangelo used a stippling, or dabbling, effect with the chalk, which he also employed in the other presentation drawings. The stippling technique means that the delineation around the figure of Christ is darker and therefore he seems to stand out against the background. Stippling is also used to create shadows. The techniques used in the presentation drawings differ greatly to later drawings such as *Study for a Crucifixion* (*c.* 1540–55).

There are few signs of life in the figure of Christ; the skull seen at the foot of the cross symbolizes his approaching death. Under Christ's outstretched arms are the

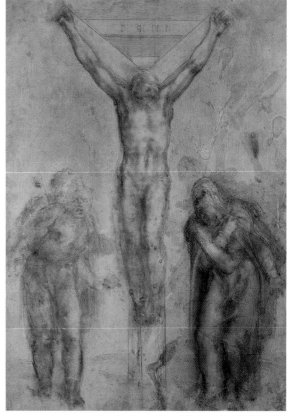

***Study for a Crucifixion* (c. 1540–55)**
Courtesy of The Bridgeman Art Library. (See p. 244)

figures of two angels. One angel looks worriedly at Christ, while the other looks despondently to the ground. Their expressions indicate that Christ is about to die. His face, as he gazes upwards to Heaven, shows signs of intense suffering and this portrayal was greatly admired by Vittoria Colonna for the profound religious sentiments it portrayed.

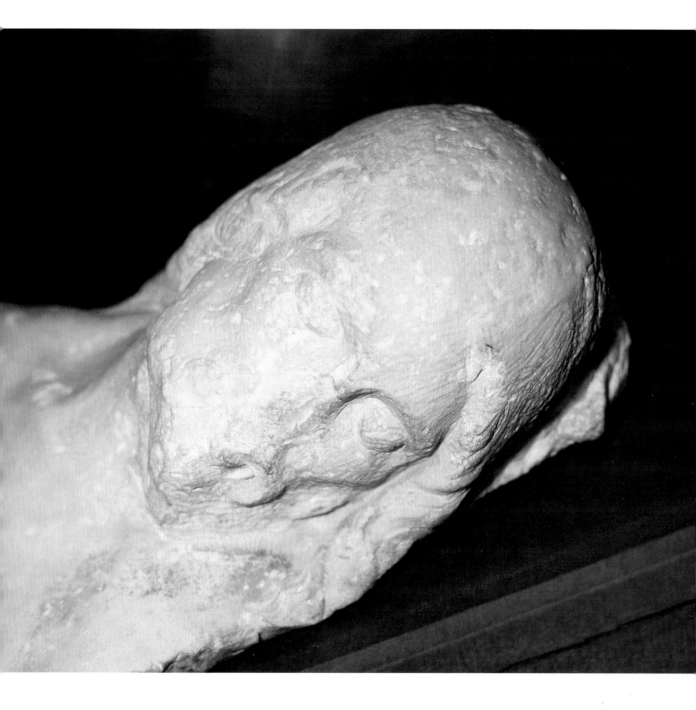

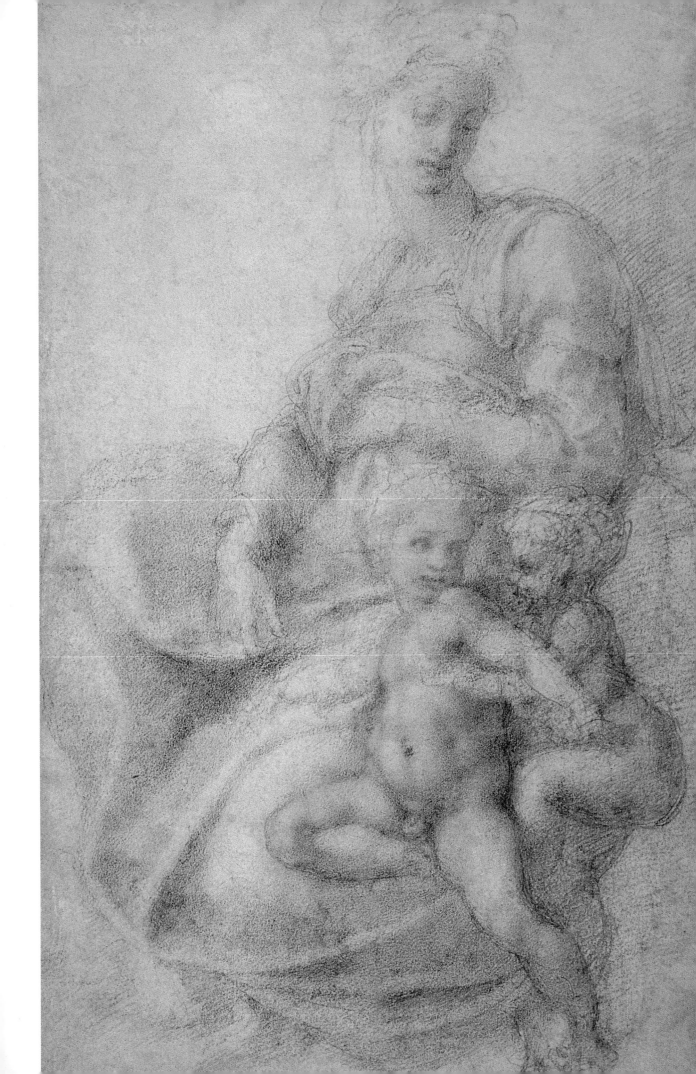

MADONNA AND CHILD WITH INFANT ST JOHN
(DATE UNKNOWN)
Courtesy of The Bridgeman Art Library

*T*HE last works of Michelangelo were religious in content, reflecting his deepening spirituality. From his work as architect at St Peter's in Rome, through to his final *Pietà* sculptures and his last drawings, Michelangelo seems to have been seeking redemption through his art; trying to find some visual expression of his intense religious beliefs.

This drawing is revisiting the theme of the Madonna and Child with St John the Baptist that Michelangelo had explored in his earlier career with the three tondos, especially the two marble reliefs of the *Pitti Tondo* and the *Taddei Tondo* (both *c*. 1504).

Michelangelo's treatment of *Madonna and Child with Infant St John* is unusually light. The two children seem playful, cherubic and much like a pair of mischievous caryatid from the Sistine Chapel ceiling frescoes (1508–12). The positioning has also changed: whereas St John in all three early tondos was at a distance from Christ, here he is directly behind him with one of his arms held around him. The Madonna also seems less introverted than in the earlier marble reliefs, in which she looks out towards the viewer, ignoring her son who leans on her lap.

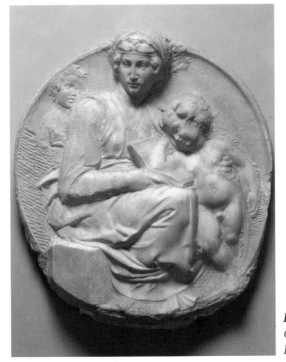

***Pitti Tondo* (*c*. 1504)**
Courtesy of The Bridgeman Art Library. (See p. 44)

STUDY FOR THE LAMENTATION OVER THE DEAD CHRIST
(DATE UNKNOWN)
Courtesy of The Bridgeman Art Library

*S*TUDY *for the Lamentation Over the Dead Christ* uses the same
techniques as the other presentation drawings to Vittoria
Colonna, of stippling the chalk so that the images are formed in
chiaroscuro. Like the sculpture of the St Peter's *Pietà* (1497–99), the
Lamentation of Christ depicts a scene with the Madonna holding the
body of Christ. The drawing differs from a Pietà in that there are several
other figures in the scene.

The Madonna looks away from her son, leaning her head upon
the figure to her left, who huddles close to her, offering sympathy. Two
more figures around the Madonna look in horror at the body of Christ.
There is a further face on the left, just barely seen, that seems to indicate
the presence of yet more people behind the group.

The *Lamentation Over the Dead Christ* shows the body of Christ
positioned in the lap of the Madonna and the practical and physical diffi-
culties posed by a *Pietà*, of a woman supporting a grown man, are
removed by the placing of the Madonna on the ground. The body of
Christ also rests on the ground as well as on the leg of the figure next to
the Madonna.

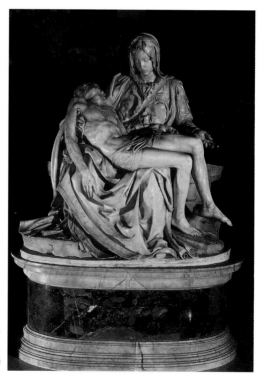

Pietà **(1497–99)**
Courtesy of The Bridgeman Art Library.
(See p. 26)

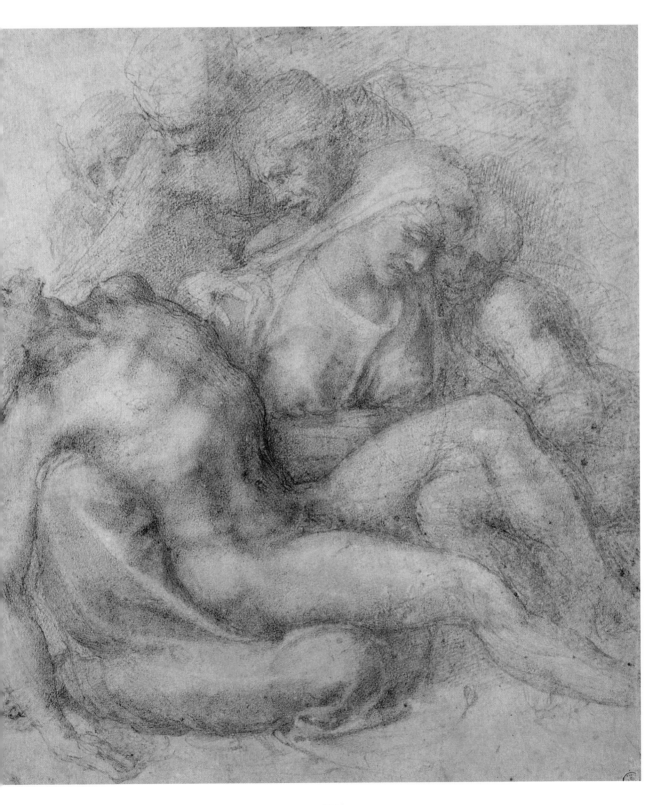

THE CONVERSION OF ST PAUL (1542–45)

Courtesy of The Bridgeman Art Library

UPON completing *The Last Judgment* (1536–41) in the Vatican, Pope Paul III asked Michelangelo to decorate his own private chapel, the Capella Paolina, which was adjacent to the Sistine Chapel and in which popes were selected at that time. Michelangelo began in 1542 with *The Conversion of St Paul*, a theme chosen in deference to Paul III. Before his vision of God and subsequent conversion to Christianity, Paul was a Pharisee named Saul who was traveling along the road to Damascus to murder the Christians who lived there. Although historically St Paul was young, here he is depicted as an old man of a similar age to the pope.

The *Conversion* fresco was begun shortly after the unveiling of *The Last Judgment*, but the coloring within the piece shares more with that used in the ceiling of the Sistine Chapel. In the *Conversion*, the colors are bright and varied, with none of the drabness that invades *The Last Judgment*. The whole fresco is infused with the light that the figure of Christ directs at St Paul.

Despite the many figures within the work, the viewer's attention is focused on two figures: that of St Paul as he lies on the ground, and on Christ as he hurls himself down from the Heavens, with a blazing light in his path. Michelangelo reverted to a more traditional portrayal of Christ here than in *The Last Judgment*.

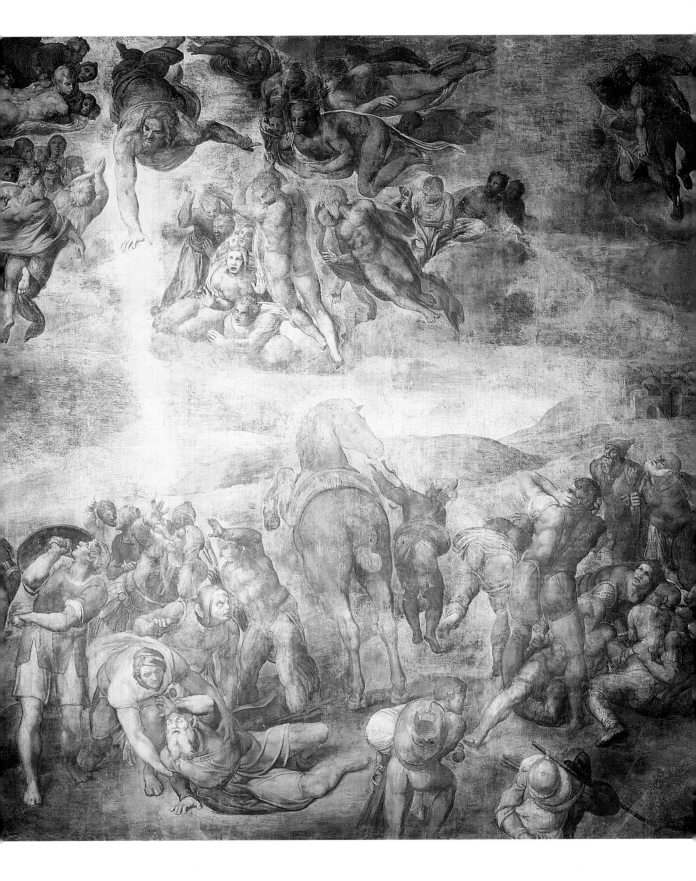

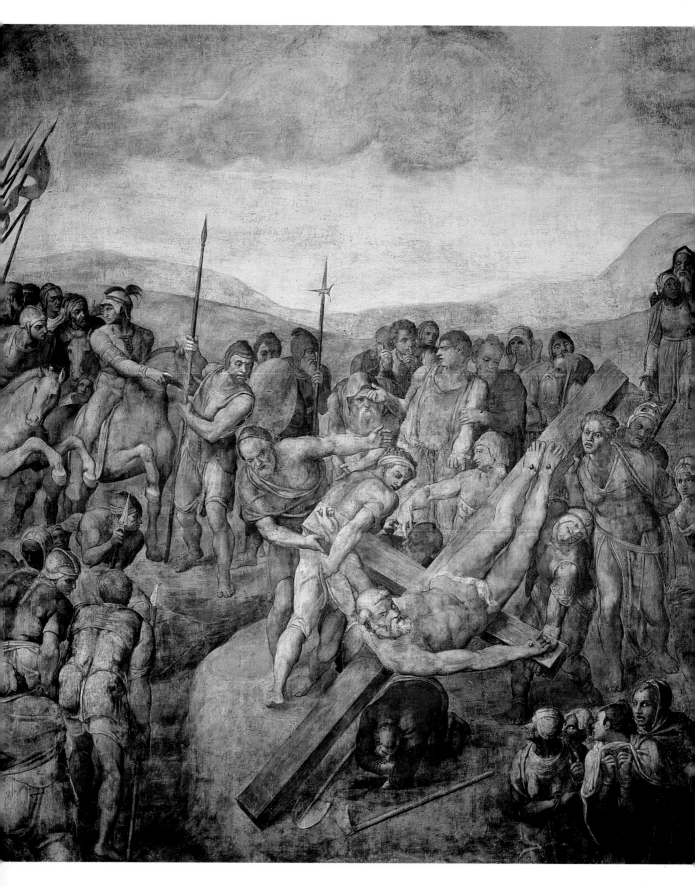

THE CRUCIFIXION OF ST PETER (1542–50)
Courtesy of The Bridgeman Art Library

*T*HE *Crucifixion of St Peter* was chosen as decoration for Pope
Paul III's private chapel in the Vatican because in Christian
tradition Peter was the first pope and therefore father of the
new Church.

There is a circular motion within *The Crucifixion of St Peter* akin
to that in *The Last Judgment* (1536–41). The figures are all placed in a
wide circle around the central figure of Peter. People point to Peter to
emphasize the focus on him and the women in the near foreground
direct the gaze to him with turned heads and wide-eyed stares.
Michelangelo increased the intensity of the light within the center of the
picture to further focus the viewer's attention on the figure of St Peter.

Four men are preparing to stand the cross that bears the saint.
St Peter chose to be crucified upside down, and in order to avoid
compositional difficulties, Michelangelo chose to show the cross as it
is about to be erected so that St Peter is able to pull himself up to glare
fiercely out at the viewer. The impact of his accusatory stare outwards
enhances the fact that he is the focus of everybody else in the painting.

INNER COURTYARD, PALAZZO FARNESE (BEGUN 1547)

Courtesy of The Bridgeman Art Library

*T*HE Farnese Palace in Rome was mainly built to
the designs of Antonio da Sangallo the Younger,
who also worked on St Peter's. He began work on
the Palace in 1517 and by his death in 1534, the building
had reached the second story, with the facade almost com-
plete. The completion of the palace was thrown open to a
public design competition in 1547; Michelangelo's successful
design included an additional third story for the inner
courtyard of the palace and the large cornice that now
surmounts the façade.

In the courtyard, Sangallo's middle story is clearly
much more traditional than the ornate, grandiose style
Michelangelo employed for his third story. The windows are
surmounted by heavy, arched pediments, decorated with a
ram's head placed centrally in each and garlands flowing
from either side. These pediments do not connect with the
windows but rest upon the capitals that crown the pilasters.
On top of the window frames are lion's heads. The columns
that flank the windows of the second story have become
dominating pilasters by the third story. Michelangelo also
altered the second story by adding triangular pediments and
the entablature decorated with a garland motif.

St Peter's Basilica (Begun 1546)
Courtesy of The Bridgeman Art Library. (See p. 254)

DUOMO PIETÀ (C. 1547–55)

Courtesy of AKG London

ICHELANGELO worked on the *Duomo Pietà* intermittently for seven years. He carved it for his family tomb as a fitting memorial for himself and the family he loved so well. By 1547 he was 70 years old and the knowledge of his own mortality was evidently important in this work. The sculpture is housed in the Museo dell' Opera del Duomo in Florence and is sometimes called *The Deposition of Christ*, as is the painting of *The Entombment*, which illustrates a similar scene.

The man at the back supporting the body of Christ is Nicodemus, who was a follower of Jesus and, together with Joseph, helped take down his body from the cross. He was also a sculptor who carved the visions that God sent him; poignantly Michelangelo has given Nicodemus his own features.

The deformed left arm of Christ has clearly been broken in several places and his right leg is missing altogether. According

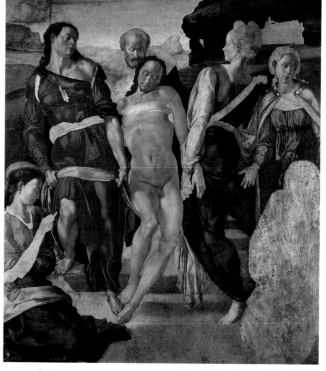

The Entombment (c. 1506)
Courtesy of The Bridgeman Art Library. (See p. 49)

to Vasari, Michelangelo was deeply discouraged both by the *Pietà* and his own failing abilities, and attacked the statue in a fit of frustration. He later gave the *Pietà* to his assistant Tiberio Calcagni, who attempted to finish it; the incongruous figure on the right, Mary Magdalen, is attributed to his weak craftmanship.

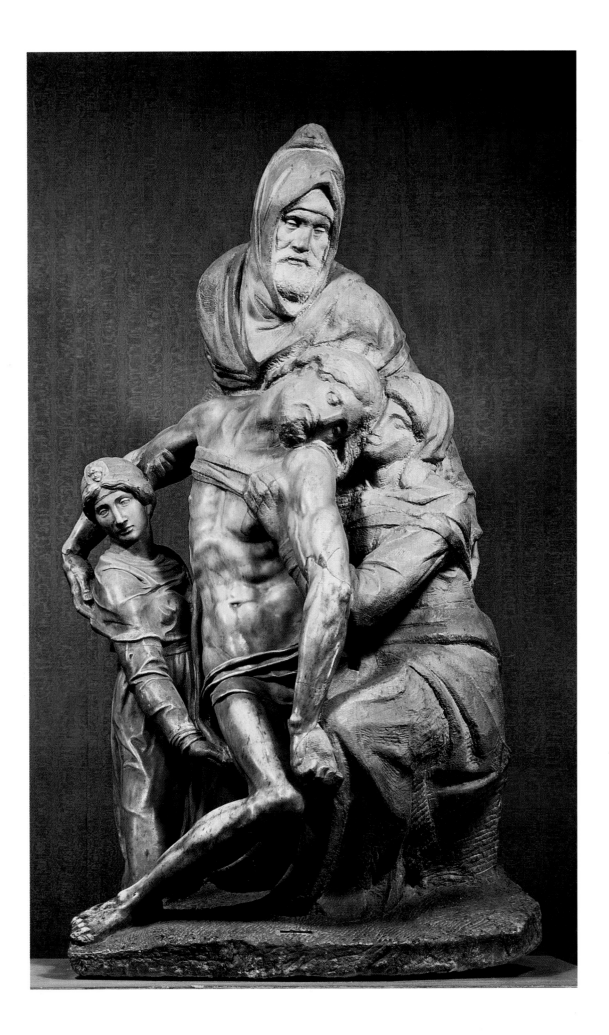

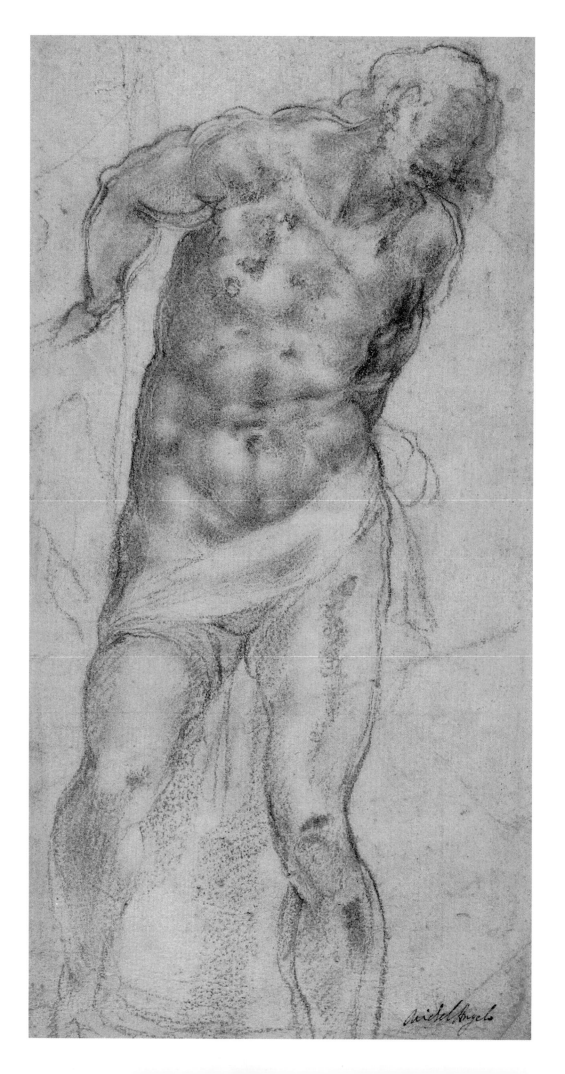

FIGURE STUDY (DATE UNKOWN)
Courtesy of The Bridgeman Art Library

MICHELANGELO has been quoted as saying that an "artist must have his measuring tools, not in the hand, but in the eye, because the hands do but operate, it is the eye that judges...." He was a superb draftsman, a skill that he believed was paramount to all the arts in which he excelled, whether it was sculpture, painting, or architecture.

This figure study shows the artist's skills at handling the body in movement. The man's torso appears to be pushing forward out of the frame, half stumbling towards the viewer. The lack of facial features add to this stumbling quality, as does the sway of his body to one side and the arms thrown far back from the body. The man is thick-set, massive, and reminiscent of the heavier representations of figures that appeared in the artist's later paintings, such as those in the fresco of *The Crucifixion of St Peter* (1542–50). The heavier forms that filled Michelangelo's later work have been seen as evidence of his disillusionment with the portrayal of the perfect male form, which had once been abundant in his exploration of the nude in movement seen in the Sistine Chapel.

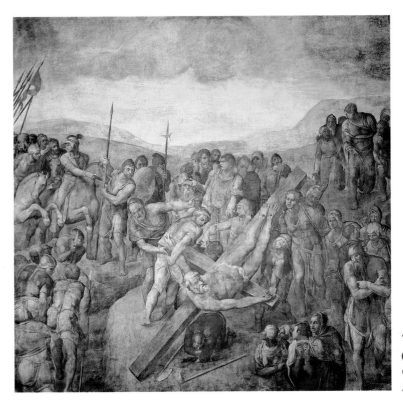

The Crucifixion of St Peter (1542–50)
Courtesy of The Bridgeman Art Library. (See p. 235)

STUDY FOR THE HOLY FAMILY (EPIFANIA) (C. 1553)

Courtesy of The Bridgeman Art Library

*T*HERE is much mystery surrounding the cartoon of the *Holy Family (Epifania)*; it is unclear why this large preparatory drawing was produced and equally uncertain what the cartoon is depicting. It was later used by Ascanio Condivi, Michelangelo's friend and biographer, as the basis for his version of the painting.

The central figure is the Virgin Mary, who shelters Christ beneath her legs. The other child is St John the Baptist. On her right, Mary pushes away Joseph, whose features are clearly a self-portrait by Michelangelo. Mary is in deep discussion with the androgynous figure on her left, who leans towards her. There are several other outlines of faces within the cartoon, which are also leaning towards Mary, as if straining to hear the discussion.

One explanation of the cartoon's subject is that the surrounding vague outlines are the half-brothers and half-sisters of Christ, who were Joseph's children from an early marriage. The androgynous figure may be St Julian, who was renowned for his chastity and may be encouraging Mary's continuing chastity, hence she is pushing Joseph away.

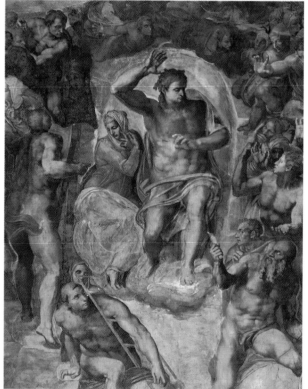

Detail of St Bartholomew from The Last Judgment (1536–41)
Courtesy of AKG London. (See p. 214)

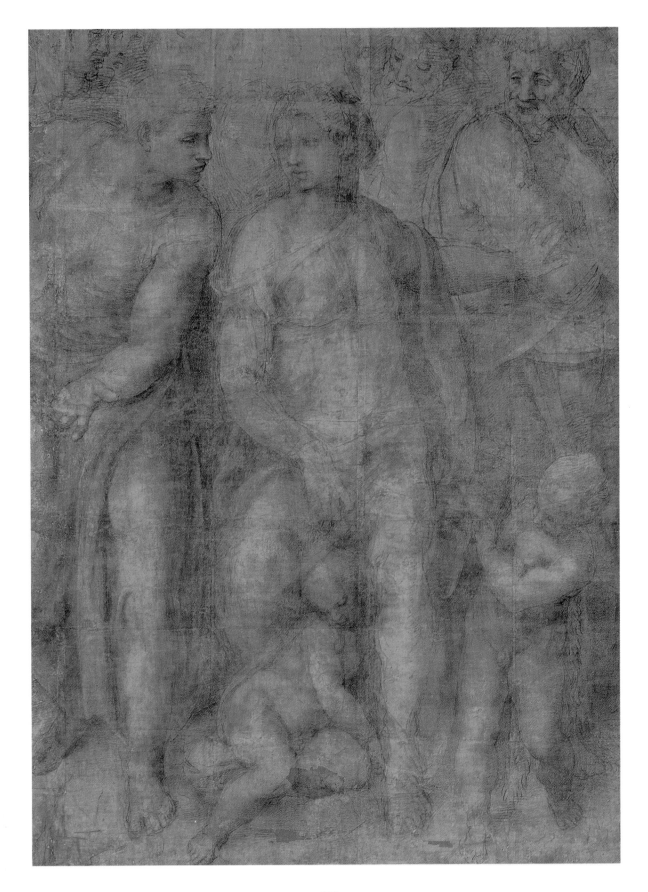

STUDY FOR A CRUCIFIXION
(WITH THE VIRGIN AND ST JOHN) (1550–55)

Courtesy of The Bridgeman Art Library

*T*HIS crucifixion scene is one of several that Michelangelo worked on during his final years. It uses the medium of pencil and black chalk on paper. At one point Michelangelo intended to make a fitting memorial to his great friend Vittoria Colonna, who died in 1547, and it is possible that some of the crucifixion drawings are designs made for this purpose.

On the right is the hazy figure of St John, his mouth agape, eyes wide as if in dismay, much like the expressions of some of the sinners in *The Last Judgment* (1536–41). All three figures have been sketched and re-worked as Michelangelo strived for the ideal postures that he was seeking. As a result of this reworking, their outlines are blurred and both the Virgin, who stands on Christ's left, and St John appear to have double images behind them, giving the picture a haunting quality.

The design of the cross means that Jesus's arms are high above his head. This placement is echoed by the form of Mary, who stands with her arms crossed protectively against her chest. Michelangelo altered the picture to make this possible and the original position of her arm is easily seen.

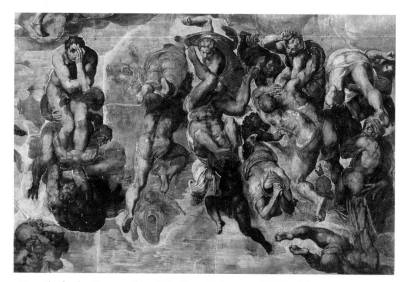

***Detail of The Sinners from The Last Judgment* (1536–41)**
Courtesy of The Bridgeman Art Library

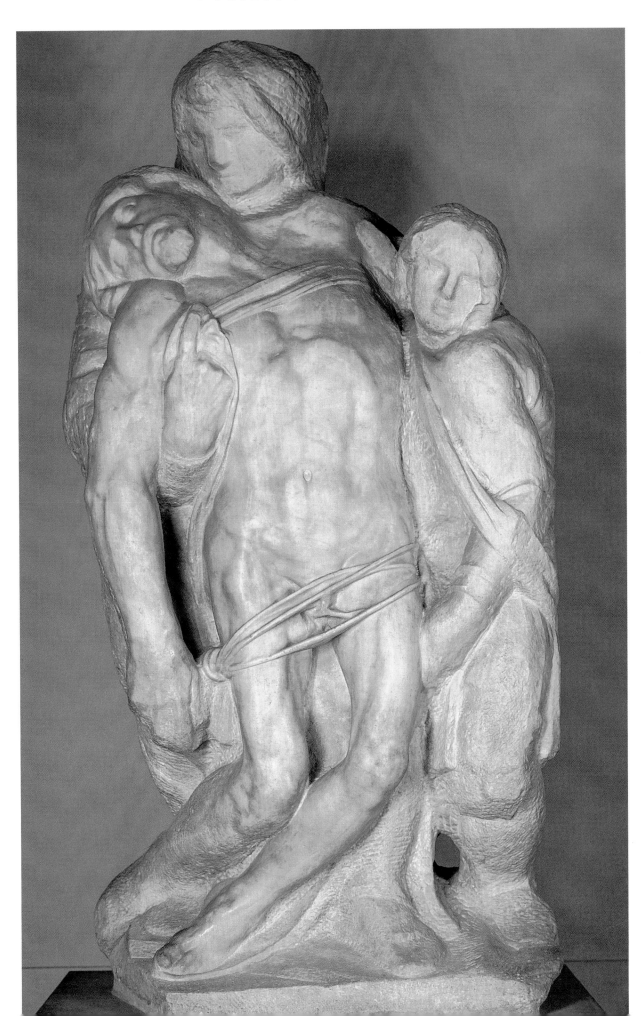

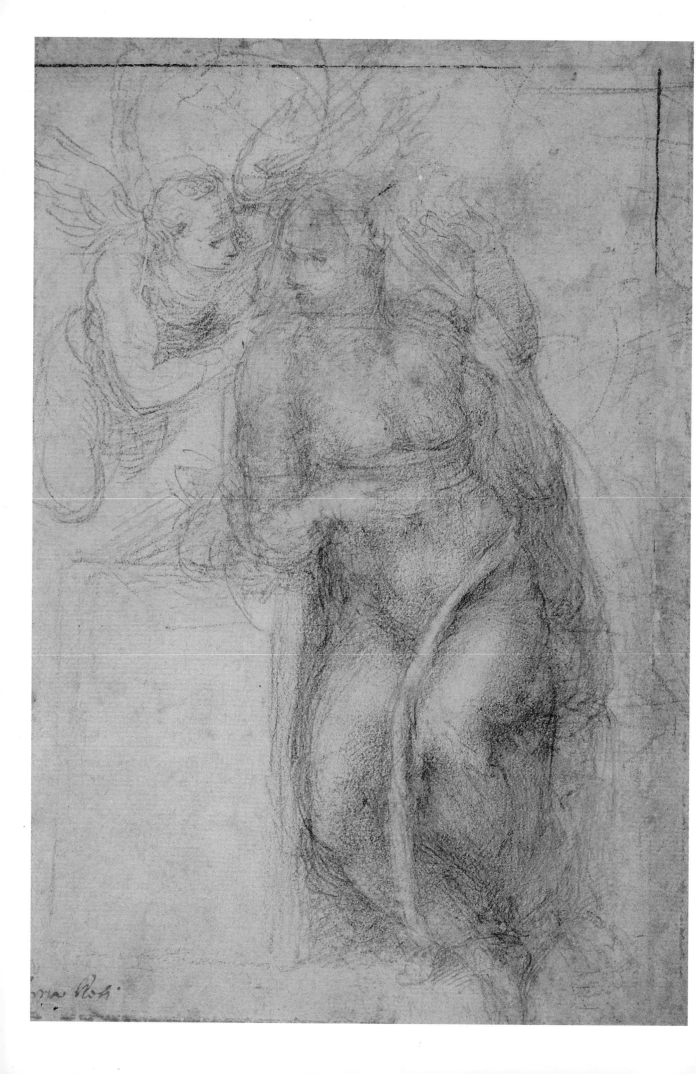

THE ANNUNCIATION (C. 1560)

Courtesy of The Bridgeman Art Library

ICHELANGELO'S final drawings lacked the clear and precise definition of his earlier sketches, such as the *Pietà* (1497–99). This sketch was drawn when Michelangelo was aged around 85, so perhaps the vagueness of the lines can be attributed to a certain physical frailty—his biographies record various illnesses that plagued him in his final years. *The Annunciation* is a simple composition, showing the Virgin Mary leaning against a block, her face turned towards Gabriel, who flies by her side whispering in her ear.

Mary, like the figures in *The Last Judgment* (1536–41), is heavy and solid, not like the fine-featured young woman carved in the *Pietà* in St Peter's. The outline of Mary has been traced repeatedly as the artist attempted to find the form that he envisioned. Earlier placements put Mary to the right of the picture, and these lines, still visible, form an echo of her figure as if she was moving towards Gabriel. Michelangelo destroyed many of his sketches in later years; often in anger that he was unable to portray the image in his mind onto paper adequately.

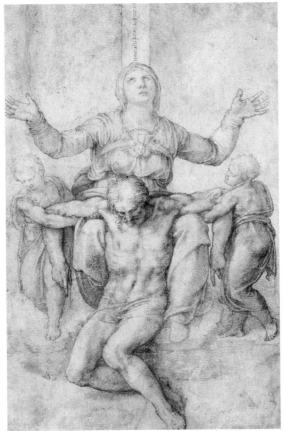

Pietà *(Drawing)* (1538–40)
Courtesy of The Bridgeman Art Library. (See p. 223)

RONDANINI PIETÀ (c. 1556–64)

Courtesy of The Bridgeman Art Library

THE *Rondanini Pietà* (named after the palace where it was housed) was the final sculpture on which Michelangelo worked. He was working on the sculpture up to six days before his death. Working with marble takes considerable strength; although Michelangelo was almost 90 by this time, he was in the habit of carving a little of the *Pietà* each day.

The *Rondanini Pietà* differs from other of Michelangelo's Pietàs in that the figure of the Madonna is standing on a raised level, the body of Christ leans back against her and she supports his body from behind. Michelangelo's frustration with the erosion of his sight and skills is keenly felt within the piece. The bodies and scale of the two figures bear no relation to the lower legs of Christ or to the dismembered right arm that can be seen on the left. It is possible Michelangelo became unhappy with the sculpture and began decreasing the scale, starting from the top, to create smaller figures from the block.

Pietà (Drawing) (1538–40)
Courtesy of The Bridgeman Art Library. (See p. 223)

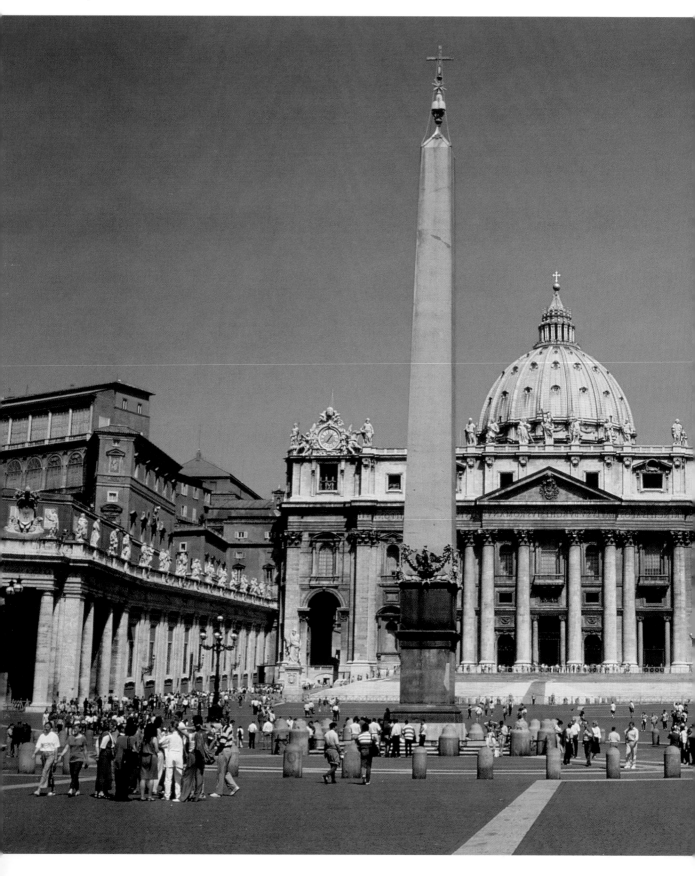

ST PETER'S BASILICA (BEGUN 1546)

Courtesy of The Bridgeman Art Library

EMPEROR Constantine (*c.* 288–337 AD) built the original St Peter's church over his tomb in the 4th century. Pope Julius II initially commissioned Michelangelo's great rival Bramante to renovate the building, but as the structure had deteriorated, the architect began to demolish the old building and created designs for a new, grand church. Bramante died in 1514 and was replaced by several successive architects, including his nephew Raphael. Pope Paul III approached Michelangelo in 1546 following the death of Sangallo the Younger; although reluctant, Michelangelo accepted the commission in 1547.

Bramante died leaving incomplete plans for St Peter's, which were modified by later architects. Despite his intense dislike of Bramante, Michelangelo chose to return to much of his original design, rejecting Sangallo's later plans. The workers on St Paul's held allegiance to Sangallo, having worked under him for many years, and Michelangelo's changes made him unpopular. He justified himself by saying that Bramante's designs were "not full of confusion, but clear, pure, and full of light, so that it did not in any way damage the palace ... whoever departs from this order of Bramante's, as Sangallo has done, departs from the truth."

AERIAL VIEW OF ST PETER'S BASILICA (1547–1564)
Courtesy of The Bridgeman Art Library

MICHELANGELO once remarked light-heartedly that "one could expect to see the last day of the world sooner than see St Peter's finished." He would accept no payment for his work on the basilica, and viewed the project as spiritually redeeming. During the 17 years that he spent working on St Peter's, the building work was considerably progressed and by the time of his death in 1564, a large part of the drum that the cupola rests on had already been erected.

Following Michelangelo's death, Pope Paul III set a brief that his designs for St Peter's were still to be adhered to, but as few clear or instructive plans were left by the artist to show his intentions, One major change in design was the form of the nave being changed from the Greek cross plan of Michelangelo's and Bramante's to the Latin cross design that can now be seen.

Piazza del Campidoglio (c. 1538)
Courtesy of The Bridgeman Art Library. (See p. 218)

Overall however, Michelangelo did succeed in setting the style of the building. The cupola was completed after his death, largely to his design. The columns and rectangular windows with their arched pediments are reminiscent of his work in the *Piazza del Campidoglio*.

AUTHOR BIOGRAPHIES AND ACKNOWLEDGMENTS

For Richard, Andrew, Jonathon, and Matthew.
Kirsten Bradbury was born in 1969. Her childhood was spent living in New Zealand and the West Country of England; as an adult she moved to London. She undertook an arts degree at the University of Surrey and currently combines her writing career with working in the music industry.

For Dom and John, for always being there.
Lucinda Hawksley was born in 1970 and lives in London. She is currently working towards a post-graduate thesis in Literature and History of Art.

While every endeavor has been made to ensure the accuracy of the reproduction of the images in this book, we would be grateful to receive any comments or suggestions for inclusion in future reprints.

With thanks to The Bridgeman Art Library and AKG London for assistance with sourcing the pictures for this series of books. Grateful thanks also to Josephine Cutts, Katie Cowan, and Sasha Heseltine.

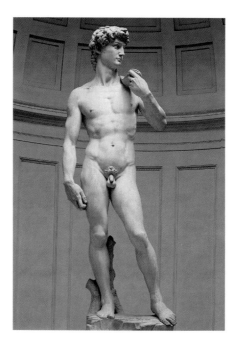